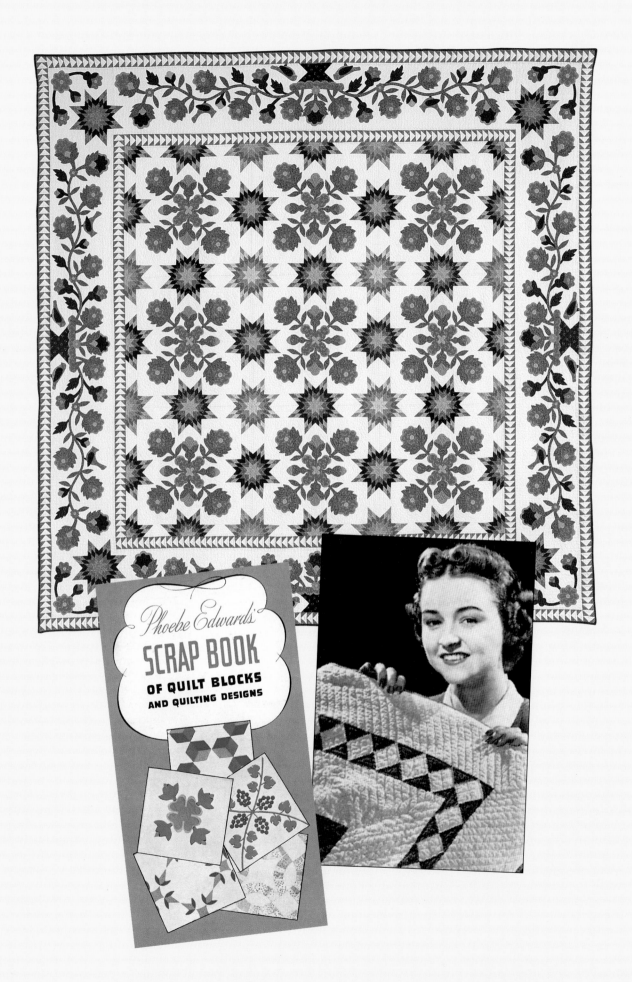

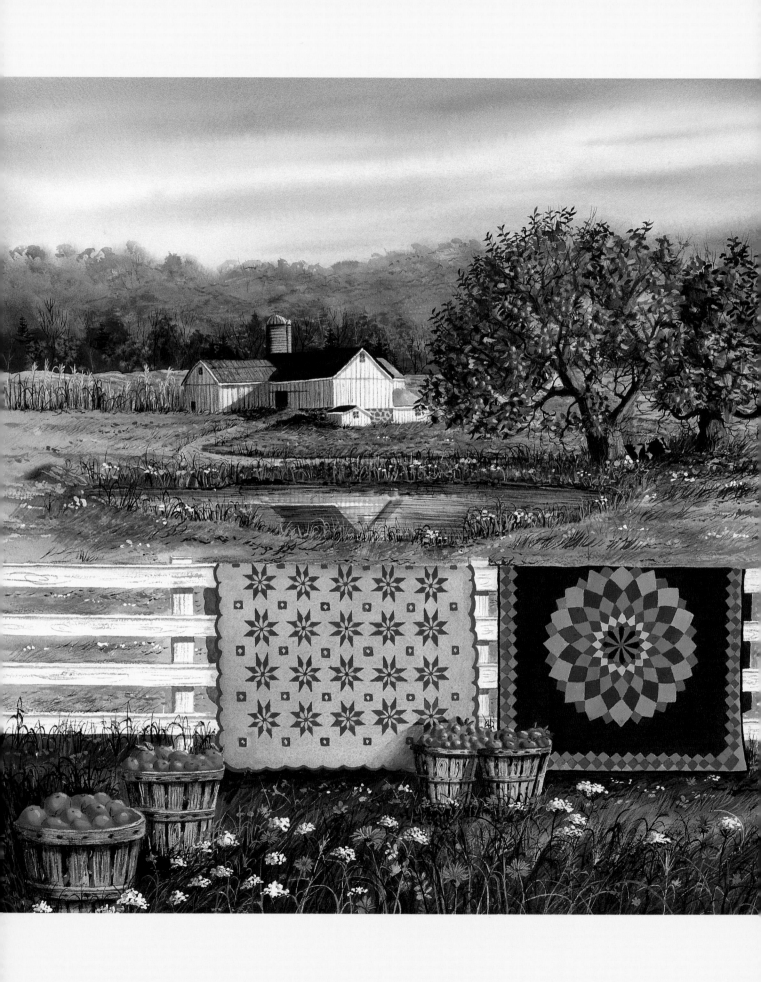

ONCE UPON A
QUILT

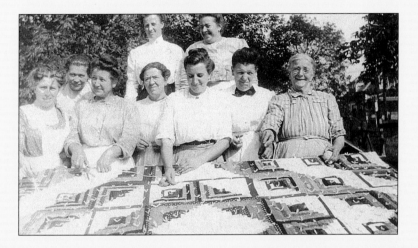

A SCRAPBOOK OF QUILTING
PAST AND PRESENT

Margret Aldrich, Editor

With writings, artwork, and photographs from Sandra Dallas, Helen
Kelley, Shelly Zegart, Merikay Waldvogel, Stella Rubin, Lisa Boyer,
Ami Simms, Mary Eleanor Wilkins Freeman, Carolyn O'Bagy Davis,
Karen Biedler Alexander, Warren Kimble, Diane Phalen,
Dan Campanelli, Judy Wickersham Schauermann, Dennis McGregor,
Rebecca Barker, and others.

A TOWN SQUARE BOOK

Voyageur Press

Edited by Margret Aldrich
Designed by Maria Friedrich
Printed in China

03 04 05 06 07 5 4 3 2 1

Library of Congress Cataloging-in-Publication Data

Once upon a quilt : a scrapbook of quilting past and present / Margret Aldrich, editor ; with writings, artwork, and photographs from Sandra Dallas ... [et al.].
 p. cm.
"A Town Square book."
 ISBN 0-89658-030-X (hardcover)
 1. Quilting—United States—Miscellanea. 2. Quilts—United States—Miscellanea. 3. Patchwork—United States—Miscellanea. I. Aldrich, Margret, 1975- II. Dallas, Sandra.
 TT835.O635 2003
 746.46—dc21
 2003007195

Distributed in Canada by Raincoast Books
9050 Shaughnessy Street, Vancouver, B.C. V6P 6E5

Published by Voyageur Press, Inc.
123 North Second Street, P.O. Box 338,
Stillwater, MN 55082 U.S.A.
651-430-2210, fax 651-430-2211
books@voyageurpress.com
www.voyageurpress.com

Educators, fundraisers, premium and gift buyers, publicists, and marketing managers: Looking for creative products and new sales ideas? Voyageur Press books are available at special discounts when purchased in quantities, and special editions can be created to your specifications. For details contact the marketing department at 800-888-9653.

Permissions
"Why We Love Quilts" by Merikay Waldvogel, from HGTV Ideas magazine, November/December 1999. Copyright © 1999 by Merikay Waldvogel. Used by permission of HGTV and the author.

"Are You a Quilting Fanatic" by Ami Simms. Copyright © 1986 by Ami Simms. Used by permission of the author.

"Fannie and the Busy Bees" by Carolyn O'Bagy Davis, from Uncoverings 2002: Volume 23 of the research papers of the American Quilt Study Group. Copyright © 2002 by Carolyn O'Bagy Davis. Used by permission of the author.

"Alice's Tulips" from Alice's Tulips by Sandra Dallas. Copyright © 2000 by Sandra Dallas. Reprinted by permission of St. Martin's Press, LLC.

"The Low Cost of Quilting" from A Year in the Life: 52 Weeks of Quilting by A. B. Silver. Copyright © 2000 by A. B. Silver. Used by permission of the author.

"The Quilters Hall of Fame" by Karen Biedler Alexander. Copyright © 2003 by Karen Biedler Alexander. Used by permission of the author.

"Quilting Outlaw" from That Dorky Homemade Look by Lisa Boyer. Copyright © 2002 by Good Books. Used by permission of Good Books.

"Quilts as Women's Art" by Shelly Zegart. Copyright © 2003 by Shelly Zegart. Used by permission of the author.

"Starting from Square One" from Every Quilt Tells a Story by Helen Kelley. Copyright © 2003 by Helen Kelley. Used by permission of the author.

On the endsheets: *Members of a quilting party gather together in this photo from 1880. (Courtesy of Glendora Hutson)*

On the frontispiece: *Great Lakes Stars and Flowers, made by Rita Verroca; a booklet of quilt blocks from the Stearns & Foster Company; and a cheerful quilter.*

On the title pages: *It's apple-picking time in the countryside, as quilts hang on a whitewashed fence in Diane Phalen's painting "Amish Roadside Market." (Artwork © Diane Phalen)*

Inset on the title page: *A group of women pose around the quilting frame in this image from the early 1900s. (Courtesy of Janet Finley)*

On the facing page: *This whimsical quilt, circa 1910, features birds perched on tree branches and tiny blue eggs waiting to hatch in their nests. (Stella Rubin Antiques)*

On the contents page: *Quilts of many colors pile up in a glorious heap in the painting "Stacked Flowers" by Ohio artist Rebecca Barker. From the top, the patterns are Nose Gay, Rosebud, Rose, Grandmother's Flower Garden, Tulip, Whig Rose, Potted Star Flower, and Flowering Almond. (Artwork © Rebecca Barker, all rights reserved, licensed by The Intermarketing Group)*

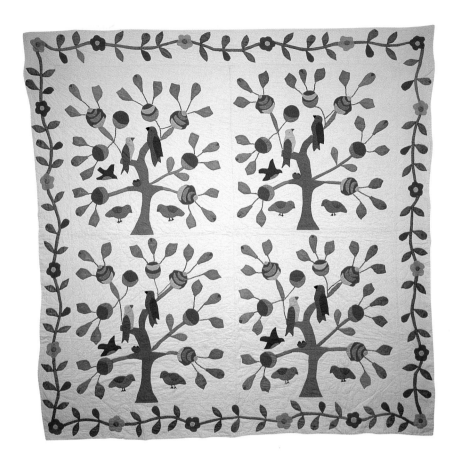

ACKNOWLEDGMENTS

My gratitude goes to all of the people who contributed their time and talents to this book.

Sincere thanks to Karen Biedler Alexander, Mary Leman Austin and Melissa Karlin Mahoney of *Quilter's Newsletter Magazine*, Rebecca Barker, Tom Benda at Apple Creek Publishing, Lisa Boyer, Karen Kay Buckley, Dan Campanelli, Sandra Dallas, Carolyn O'Bagy Davis, Adele Earnshaw, Janet Finley, Linda Gerson at the Intermarketing Group, Judith W. Huey, Glendora Hutson, Helen Kelley, Warren Kimble, Doug Knutson, Dennis McGregor, Melissa Nilsen, Rosalind Webster Perry, Diane Phalen, the Quilters Hall of Fame, Nancy Rink, Cindy Starkey Robinson, Stella Rubin of Stella Rubin Antiques in Potomac, Maryland, Judy Wickersham Schauermann, A. B. Silver, Ami Simms, Gerry Sweem, Rita Verroca, Merikay Waldvogel, Carolyn Watson, Carol White of Arts Uniq,' Inc., and Shelly Zegart.

And, as always, special thanks to Gary Kunkel.

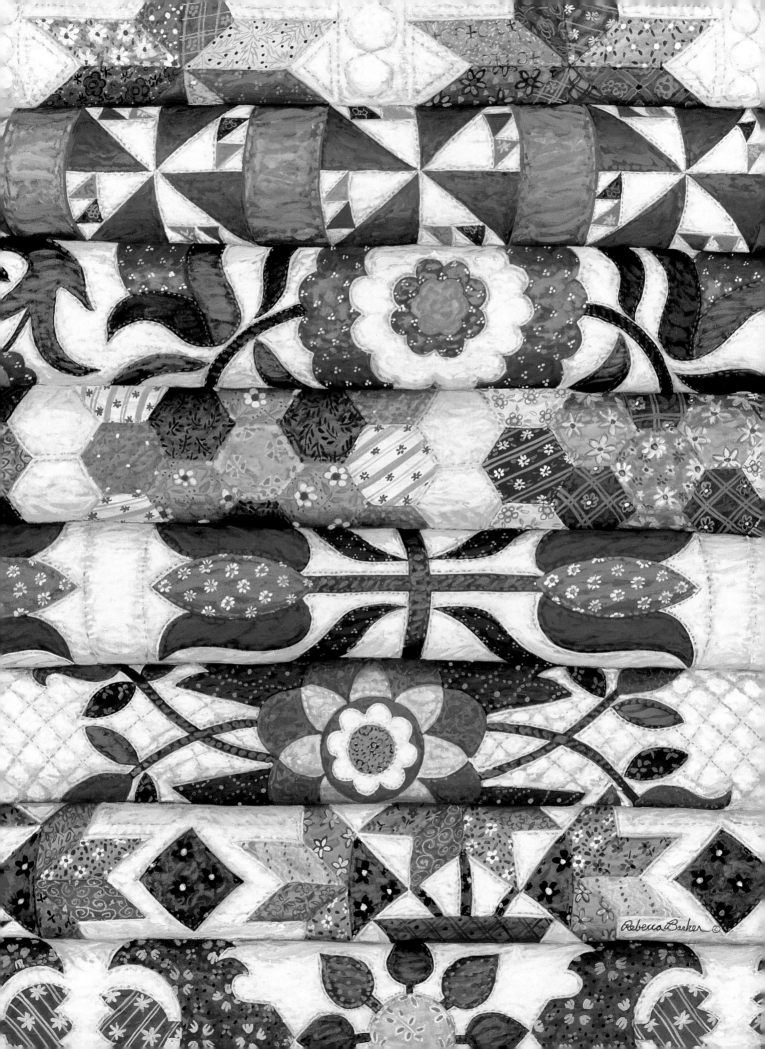

CONTENTS

Introduction **ONCE UPON A QUILT** 9

Chapter 1 **A TIME TO QUILT** 13

Why We Love Quilts 15
by Merikay Waldvogel

Are You a Quilting Fanatic? 21
by Ami Simms

Ruth's Crazy Quilt 29
by Sydney Dayre

Chapter 2 **PIECES OF THE PAST** 37

An Honest Soul 39
by Mary Eleanor Wilkins Freeman

Mandy's Quilting-Party 51
by Anonymous

Fannie and the Busy Bees 61
by Carolyn O'Bagy Davis

Chapter 3 **PATCHWORK HOPES** 71

Hannah's Quilting 73
by Anonymous

Alice's Tulips 85
by Sandra Dallas

The Low Cost of Quilting 97
by A. B. Silver

Chapter 4 **THREADS OF CHANGE** 103

The Quilters Hall of Fame 105
by Karen Biedler Alexander

Quilting Outlaw 115
by Lisa Boyer

Quilts as Women's Art 123
by Shelly Zegart

Chapter 5 **QUILTS EVERLASTING** 133

Starting from Square One 135
by Helen Kelley

The Rose and Lily Quilt 141
by Elsie Singmaster

The Ashley Star 151
by Marjorie Hill Allee

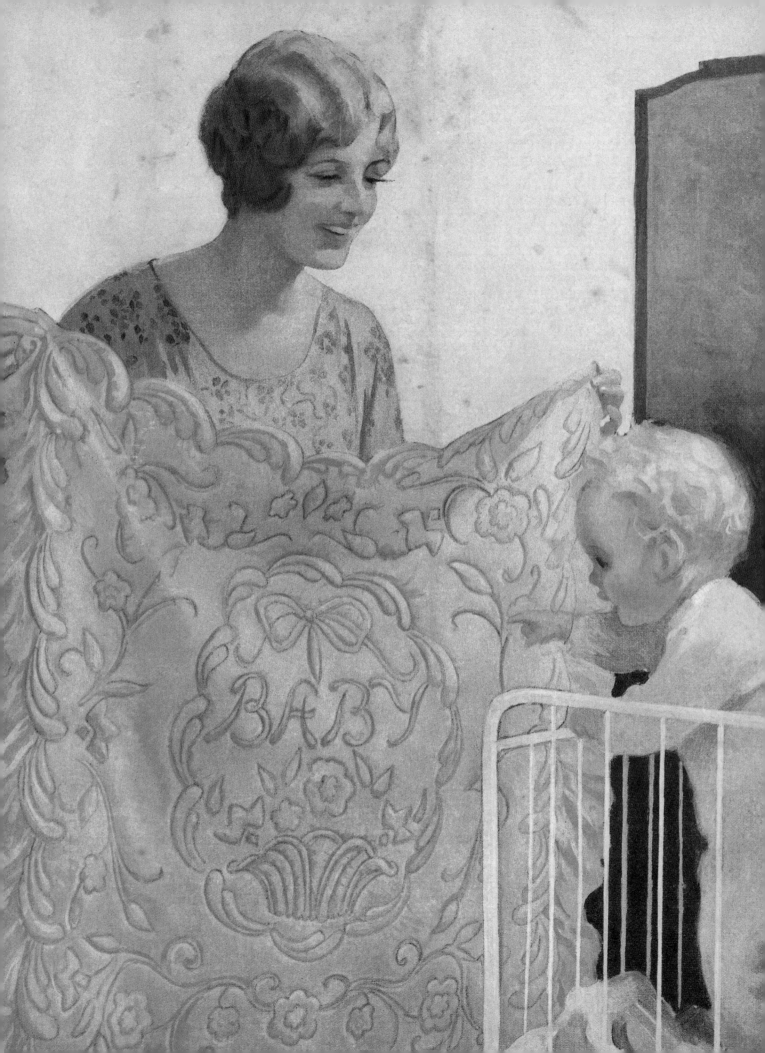

ONCE UPON A QUILT

When my oldest friend, Traci, told me that she was going to have her first child, I was inspired to begin my first quilt. It was to be a gift for her new bundle of joy, and I thought nine months were surely enough time to finish it.

I began poring over my stacks of quilt history books, searching for inspiration. I spent a week contemplating borders and another thinking about a color scheme. I traveled around the Internet, stopping at different sites along the way that sold fabric by the yard, fat quarter, or bundle of pre-cut squares. The plethora of choices was overwhelming, but I finally settled on a collection of reproduction 1930s feedsack fabrics. They were printed with tiny flowers, miniscule animals, and little boys and girls tumbling across pastel or sherbet backgrounds.

With a sampling of my quilt-top fabrics in hand, I took a trip to the local quilt shop in search of a coordinating backing material. The bolts of fabric seemed to stand at attention when I walked in the door, and each stack of pristine cotton folds called me to unroll a length to feel between my thumb and forefinger. The aisles were arbors of deep reds and burgundies, blues and indigos, browns and chocolates. I finally came to a row of yellow and discovered that the sunny hue complemented each of my quilt-top fabrics. After a half-hour of careful inspection, and a few words of encouragement from the quilt-shop owner, I chose an expanse of buttercup-colored fabric that had small white rabbits hopping about the cheery backdrop. With one hurdle cleared, I asked for advice on picking my thread and batting and left the shop with a large bundle under my arm and a feeling of accomplishment.

Now that all of the necessary materials were gathered, I pulled out the tools my sister had given me the previous Christmas: an Olfa mat, a rotary cutter, a plastic ruler, and marking pens. Not yet decided on a pattern, I cut out some squares and triangles and sat on the floor of my living room, playing with the shapes and moving them around into different formations. I finally settled on a Windmill pattern, because I liked the feeling of movement and animation it gave to the characters printed on the fabric. This was progress!

BABY'S FIRST QUILT
Quilts are often given as gifts for a new bride or a new mother. This illustration from the cover of the June 1928 Needlecraft Magazine *shows a pink whole-cloth quilt stitched for the family's pride and joy.*

I wanted the quilt to be special. I wanted it to be meaningful. I decided to piece it entirely by hand. There are probably more than a few seasoned quilters out there laughing as they read my good—if misguided—intentions, but as a beginner, I didn't know any better. I thought that putting my blood, sweat, and tears (literally) into hand stitching the quilt would make it a more heartfelt gift.

I actually did enjoy the handwork. After sitting at a computer much of the day, it was therapeutic to relax with a stack of fabric shapes, a needle, and thread, stitching away as I listened to the TV or radio, or chatted with a friend who stopped by for a visit. Using a speaker phone, I could even talk with loved ones who were far away while I pieced my patchwork quilt—and they couldn't see my grimaces when I pricked my finger or had to rip out a seam.

A feeling of victory came with the completion of each nearly square block, made even squarer with some creative ironing. But my stack of Windmill blocks grew slowly, as my quiltmaking was interrupted by the happenings of everyday life: appointments that had to be made, deadlines at work that had to be kept, laundry that had to be done, and other projects that had to be started. There were weddings to celebrate and funerals to attend; there were birthday dinners and graduation ceremonies. Each of these events worked their way into my quilt, because they were part of my thoughts as I sat and stitched.

They say there is a story behind every quilt, and I whole-heartedly believe that is true. My Windmill quilt is still without an ending, as Traci's baby boy was ready to come into the world complete and perfect before it was. It waits in my sewing project drawer, gathering more memories and stories, making sporadic appearances as I piece a block here and there, straighten stitches, and rearrange colors. By the time it is finished, it will hold years of my life in its kaleidoscope of hues, and it will tell a tale of patience and care. In the meantime, I'll hope that Traci decides to have a big family—perhaps my quilt will be ready in time for her third (or fourth) child.

The stories collected in this anthology come from a wide range of authors and experiences. There are

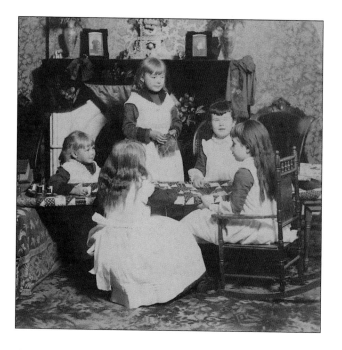

THE LITTLEST QUILTERS
Five young girls work on their first quilt in this nineteenth-century stereoview.

quilting humorists and essayists like Ami Simms, Lisa Boyer, A. B. Silver, and Helen Kelley who have a tall tale or words of wisdom to share; expert quilters and quilt historians such as Merikay Waldvogel, Carolyn O'Bagy Davis, Karen Biedler Alexander, and Shelly Zegart who illuminate the world of quilting days gone by; and fiction writers both old and new, including Sandra Dallas, Mary Eleanor Wilkins Freeman, Sydney Dayre, Elsie Singmaster, and Marjorie Hill Allee, who have a great yarn to pass along.

The photographs and artwork that complement the text were provided by such talented folks as Diane Phalen, Rebecca Barker, Dan Campanelli, Adele Earnshaw, Judy Wickersham Schauermann, Doug Knutson, Dennis McGregor, Carolyn Watson, Judith W. Huey, Warren Kimble, Pauline Eblé Campanelli, the Quilters Hall of Fame, Mary Leman Austin and Melissa Karlin Mahoney of *Quilter's Newsletter Magazine,* Stella Rubin, and Harriet Wise.

I hope the pieces and pictures in this scrapbook of quilting past and present inspire you recall your own quilting stories. Enjoy!

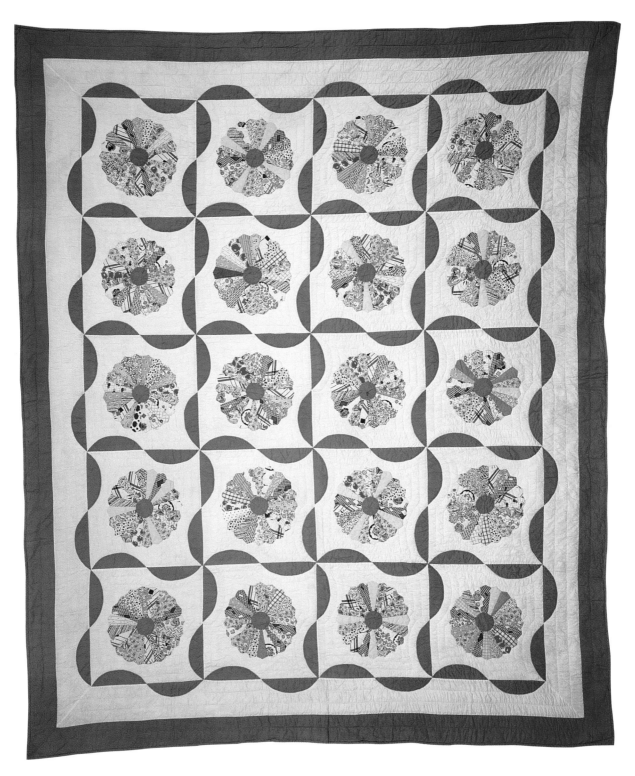

DRESDEN PLATE
This quilt was pieced from scraps of multicolored cotton feedsacks, which seem to give it a cheery disposition. It was made circa 1930, and measures 74 by 80 inches. (Stella Rubin Antiques)

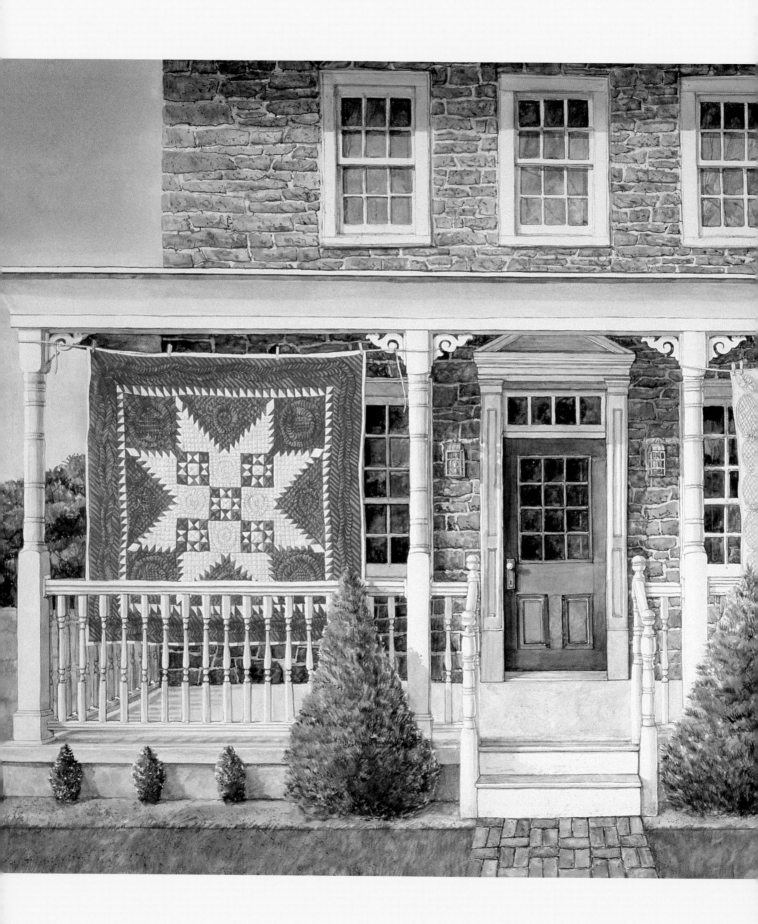

A TIME TO QUILT

*"The quilt, that most anonymous of women's arts, rarely signed or dated,
summarizes more than any other form the major themes in a woman's life—
its beginnings, endings, and celebrations retold in bits of colored cloth."*
—Mirra Bank, Anonymous Was a Woman, 1979

It is difficult to pinpoint what it is about quilts, both past and present, that makes them so appealing. Do we admire them for their beauty and originality? Do quilts remind us of simpler times and days gone by? Do we appreciate the connection patchwork gives us to previous generations of quilters? These reasons and more endear us to the classic art of the quilt.

The selections in this chapter explore just a few of the ways quilts have stood the test of time and claimed their place in our memories and everyday lives.

"QUILTS FOR SALE"
Left: *Two star quilts hang on the front porch of a weathered stone farmhouse in this watercolor by Dan Campanelli. (Artwork © Dan Campanelli, published by New York Graphic Society)*

PAGE TURNER
Above: *The latest and best quilt patterns could be had for ten cents in 1945. This booklet from Coats and Clark shows a Chimney Sweep quilt on its cover.*

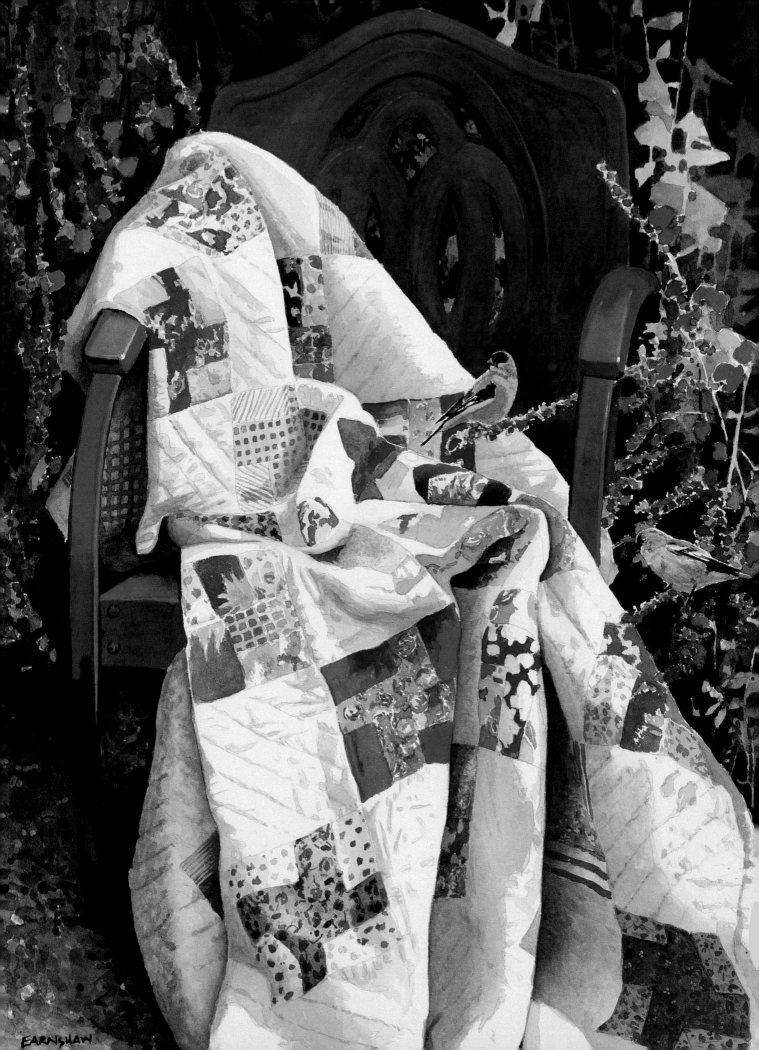

Why We Love Quilts

By Merikay Waldvogel

QUILTS OCCUPY THE memories and minds of countless quilt admirers around the world—they are a timeless part of our homes, our hearts, and our heritage. In this essay, Merikay Waldvogel traces the steps of quilting history from the Civil War to the present day, musing on the importance of patchwork in our lives.

Merikay, a nationally known quilt authority, is a writer, curator, and lecturer. Her books include *Quilts of Tennessee: Images of Domestic Life Prior to 1930* and *Southern Quilts: Surviving Relics of the Civil War* with Bets Ramsey; *Patchwork Souvenirs of the 1933 Chicago World's Fair* with Barbara Brackman; and *Soft Covers for Hard Times: Quiltmaking and the Great Depression.*

Put a quilt in an eighty-year-old woman's lap and you'll unlock a treasure chest of memories: of collecting feedsacks, tracing around a teacup to mark a quilt top, and feeding fried apple pies to children on the porch while their mothers quilted away around a frame hung from pulleys in the ceiling. "Quiltings" really happened—and still go on today. In fact, as the twenty-first century begins, we continue to be fascinated by and drawn to quilts, the stories they tell, and the painstaking process by which they are made.

American quilts are thought to have originated more than two hundred years ago in rural areas where women, out of necessity, turned patches of discarded cloth and clothing into bed covers both decorative and warm. Although somewhat romanticized, this notion of a patchwork quilt embodies the best of the "can-do" American spirit.

Quiltmaking has weathered its fair share of periods of popularity and decline. Following the Civil War, quiltmaking surged as textile mills produced millions of yards of low-cost print fabric and women's magazines distributed quilt patterns nationwide. The crazy quilt fad of the same era became so popular it threatened to overshadow traditional quilt designs. By the early 1900s, crazy quilts were derided as "garish." In contrast, the new floral applique designs by Marie Webster of Marion, Indiana, offered a breath of fresh air. Introduced in full color in the January 1911 *Ladies' Home Journal*, her quilts revived the center medallion format of early 1800s quilts.

National concern for preserving America's crafts soon led the Metropolitan Museum of Art in New York City to open its American Wing in 1924. This prompted the first revival of collecting and making quilts.

The very modern American women of the 1920s—members of that rising middle class newly able to afford "ready-made" clothing and dry goods—had to be persuaded to make quilts. So women's magazines promoted quiltmaking with images of smartly dressed women choosing quick projects such as patchwork pillows and ready-cut quilt kits.

In the 1930s quiltmaking resurged again, this time because of the Great Depression. "Making do" was the order of the day, and creating quilts fit the bill. Mail-order companies and daily newspapers sold copies of hundreds of new patterns. Quilt contests attracted thousands of quilts, and not just from rural areas. Sales of thread, cloth, and batting soared—for a while.

Quiltmaking suffered its next decline during World War II when the domestic sale of cloth was restricted. At the same time, many women took wartime jobs outside their homes; when the war was over, they weren't enthusiastic about jumping back on the quilting bandwagon.

In fact, quilts and quiltmaking didn't come back into vogue until the nation prepared to celebrate its bicentennial in 1976. Once again, the quilt was looked at as a way to inspire pride in America's traditions and heritage.

That's about the time I had my quilt awakening. My "modern" mother sewed clothes for my sisters and me in the 1950s but never made a quilt. Although a modern young woman myself, living and working in Chicago in the 1970s, I succumbed to the back-to-the-earth movement and learned to weave and knit. One Saturday morning in 1974 while I window-shopped, a brown-and-green North Carolina Lily quilt caught my eye and my heart. Its unconventional design and colors grabbed me.

I walked into that store, handed over one hundred dollars and walked out with a quilt under my arm. *What had I done?* I wondered. I'd spent a lot of money for a quilt that wasn't even meant for my bed. I planned to hang it on the wall above my loom.

Without intending to, I had started a quilt collection that would soon grow and grow. I had also made a life discovery: I was so inspired by quilts, their makers, and their stories, that I would eventually abandon my chosen career to research and write about quilts and quilting.

Today I own over one hundred quilts. In the beginning, I was drawn to the fabrics in late nineteenth century quilts. Log cabin quilts were my favorites. In 1990, I wrote a book on Depression-era quilts, *Soft Covers for Hard Times*. I included photographs and descriptions of quilts, interviews with quiltmakers of the 1930s, and their pattern sources in newspapers and women's magazines. This became my plea to save not only quilts themselves and their stories, but also the

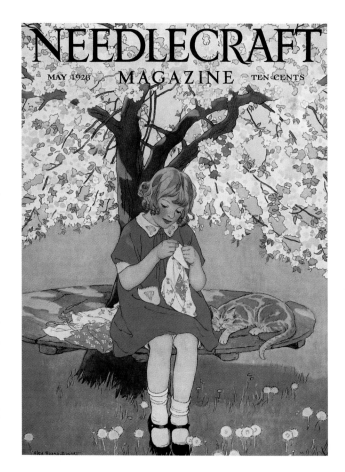

FIRST LOVE

A young girl pieces her first nine-patch blocks under the pink blossoms of a cherry tree on the cover of this May 1928 Needlecraft Magazine. An early love of quilting promises a lifetime of respect for the craft.

FLORAL MEDALLION
*A circle of rosy-hued posies dominate the center of this appliquéd quilt, made circa 1870 and measuring 88 by 70 inches.
(Stella Rubin Antiques)*

STAR WITH HORSES AND DEER
This clever cotton quilt was made in New York State circa 1870 and measures 80 by 84 inches.
Notice that the horses' tails differ, and that both bucks and does are included on the quilt. (Stella
Rubin Antiques)

paper patterns and other ephemera that were part of our quilting heritage.

At a quilt lecture in Birmingham, Alabama in 1992, the local guild president told me about a pattern collection for sale at a country church rummage sale. I made the decision to purchase that pattern collection (over one hundred file boxes) about as quickly as I decided to buy my first quilt fifteen years earlier. The archive of patterns compiled by Mildred Dickerson and her round robin pattern friends in the 1970s and 1980s has shaped my life's work with quilts ever since. I never knew Mildred Dickerson, but my respect for her efforts is indescribable. Like me, she did not make quilts—although I suspect, like me, she could have if she had had the time.

Back in the 1970s, I thought I was "doing my own thing" because I decorated with quilts; in fact, I was not alone. Other baby boomers, such as Jonathan Holstein and Gail van der Hoof, had discovered America's folk heritage. In 1971, they convinced the Whitney Museum of American Art in New York City to exhibit their own collection of pieced quilts. By moving the quilt from the bed to the wall, they not only raised the status of the quilt for study purposes, but also inspired a new quilt type—the art quilt.

Quilt stores with fabrics, tools, books, and classes opened to serve the special needs of quilters. Quilt magazines provided patterns and support for the quiltmaking movement, and annual quilt festivals attracted tens of thousands of people.

AN AFTERNOON OF APPLIQUÉ
Stitching a quilt on the front porch, as shown in this vintage photograph, is a fine way to spend the day.

Quilt groups formed, including the American Quilt Study Group, a network of quilt historians who exchange and publish their quilt findings. During the 1980s and 1990s, state quilt surveys modeled on a program in Kentucky recorded quilters' stories and documented quilts by the thousands.

The late-twentieth-century resurgence of interest in quilting prompted a plethora of books by academics and enthusiasts, exhibits across the country, and documentary films chronicling quilting's history, artisans, designs and their meanings, and techniques. The Internet also greatly facilitated communication among quilters and opened up opportunities for discussion and exhibition online. Distance-learning programs offered through colleges and universities now include quilt and textile history courses.

All this attention to America's historic quilts has led to an increase in collecting and preserving quilts and a growing interest in quiltmaking that will continue for generations. And why not? Quilts have a magnetism all their own. Maybe it's the familiarity of their components or the excitement of seeing the larger pattern emerge as the pieces are sewn together. Maybe it's the storytelling that goes on around a frame or the joy of seeing hard work admired and loved. Maybe it's the recognition of women's ingenuity and craftsmanship. Maybe it's the satisfaction of continuing a tradition and creating a legacy.

Maybe it is all of those things.

Are You a Quilting Fanatic?

By Ami Simms

ANYONE ONE WHO makes, collects, or admires quilts knows that there is a thin line between love and obsession. When you would rather quilt than eat, prefer a trip to the quilt shop over a trip to Tahiti, and dream about fat quarters, you might be a quilt-oholic.

Ami Simms is a quilter, lecturer, author, and teacher, who has led quilting workshops around the globe in countries such as Australia, England, Italy, and the Netherlands. Here, Ami takes a humorous look at the life of a quilt fanatic. Thank goodness, she's not one!

I love everything quilt-related, but thank goodness I'm not a fanatic! Fanatics are weird. They have uncontrollable, obsessive, almost perverse addictions to a particular point of view, philosophy, or way of life. I just like to quilt a little. I'm perfectly normal.

Joggers are fanatics. They have to run every day to get their jollies. They even run when they're on vacation. I can go two, maybe three days without picking up a needle. And I only take my quilting projects on vacation with me when I know that I'll have enough free time to make the effort worthwhile. Anything less than six minutes and I leave the stuff at home.

Compulsive shoppers are fanatics. They have to buy everything in sight in order to be satisfied. They have to own the hottest new fashion, or latest thing-a-ma-bob, even if they have absolutely no use for it. They're not happy unless they're spending money. I only buy fabric when I see it. If I go to store and they don't sell fabric, then I just don't buy any. I am always in complete control. And I only buy quilting supplies that I need, or that I might at some future point in time be able to manufacture a need for. Just because there is no quilting gadget currently on the market that I don't already own does not imply fanaticism. It just means I am an aware consumer.

Cleanliness freaks are fanatics. They spend all their time clutching dust rags or waiting for the ash on someone's cigarette to fall off so they can wisk it away. If they can't pick something up and put it away somewhere, then they wash it. I don't have time for all that. If you can step over it, walk around it, or put it off until later, then that's good enough for me. Anything else takes too much time away from quilting.

Car buffs are fanatics. Their lives revolve around taking cars apart only to put them back together again. They spend every waking hour either tinkering with the insides or polishing the outsides. Quilting is not my WHOLE life. There are other things that I enjoy doing, it's just that

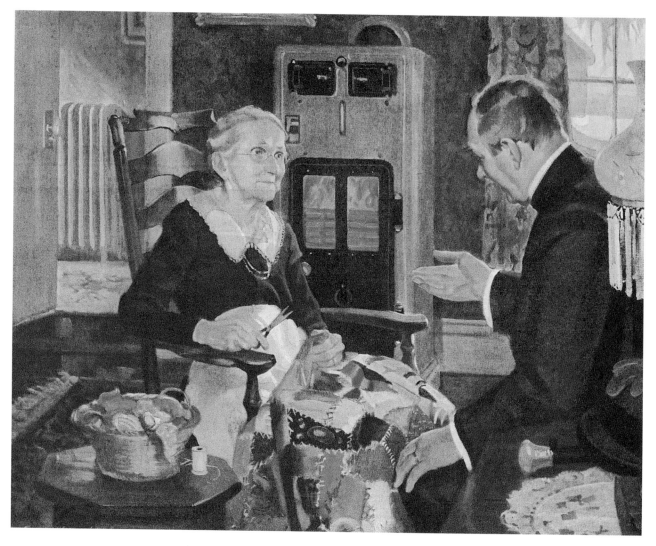

PATCHWORK PATIENCE
Granny feigns interest in the conversation at hand, but the truth is, she'd rather be quilting. This image appeared in an ad for the American Radiator Company in the October 1925 issue of The Country Gentleman.

I can't think of what they are right now. And, I'll admit that while I spend a lot of time making quilts, writing about quilts, teaching people to make quilts, or just plain thinking about quilts, I spend time doing other things too. One night last week I cooked dinner.

Animal lovers are fanatics. They love anything with fur that barks or meows, just as long as it makes it to the newspaper in time. They want to protect every species, regardless of how it looks, what it eats, or how badly it smells. Thank goodness, in my love of quilts I am more discriminating. I only like quilts that are made of cloth.

Gourmet cooks are fanatics. They spare no trouble or expense to prepare exotic dishes that stave off hun-

ger just as well as something that would cost half as much and take a quarter of the time to make. To think that there is any correlation whatsoever between quiltmaking and this kind of food preparation is totally absurd.

Fanatics are those poor souls that hold their view above all others, wish to associate only with those people who feel as they do, and want everyone else to discover and partake of their particular lunacy because they are so enamored of it. Just because I think that quiltmaking is a great way to spend my time, that all my friends happen to be quiltmakers, and that I think everyone ought to whip out a thimble and give it a try, does not make me a fanatic. *I'm a "Quilt Enthusiast!" And there's a difference!*

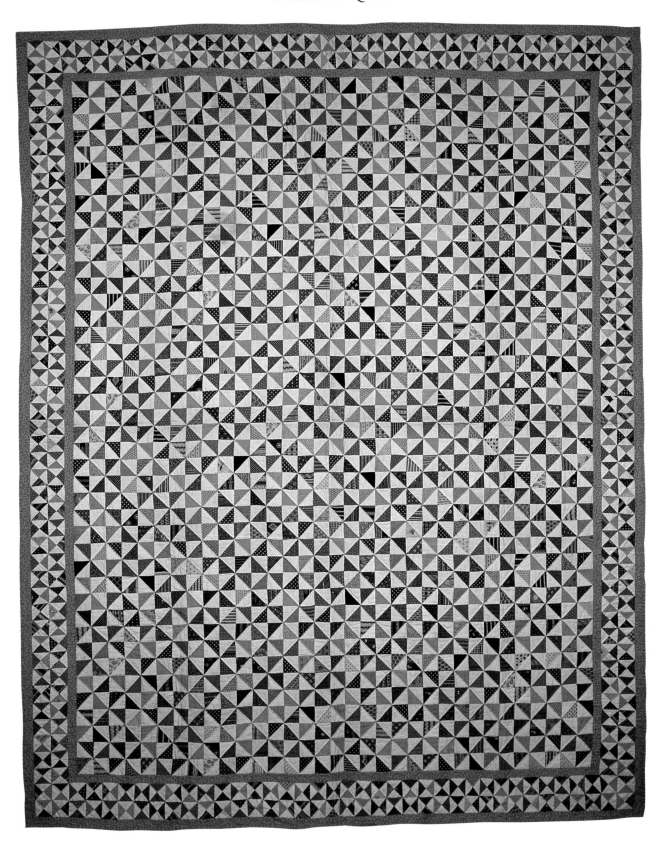

PERFECT PIECING
One can only imagine how many hours were spent piecing this Triangle quilt. It was made circa 1880 in Pennsylvania and measures 78 by 92 inches. (Stella Rubin Antiques, photograph by Harriet Wise)

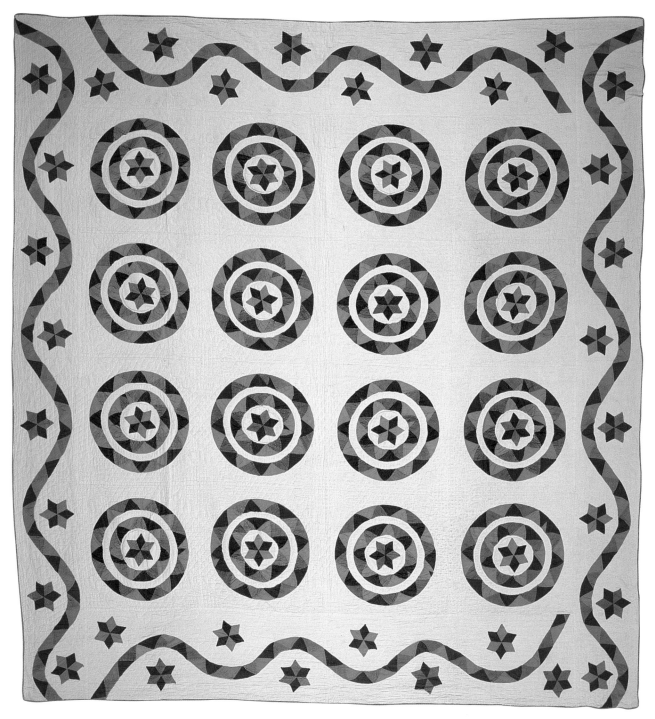

STARS AND CIRCLES
This fanciful cotton quilt was made in Pennsylvania circa 1880. It is 81 by 85 inches and features an interesting serpentine border. (Stella Rubin Antiques)

BATTING 101
These quilt enthusiasts have fallen under the spell of Mountain Mist batting.

You know you're a quilt enthusiast when you . . .

. . . bathe your child wearing rubber gloves because you don't want the warm water to soften your quilting calluses.

. . . want to be buried with your thimble on.

. . . carry around more photographs of your quilts than you do of your kids.

. . . tailgate just to get a better look at the quilt sitting on the back window ledge of the car in front of you.

. . . think a bed looks naked without a quilt on it.

. . . find Michael James more exciting than Mel Gibson.

. . . peel off the "Save the Whales" bumper sticker and replace it with "Quilters Make Better Lovers."

. . . own more quilts than beds to put them on.

. . . instruct your children: "In case of fire, grab at least one quilt on the way out."

. . . watch a romantic movie, and pay more attention to the quilt ON the bed than the action IN it.

. . . prefer quilting to eating.

. . . could probably stock a fabric store with just the material squirreled away under your bed.

. . . take a 150-watt light bulb on vacation so you can sew in your hotel room.

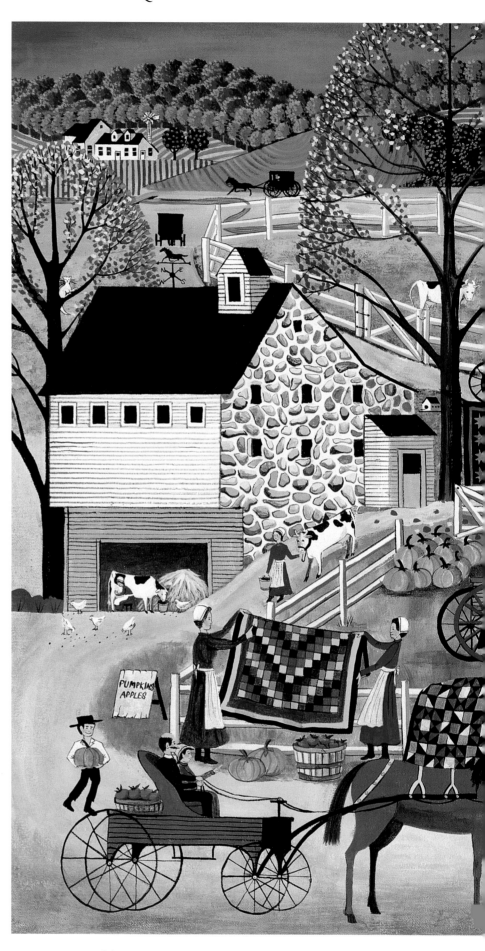

"AMISH QUILT SALE"
Artist Judy Wickersham Schauermann often incorporates quilts into her paintings. This scene shows the colorful handwork of the Amish, who have put their wares on display. (Artwork © Judy Wickersham Schauermann)

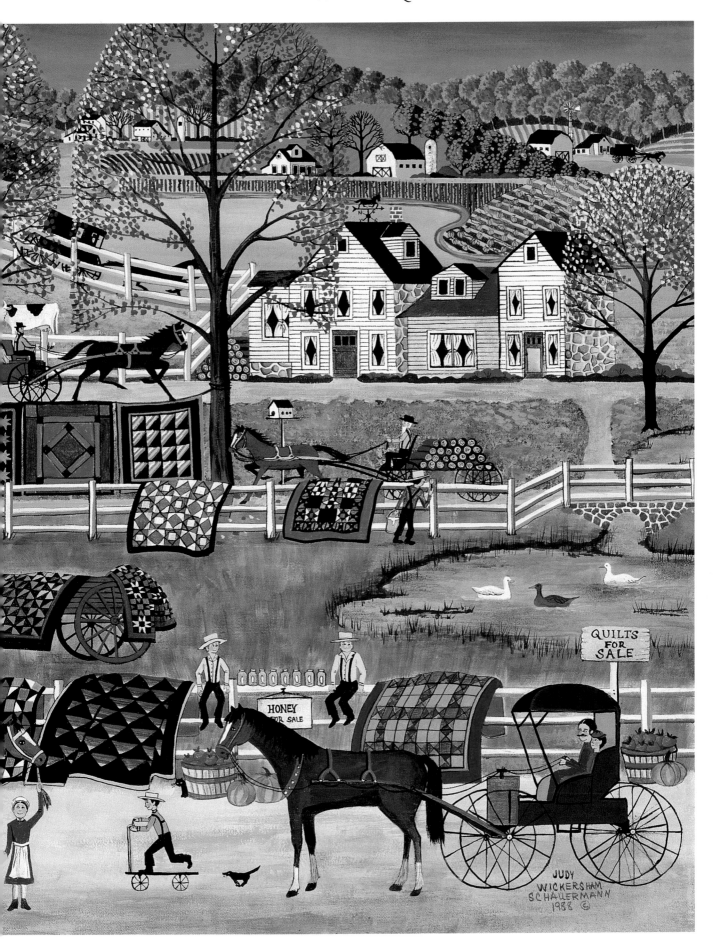

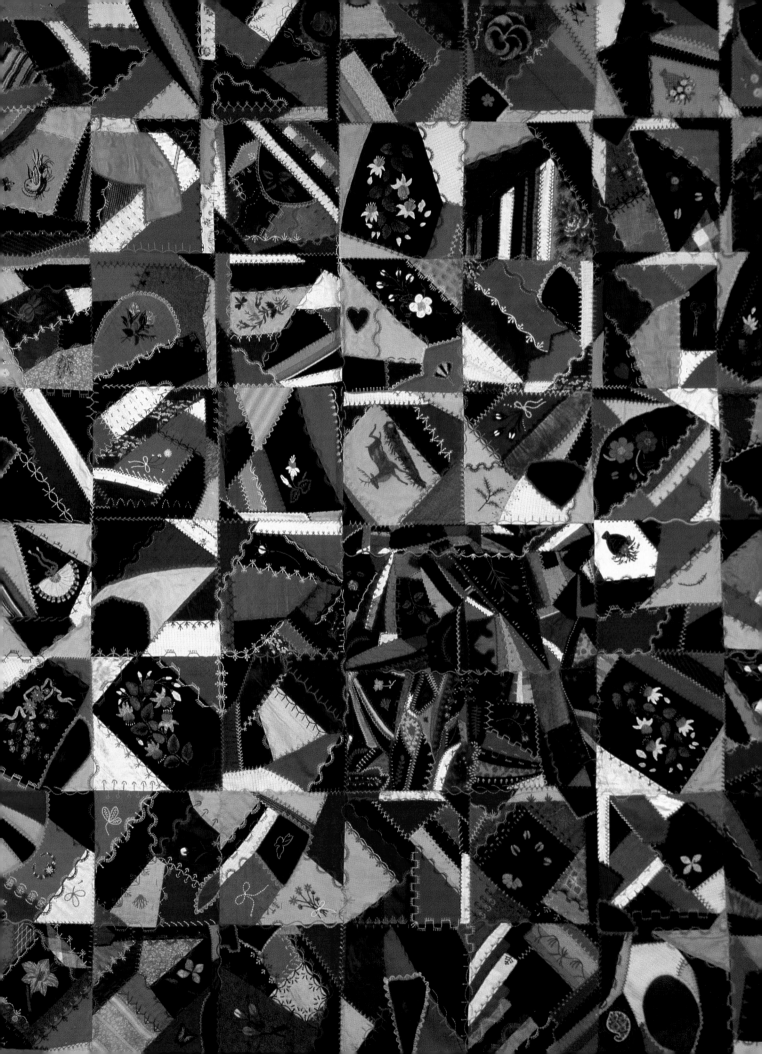

Ruth's Crazy Quilt

By Sydney Dayre

AFTER AN ACCIDENT renders her unable to walk, a young woman named Ruth wonders if her plans to become a schoolteacher and help her mother with the household finances are finished. When she decides to pick up a needle and thread, however, her entire future changes. Ruth becomes masterful at intricate embroidery work and makes a glorious crazy quilt, using scraps of silk, bits of her mother's wedding dress, pieces of her father's army coat, and plenty of imagination.

Although first published in 1886, this story illustrates lessons of patience and dedication that are still acutely relevant today.

CRAZY QUILT DETAIL
Crazy quilts were all the rage following the Centennial Exposition in Philadelphia in 1876, where Americans were first exposed to Japanese art and culture. This detail comes from an 80-inch-square wool, velvet, and silk quilt made circa 1890. (Stella Rubin Antiques, photograph by Harriet Wise)

I've passed! I've passed! Only one more year of study, and then—no more hard work for poor old mother!" Ruth flung down her books, and threw her arms around her mother's neck. "Mr. Blake has promised me a school next year with good pay. Sit down, mother; you sha'n't do another thing to-night. I'll get tea. Here, Cricket—won't Cricket have plenty of new shoes when sister's making plenty of money?" And the lively girl lifted the little one to her shoulder, and seizing a pail, danced out to the spring, singing,

"Ride a fine horse to Banbury Cross."

She was the very picture of girlish health and happiness. Happiness in spite of her life of struggle, for those who know can tell that few things in life bring more joy than the overcoming of difficulties through the strength of the blessings of a loving heart and fresh young courage and energy, all borne up by bounding health. For years Ruth had shared as far as possible all her mother's cares, always looking forward to the time when she could bring her own earnings for the general help, little dreaming how far the every-day help given by her sunny sweetness of temper and her bright hopefulness went in lightening the load.

"I'll frow oo in," said the merry youngster, as she set him down beside the spring. "Zen oo be a bid fis." He gave her a little push, but she just then stooped to the water, and he lost his balance. With a little scream he seized her arm as she quickly turned to catch hold of him, and Ruth never could tell how it came about, but the sudden weight, coming in a manner for which she was not prepared, caused her to miss her footing. With a desperate effort she managed to swing the child back upon the grass, but in doing so she fell heavily upon the edges of the stones which bordered the spring.

"No, mother, I'm not much hurt; don't be frightened," as her mother ran out at sound of Cricket's cries. But her face was white, and she could not stand up, much less walk. She was obliged to wait until some of the nearest neighbors came and carried her in.

"I'll just lie down for an hour or two," she said, trying to laugh and to hide the pain she was suffering. But hours passed into days and days into weeks of the holidays which were to have been so full of delightful recreation and of help for mother. The doctor came and went, but never looked encouraging as she would say, "To-morrow I can sit up; yes, to-morrow I surely must be up, I have so much to do before school begins in the fall."

And then summer was almost gone, when one day she looked suddenly up into his face. "Doctor, do you know that school begins the week after next?"

"I believe it does, Ruth."

"And I'm not getting strong very fast. Vacation is almost gone. I can't help that now; but—how am I going to school if I am not stronger?"

He looked pityingly at her without any answer.

"Doctor, can't I begin school when it opens?"

"No, my dear," he said, gently.

"Then when?"

He could not bear the look of appealing misery with which she gazed in his face, as if waiting a sentence of life or death.

"Oh, some time. Soon; yes, very soon, my dear," he said, soothingly. "Be a patient, brave girl until you are well again." He went out of the room.

"Mother! mother!" she cried, in an agony of dismay, as the tender face appeared at the door. "What does he mean? When can I go to school? When can I be helping you again?"

The loving arms went around and drew her close. "Oh, my daughter! my darling! the good Lord knows when. Try to bear it for His sake and for mine."

"Mother"—her face was pressed against her shoulder—"will it be long?"

"I'm afraid so, dear." "Will it be months?" "Perhaps"

"Years?"

No answer came.

And then Ruth turned herself, body, mind, and soul, to the wall, and felt as if all the joy had gone out of the world. There was no brightness in the sunshine, no color in the flowers, and no music in the voice of the birds. Nothing was left in it but hopeless days of pain and weariness for her, and drag and drudgery for her mother.

"It would have been better for us all if I had been taken away at once," she said one day. "I used to think I could turn everything into gold for you, mother. But that was when I was well, and thought the world was full of gold," she added, bitterly.

"You keep all your gold away from me now, Ruthie," said her mother, shaking her head sorrowfully.

"I haven't any gold left, mother: I only give you more trouble, when my heart is aching to do something for you, and it cuts me like a knife to see you work so hard."

"You can do it yet, dear. I used to find half my courage in your cheery smile and your cheery ways. It's hard to lose them when I seem to need them most, daughter."

Ruth knew it, and began wondering if it would not be better to try to help in little things, now that the great things were gone beyond her reach. Mother's dear face and the affection of the little ones who came around her with soft cooings of, "Poor sister Ruthie!" were something to be thankful for yet.

"Give me the stockings to mend, mother." It tired her at first, but she found it pleasant to be busy again. She had her lounge brought into the family room, having fully made up her heroic little mind that she would smile for mother if she could never do anything else.

"I used to do a great deal of that sort of thing," her mother said, as Ruth finished her mending by working a rose-bud in satin stitch on the front of one of Cricket's stumpy little stockings.

"Let me have their best stockings, mother. I've read that it's the fashion for children to wear embroidered stockings, so ours shall be very stylish."

The soft, pretty work seemed just suited to her strength, and she amused herself by ornamenting the

"CRAZY QUILTSCAPE"
From a bird's-eye view, the patchwork fields below become a Crazy quilt of patterns and colors. Artist Rebecca Barker paints her quiltscapes in acrylic on masonite board and gets her inspiration from quilt history books and quilt shows. (Artwork © Rebecca Barker, all rights reserved, licensed by The Intermarketing Group)

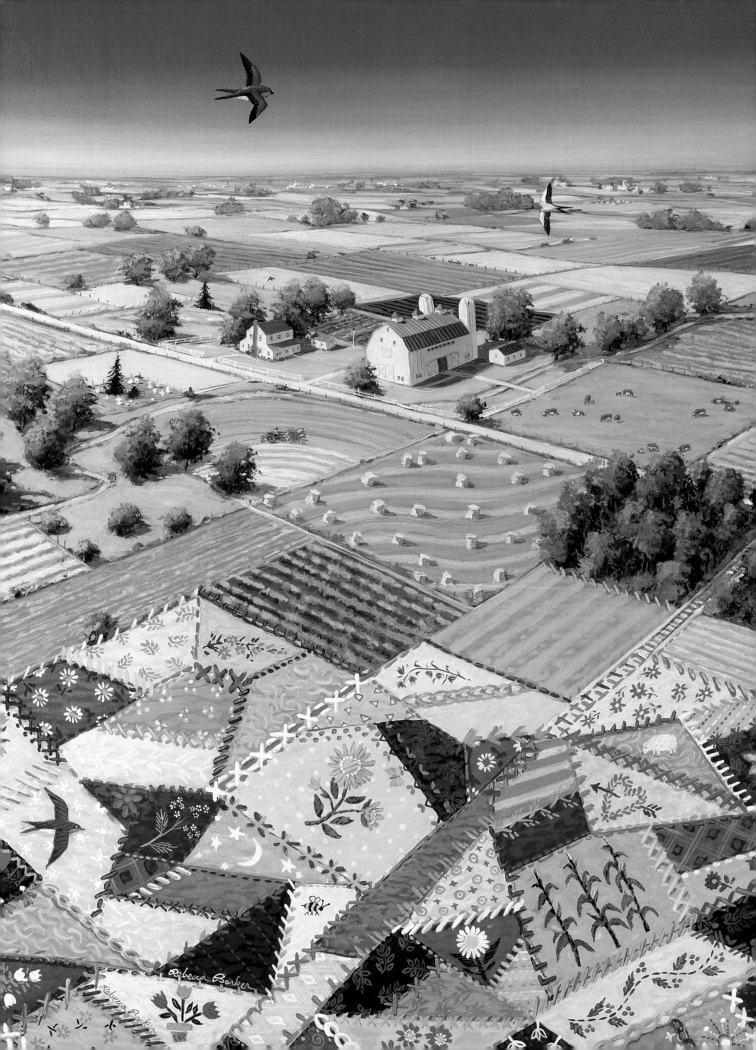

stockings with delicate flowers and traceries worthy of appearing on far finer hosiery than that of the little country children.

"Look what I have found for you!" said her mother, when these were done.

Ruth exclaimed in delight over the bundle of bright silks and velvets, and began busying herself trying how the pretty things could be wrought into things still prettier. She had seen little fancy-work, but the children brought flowers, and with patient fingers, now no longer round and firm and ruddy as formerly, but thin and delicate, she copied the daisies and pansies and lilacs until they almost seemed to stand out from the silk. With little aim but to pass away the long hours, she worked piece after piece, and her mother was fond of looking them over and declaring they were as pretty as water-color paintings, which indeed they were.

"Ess, ma'am, Oofie done 'e' posies on my tockies. S'e dess sew 'em on wiv a needle 'n' fred. I'll so oo."

Ruth from her couch could hear Cricket chatting very freely with some one at the door, and called her mother, who presently brought in a lady, followed by Cricket with one bare foot, the stocking of which he held up for inspection, in happy disregard of its streaks and stains. The visitor sat down beside Ruth, saying:

"I have been staying for a few days in the neighborhood, and I saw on Sunday some embroidered stockings on some little tots, the prettiest I have ever seen—the embroidery, I mean, and the tots too," she laughed, as Cricket still pressed his stocking upon the general attention. "And some one told me that if I came here I could see the person who worked them. You poor child, how long have you been lying here?"

The face was so bright and kind, the pressure of her hand so warm, and the voice had such a ring of earnest interest, that Ruth felt encouraged to tell all about her great trouble, and of all the trouble growing out of it, and to show her the other stockings; and she even ventured (so little did her visitor seem like a fashionable lady, or at least like Ruth's idea of a fashionable lady) to look curiously at a wonderful bag she carried.

"Crazy patchwork, you see. Did you ever make any?"

Crazy indeed it looked. Bits of silk of all colors and shades, square, round, three-cornered, oblong—every shape or no shape at all—were pieced together in a style utterly at variance with the oldfashioned ideas of careful measurement and straight seams. And from each piece a quaint bit of needle-work peeped out—a cat's head, or a squatty teapot, or a sheaf of wheat, or an autumn-tinted leaf, or what not, all joined by stitches of various patterns, on which Ruth's eyes fastened.

"No, I never saw anything so beautiful," she said.

Mrs. Hill wanted some stockings embroidered. She came again, and came often, as she grew more and more interested in the young girl, and at last, in wishing her good-by, handed her ten dollars, and told her to work her best work on the silk pieces she should send her.

She worked through the fall and winter months, finding her fingers more skillful and her fancy more fertile as she went on. She had also begun putting together her own bits of work.

"I'll make a pincushion of crazy patchwork," she said to her mother.

But it grew fast; and she next said, "It will be big enough for a bag—a good-sized bag, too!" Then, "It will make a lovely sofa-pillow."

After that she rolled and basted it up to keep it clean as she worked at intervals upon it, grafting in piece after piece, beautified by the daintiest work her hands could do.

"There's a carriage coming up the hill. Who can it be?"

Ruth looked up from the apple blossom she was shading with infinite painstaking, and stared with the others at the unusual sight.

"It's stopping here—yes. It's Mrs. Hill!" The next moment she held Ruth's hand in a firm clasp.

"Ruth, I've come to take you home with me. Will you go?"

Ruth looked in her face in blank amazement. "I! Such as I to go anywhere!" She laughed, and then cried.

"My dear child, I've got it all arranged so that you can make the journey without pain or injury. There is

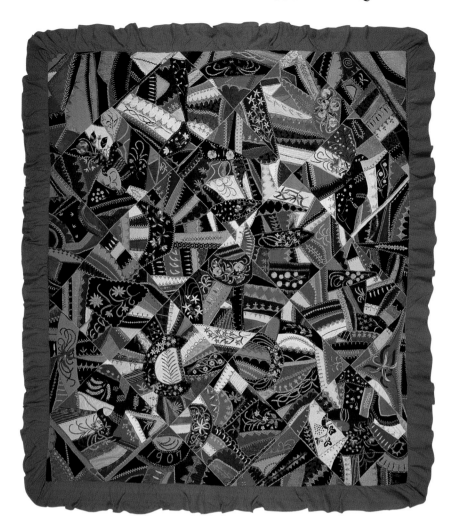

PENNSYLVANIA CRAZY QUILT
The year 1907 is stitched into this Crazy quilt, which features intricate floral embroidery and a red ruffle. It measures 54 by 84 inches. (Stella Rubin Antiques)

to be a great exhibition of art work in the city, and I want all your work to send to it; and I want you to try change of air, if your mother can spare you. I have found just what I want," said Mrs. Hill, looking over Ruth's beautiful embroidery with great satisfaction; "something different from every one else's work. I did not send you a single pattern, because I wanted you to work out your own ideas. Fairies might have done this."

Last of all Ruth unrolled her crazy patchwork—a bundle which had not been undone for months.

"Here, mother, I have made this for you."

It had grown into bedquilt size, and was heavy with its weight of exquisite needle-work. Into it she had wrought everything in the way of lovely model or original fancy which had come to her during these months of patient waiting. Upon it her mother could read a history which brought tears to her eyes; to any one else it was a study for more than one pleasant hour.

"This must go too," said Mrs. Hill, very decidedly. "I want to show it; it will make a sensation."

This is what mother found in a letter from Ruth about six weeks after she went away. A little bit of paper had fallen from it, which waited for notice until the letter was read:

"—So you see that is ninety dollars for the work Mrs. Hill sent me. And, oh! mother darling, I've sold your quilt—the quilt I have been eighteen months making for you, and which I though you'd keep all your life; but I know you'll forgive me. For that is the reason I am sending you a check for three hundred and ninety dollars, mother—yes, indeed! Three hundred dollars for a crazy quilt! Just think how much

money these city folks must have! And they all say it is not a bit too much for the work on it.

"The way it came about: Mrs. Hill sent it to the exhibition with the other things, and one day she told me that a lady had offered three hundred dollars for it. I knew you'd be thankful enough for the money, mother, but I told them about the bits of your wedding things and grandmother's dress and the scrap of father's army coat, and the lady said I could take those out. So I'm very busy just now putting other pieces in their place, and you may be very sure I'm putting my very best work upon it, when she is paying me so much money. And show it to Jack and Polly and Cricket; they'll hardly believe it, but you try to make them understand. And, oh, darling mother, I'm helping you after all!"

Polly danced about, and Jack flung his hat up to the ceiling, and Cricket rolled over on the floor, while mother wiped her eyes, and wondered if the dear daughter would not come home very soon now.

But she did not. Spring grew into summer, and Cricket, who had begun to believe that pretty things were made for the sole purpose of copying in silk embroidery, mourned over every new leaf or bud or flower which he brought in, and Ruth not there to admire and "sew it." Summer wore away, and latterly Ruth had not said one word about coming home. How long those days seemed!

"Somebody's coming! Hooyah! hooyah!" shouted Cricket one afternoon in late August. Once more a carriage was making its way up the hill.

"It's Ruth!" screamed Jack, rushing in. "I saw her face. Give me a chair to help her out." He seized one, and tore down the path, with Cricket toddling after. Mother would have followed, but sat down with trembling limbs on the door-step. Some one else was coming too—some young person, for she was running up to the house with light-stepping feet; and then mother's eyes dimmed, and her strength seemed gone, for it was Ruth's own bright face which looked lovingly into hers, and Ruth's arms which held her up.

"Oh, mother, here I am. Look at me. I'm well again, and strong, and come home to help you at last."

"All the gold has come back to me," she said on the morning when she was going again to resume the studies she loved and to carry out her old cherished plans.

"Refined gold now, dear," answered her mother, as she looked in the sweet face, and could read there much which only the two years of patient suffering could have written.

"Ah, Ruth, if you hadn't settled yourself to stocking-mending when you could do nothing else, this might never have come about."

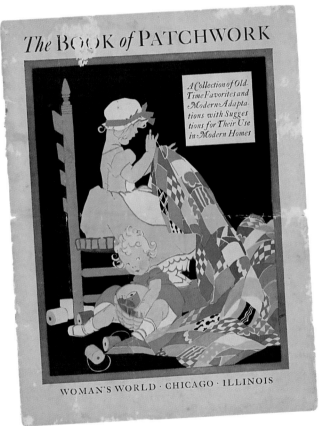

PATCHWORK RAINBOW
A colorful quilt unfolds under the hands of a skilled seamstress on the cover of The Book of Patchwork, *published by Woman's World Magazine Company in 1929.*

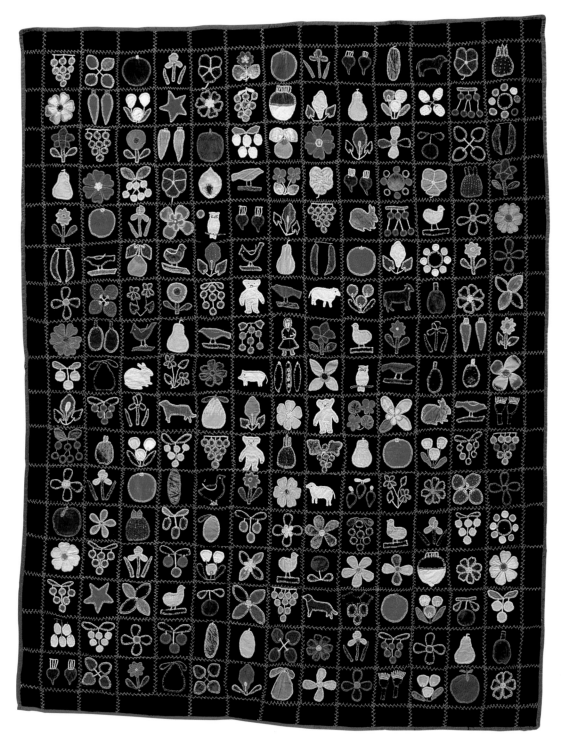

CRAZY FOR QUILTS
The Sampler quilt pictured here illustrates the influence of the Crazy quilt fad. It is appliquéd with fruits, vegetables, flowers, and animals, as well as a woman in the center of the quilt. Made circa 1890 in Maryland, it measures 80 by 70 inches. (Stella Rubin Antiques, photograph by Harriet Wise)

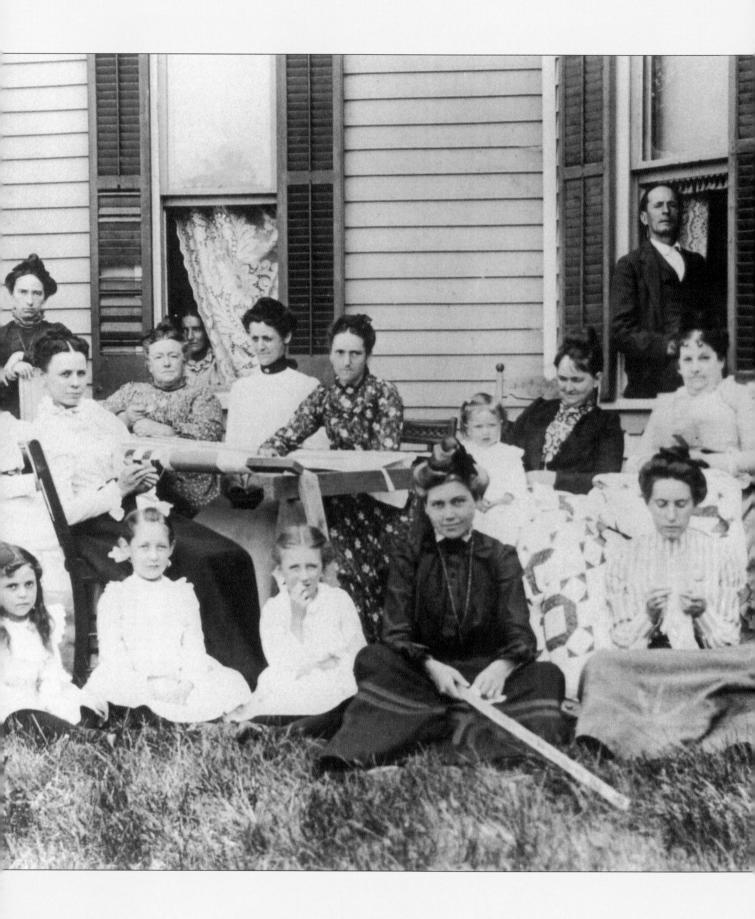

PIECES OF THE PAST

"Whether pieced, embroidered or appliquéd, quilts came to reflect the enduring spirit of women. With their profusion of colors, fabrics and detailed stitchery, quilts can be read as a kind of textile journal."
—Susan Jenkins, The American Quilt Story, 1995

As quilts and their stories are passed down to us by our mothers and grandmothers, ties to the past are fostered and strengthened. By listening to previous generations of quilters, we can learn how quilts were once made, what happened at quilting bees, and how the friendships between quilters were as warm as their quilts. And by looking closely at the scraps of fabric lovingly pieced together, threads of the quilters' lives can often be revealed.

Rememberances of quilts past are collected in this chapter, as we read of women who celebrated, socialized, and spoke through the stitches of their quilts, in both good times and bad.

QUILTING BEE
Left: *Quiltings are one of the most beloved aspects of days gone by. In this photo from 1880, women and children are gathered in the front yard to enjoy a day full of fun, hard work, and conversation—and one man sits on the window ledge to see what he can overhear. (Courtesy of Glendora Hutson)*

PRIM AND PROPER
Above: *A delicate quilter stitches a Nine Patch variation on the cover of this* Needlecraft Magazine *from September 1928.*

An Honest Soul

By Mary Eleanor Wilkins Freeman

MARY ELEANOR WILKINS Freeman was a prolific writer of the late nineteenth century, completing twenty-two volumes of short stories, fourteen novels, three plays, three books of poetry, and eight collections for children. Her realistic stories explored the subjects of women, marriage, and New England life.

This piece first appeared in *Harper's New Monthly Magazine* in 1884. It paints a portrait of Martha Patch, a poor seamstress who has been hired to make quilts from the scrapbags of two different women. In an effort to get the quilts done in a timely fashion and pieced with fabric from the correct bags, she nearly runs herself ragged.

"Thar's Mis' Bliss's pieces in the brown kaliker bag, an' that's Mis' Bennet's pieces in the bed-tickin' bag," said she, surveying complacently the two bags leaning against her kitchen-wall. "I'll get a dollar for both of them quilts, an' thar'll be two dollars. I've got a dollar an' sixty-three cents on hand now, an' thar's plenty of meal an' merlasses, an' some salt fish an' pertaters in the house. I'll get along middlin' well, I reckon. Thar ain't no call fer me to worry. I'll red up the house a leetle now, an' then I'll begin on Mis' Bliss's pieces."

The *house* was an infinitesimal affair, containing only two rooms besides the tiny lean-to which served as a wood-shed. It stood far enough back from the road for a pretentious mansion, and there was one curious feature about it—not a door nor window was there in front, only a blank, unbroken wall. Strangers passing by used to stare wonderingly at it sometimes, but it was explained easily enough. Old Simeon Patch, years ago, when the longing for a home of his own had grown strong in his heart, and he had only a few hundred dollars saved from his hard earnings to invest in one, had wisely done the best he could with what he had.

Not much remained to spend on the house after the spacious lot was paid for, so he resolved to build as much house as he could with his money, and complete it when better days should come.

This tiny edifice was in reality simply the L of a goodly two-story house which had existed only in the fond and faithful fancies of Simeon Patch and his wife. That blank front wall was designed to be joined to the projected main building; so, of course, there was no need of doors or windows. Simeon Patch came of a hard-working, honest race, whose pride it had been to keep out of debt, and he was a true child of his ancestors. Not a dollar would he spend that was not in his hand; a mortgaged house was

his horror. So he paid cash for every blade of grass on his lot of land, and every nail in his bit of a house, and settled down patiently in it until he should grub together enough more to buy a few additional boards and shingles, and pay the money down.

That time never came: he died in the course of a few years, after a lingering illness, and only had enough saved to pay his doctor's bill and funeral expenses, and leave his wife and daughter entirely without debt, in their little fragment of a house on the big, sorry lot of land.

There they had lived, mother and daughter, earning and saving in various little, petty ways, keeping their heads sturdily above water, and holding the dreaded mortgage off the house for many years. Then the mother died, and the daughter, Martha Patch, took up the little homely struggle alone. She was over seventy now—a small, slender old woman, as straight as a rail, with sharp black eyes, and a quick toss of her head when she spoke. She did odd housewifely jobs for the neighbors, wove rag-carpets, pieced bed-quilts, braided rugs, etc., and contrived to supply all her simple wants.

This evening, after she had finished putting her house to rights, she fell to investigating the contents of the bags which two of the neighbors had brought in the night before, with orders for quilts, much to her delight.

"Mis' Bliss has got proper handsome pieces," said she—"proper handsome; they'll make a good-lookin quilt. Mis' Bennet's is good too, but they ain't quite ekal to Mis' Bliss's. I reckon some of 'em's old."

She began spreading some of the largest, prettiest pieces on her white-scoured table. "Thar," said she, gazing at one admiringly, "that jest takes my eye; them leetle pink roses is pretty, an' no mistake. I reckon that's French caliker. Thar's some big pieces too. Lor', what bag did I take 'em out on! It must hev been Mis' Bliss's. I mustn't git 'em mixed."

She cut out some squares, and sat down by the window in a low wooden rocking-chair to sew. This window did not have a very pleasant outlook. The house was situated so far back from the road that it commanded only a rear view of the adjoining one. It was a great cross to Martha Patch. She was one of those women who like to see everything that is going on outside, and who often have excuse enough in the fact that so little is going on with them.

SCRAP BOOK
The Stearns & Foster Company of Cincinnati, Ohio, released this booklet of quilt blocks in 1945 to celebrate their centennial anniversary. They are best known for the production of Mountain Mist batting.

"It's a great diversion," she used to say, in her snapping way, which was more nervous than ill-natured, bobbing her head violently at the same time—"a very great diversion to see Mr. Peters's cows goin' in an' out of the barn day arter day; an' that's about all I do see—never git a sight of the folks goin' to meetin' nor nothin'."

The lack of a front window was a continual source of grief to her.

"When the minister's prayin' for the widders an' orphans he'd better make mention of one more," said she, once, "an' that's women without front winders."

She and her mother had planned to save money enough to have one some day, but they had never been able to bring it about. A window commanding a view of the street and the passers-by would have been a great source of comfort to the poor old woman, sitting and

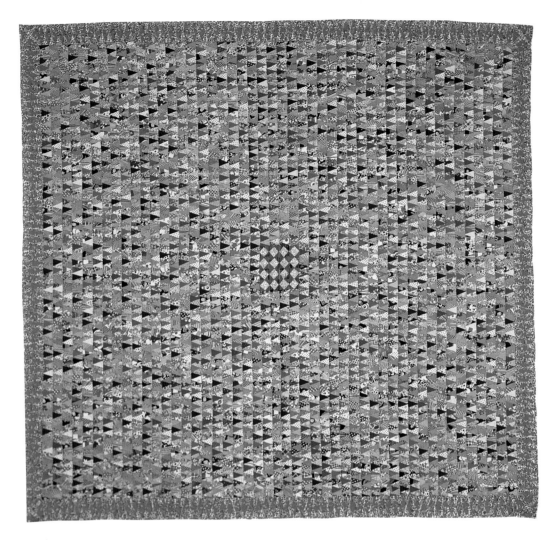

TOO MANY TRIANGLES
The 86-by-80-inch Triangle quilt pictured here was completed in Virginia circa 1930. The multitude of pieces that make up the quilt top is mind boggling. (Stella Rubin Antiques)

sewing as she did day in and day out. As it was, she seized eagerly upon the few objects of interest which did come within her vision, and made much of them. There were some children who, on their way from school, could make a short cut through her yard and reach home quicker. She watched for them every day, and if they did not appear quite as soon as usual she would grow uneasy, and eye the clock, and mutter to herself, "I wonder where them Mosely children can be?" When they came she watched their progress with sharp attention, and thought them over for an hour afterwards. Not a bird which passed her window escaped her notice. This innocent old gossip fed her mind upon their small domestic affairs in lieu of larger ones. To-day she often paused between her stitches to gaze

absorbedly at a yellow-bird vibrating nervously round the branches of a young tree opposite. It was early spring, and the branches were all of a light-green foam.

"That's the same yaller-bird I saw yesterday, I do b'lieve," said she. "I reckon he's goin' to build a nest in that ellum."

Lately she had been watching the progress of the grass gradually springing up all over the yard. One spot where it grew much greener than elsewhere her mind dwelt upon curiously.

"I can't make out," she said to a neighbor, "whether that 'ere spot is greener than the rest because the sun shines brightly thar, or because somethin's buried thar."

She toiled steadily on the patchwork quilts. At the end of a fortnight they were nearly completed. She

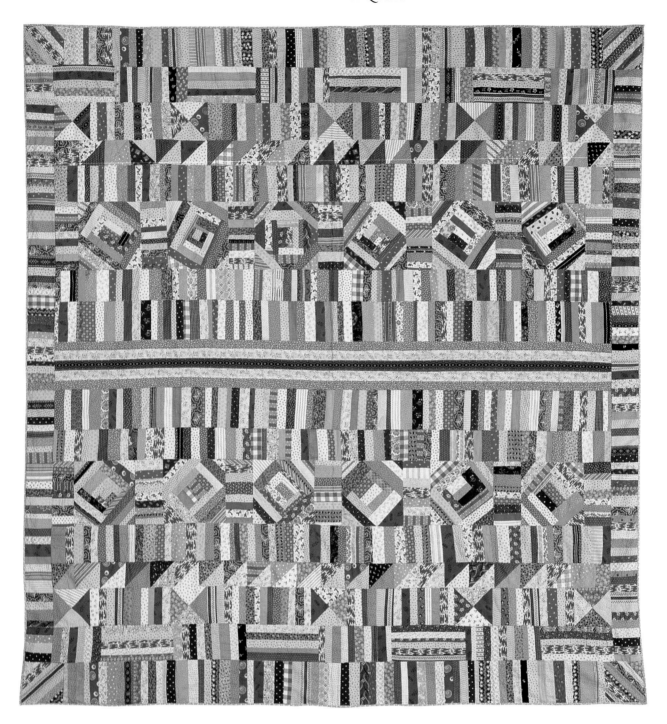

CHINESE COINS VARIATION
Quilts like these were good ways to use up smaller pieces of fabric from your scrap bag. The example pictured here was made in Pennsylvania circa 1880 from a variety of cotton scraps. (Stella Rubin Antiques)

hurried on the last one morning, thinking she would carry them both to their owners that afternoon and get her pay. She did not stop for any dinner.

Spreading them out for one last look before rolling them up in bundles, she caught her breath hastily.

"What hev I done?" said she. "Massy sakes! I hevn't gone an' put Mis' Bliss's caliker with the leetle pink roses on t in Mis' Bennet's quilt? I hev, jest as sure as preachin! What shell I do?"

The poor old soul stood staring at the quilts in pitiful dismay. "A hull fortni't's work," she muttered. "What shell I do? Them pink roses is the prettiest caliker in the hull lot. Mis' Bliss will be mad if they air in Mis' Bennet's quilt. She won't say nothin', an' she'll pay me, but she'll feel it inside, an' it won't be doin' the squar' thing by her. No; if I'm goin to airn money I'll airn it."

Martha Patch gave her head a jerk. The spirit which animated her father when he went to housekeeping in a piece of a house without any front window blazed up within her. She made herself a cup of tea, then sat deliberately down by the window to rip the quilts to pieces. It had to be done pretty thoroughly on account of her admiration for the pink calico, and the quality of it—it figured in nearly every square. "I wish I hed a front winder to set to while I'm doin' on't," said she; but she patiently plied her scissors till dusk, only stopping for a short survey of the Mosely children. After days of steady work the pieces were put together again, this time the pink-rose calico in Mrs. Bliss's quilt. Martha Patch rolled the quilts up with a sigh of relief and a sense of virtuous triumph.

"I'll sort over the pieces that's left in the bags," said she, "then I'll take 'em over an' git my pay. I'm gittin' pretty short of vittles."

She began pulling the pieces out of the bed-ticking bag, laying them on her lap and smoothing them out, preparatory to doing them up in a neat, tight roll to take home—she was very methodical about everything she did. Suddenly she turned pale, and stared wildly at a tiny scrap of calico which she had just fished out of the bag.

"Massy sakes!" she cried; "it ain't, is it?" She clutched Mrs. Bliss's quilt from the table and laid the bit of calico beside the pink-rose squares.

TEST OF TIME
This engraving, "The Patchwork Quilt," which originally appeared in the December 21, 1872, issue of Harper's Weekly shows an old soul bent over the quilting frame. The magazine claimed that quilts were a dying tradition and would soon be obsolete.

"It's jest the same thing," she groaned, "an' it came out on Mis' Bennet's bag. Dear me suz! dear me suz!"

She dropped helplessly into her chair by the window, still holding the quilt and the telltale scrap of calico, and gazed out in a bewildered sort of way. Her poor old eyes looked dim and weak with tears.

"Thar's the Mosely children comin'," she said; "happy little gals, laughin' an' hollerin, goin' home to their mother to git a good dinner. Me a-settin' here's a lesson they ain't larned in their books yit; hope to goodness they never will; hope they won't ever hev to piece quilts fur a livin', without any front winder to set to. Thar's a dandelion blown out on that green spot. Reckon thar is somethin' buried thar. Lordy massy! hev I got to rip them two quilts to pieces agin an' sew 'em over?"

Finally she resolved to carry a bit of the pink-rose calico over to Mrs. Bennet's and find out, without betraying the dilemma she was in, if it were really hers.

Her poor old knees fairly shook under her when she entered Mrs. Bennet's sitting-room.

"Why, yes, Martha, it's mine," said Mrs. Bennet, in response to her agitated question. "Hattie had a dress like it, don't you remember? There was a lot of new pieces left, and I thought they would work into a quilt nice. But, for pity's sake, Martha, what is the matter? You look just as white as a sheet. You ain't sick, are you?"

"No," said Martha, with a feeble toss of her head, to keep up the deception; "I ain't sick, only kinder all gone with the warm weather. I reckon I'll hev to fix me up some thoroughwort tea. Thoroughwort's a great strengthener."

"I would," said Mrs. Bennet, sympathizingly; "and don't you work too hard on that quilt; I ain't in a bit of a hurry for it. I sha'n't want it before next winter anyway. I only thought I'd like to have it pieced and ready."

"I reckon I can't get it done afore another fortni't," said Martha, trembling.

"I don't care if you don't get it done for the next three months. Don't go yet, Martha; you ain't rested a minute, and it's a pretty long walk. Don't you want a bit of something before you go? Have a piece of cake? You look real faint."

"No, thanky," said Martha, and departed in spite of all friendly entreaties to tarry. Mrs. Bennet watched her moving slowly down the road, still holding the little pink calico rag in her brown, withered fingers.

"Martha Patch is failing; she ain't near so straight as she was," remarked Mrs. Bennet. "She looks real bent over to-day."

The little wiry springiness was, indeed, gone from her gait as she crept slowly along the sweet country road, and there was a helpless droop in her thin, narrow shoulders. It was a beautiful spring day; the fruit-trees were all in blossom. There were more orchards than houses on the way, and more blooming trees to pass than people.

Martha looked up at the white branches as she passed under them. "I kin smell the apple-blows," said she, "but somehow the goodness is all gone out on

'em. I'd jest as soon smell cabbage. Oh, dear me suz, kin I ever do them quilts over agin?"

When she got home, however, she rallied a little. There was a nervous force about this old woman which was not easily overcome even by an accumulation of misfortunes. She might bend a good deal, but she was almost sure to spring back again. She took off her hood and shawl, and straightened herself up. "Thar's no use puttin' it off; it's got to be done. I'll hev them quilts right of it kills me!"

She tied on a purple calico apron and sat down at the window again, with a quilt and the scissors. Out came the pink roses. There she sat through the long afternoon, cutting the stitches which she had so laboriously put in—a little defiant old figure, its head, with a flat black lace cap on it, bobbing up and down in time with its hands. There were some purple bows on the cap, and they fluttered; quite a little wind blew in at the window.

The eight-day clock on the mantel ticked peacefully. It was a queer old timepiece, which had belonged to her grandmother Patch. A painting of a quaint female, with puffed hair and a bunch of roses, adorned the front of it, under the dial-plate. It was flanked on either side by tall, green vases.

There was a dull colored rag-carpet of Martha's own manufacture on the floor of the room. Some wooden chairs stood around stiffly; an old, yellow map of Massachusetts and a portrait of George Washington hung, on the walls. There was not a speck of dust anywhere, nor any disorder. Neatness was one of the comforts of Martha's life. Putting and keeping things in order was one of the interests which enlivened her dullness and made the world attractive to her.

The poor soul sat at the window, bending over the quilt, until dusk, and she sat there, bending over the quilt until dusk, many a day after.

It is a hard question to decide, whether there were any real merit in such finely strained honesty, or whether it were merely a case of morbid conscientiousness. Perhaps the old woman, inheriting very likely her father's scruples, had had them so intensified by age and childishness that they had become a little off the bias of reason.

Be that as it may, she thought it was the right

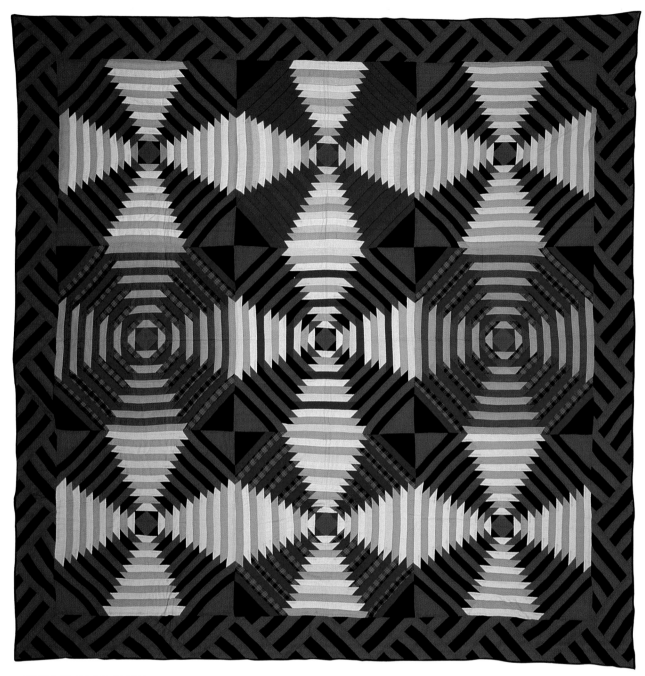

PINEAPPLE LOG CABIN
The Log Cabin quilt has many variations and has been a popular design since Civil War days. This example was made in Pennsylvania circa 1880 and measures 84 inches square. (Stella Rubin Antiques)

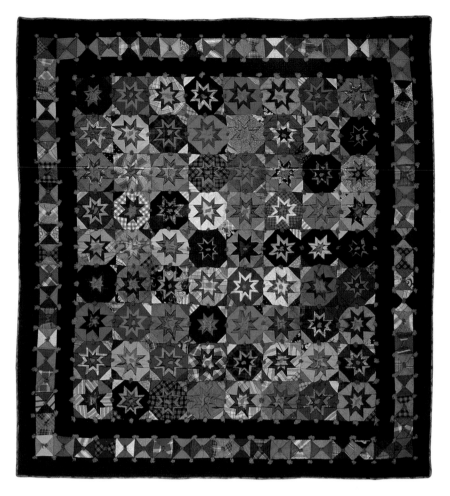

FOLDED STARS
The stars in this quilt are constructed from folded triangles, a method that resembles origami. The wool quilt was made circa 1870 in Pennsylvania. (Stella Rubin Antiques)

course for her to make the quilts over, and, thinking so, it was all that she could do. She could never have been satisfied otherwise. It took her a considerable while longer to finish the quilts again, and this time she began to suffer from other causes than mere fatigue. Her stock of provisions commenced to run low, and her money was gone. At last she had nothing but a few potatoes in the house to eat. She contrived to dig some dandelion greens once or twice; these with the potatoes were all her diet. There was really no necessity for such a state of things; she was surrounded by kindly well-to-do people, who would have gone without themselves rather than let her suffer. But she had always been very reticent about her needs, and felt great pride about accepting anything for which she did not pay.

But she struggled along until the quilts were done, and no one knew. She set the last stitch quite late one evening; then she spread the quilts out and surveyed them. "Thar they air now, all right," said she; "the pink roses is in Mis' Bennet's, an' I ain't cheated nobody out on their caliker, an' I've airned my money. I'll take 'em hum in the mornin', an' then I'll buy somethin' to eat. I begin to feel a dreadful sinkin' at my stummuck."

She locked up the house carefully—she always felt a great responsibility when she had people's work on hand—and went to bed.

Next morning she woke up so faint and dizzy that she hardly knew herself. She crawled out into the kitchen, and sank down on the floor. She could not move another step.

"Lor sakes!" she moaned, "I reckon I'm 'bout done to!"

The quilts lay near her on the table; she stared up at them with feeble complacency. "Ef I'm goin' to die, I'm glad I got them quilts done right fust. Massy, how

sinkin' I do feel! I wish I had a cup of tea."

There she lay, and the beautiful spring morning wore on. The sun shone in at the window, and moved nearer and nearer, until finally she lay in a sunbeam, a poor, shrivelled little old woman, whose resolute spirit had nearly been her death, in her scant nightgown and ruffled cap, a little shawl falling from her shoulders. She did not feel ill, only absolutely too weak and helpless to move. Her mind was just as active as ever, and her black eyes peered sharply out of her pinched face. She kept making efforts to rise, but she could not stir.

"Lor sakes!" she snapped out at length, "how long *hev* I got to lay here? I'm mad!"

She saw some dust on the black paint of a chair which stood in the sun, and she eyed that distressfully.

"Jest look at that dust on the runs of that cheer!" she muttered. "What if anybody come in! I wonder if I can't reach it!"

The chair was near her, and she managed to stretch out her limp old hand and rub the dust off the rounds. Then she let it sink down, panting.

"I wonder of I *ain't* goin' to die," she gasped. "I wonder of I'm prepared. I never took nothin' that shouldn't belong to me that I knows on. Oh, dear me suz, I wish somebody would come!"

When her strained ears did catch the sound of footsteps outside, a sudden resolve sprang up in her heart.

"I won't let on to nobody how I've made them quilts over, an' how I hevn't had enough to eat—I won't."

When the door was tried she called out feebly, "Who is thar?"

The voice of Mrs. Peters, her next-door neighbor, came back in response: "It's me. What's the matter, Marthy?"

"I'm kinder used up; don't know how you'll git in; I can't git to the door to unlock it to save my life."

"Can't I get in at the window?"

"Mebbe you kin."

Mrs. Peters was a long-limbed, spare woman, and she got in through the window with considerable ease, it being quite low from the ground.

She turned pale when she saw Martha lying on the floor. "Why, Marthy, what is the matter? How long have you been laying there?"

"Ever since I got up. I was kinder dizzy, an' hed a

dreadful sinkin' feelin'. It ain't much, I reckon. Ef I could hev a cup of tea it would set me right up. Thar's a spoonful left in the pantry. Ef you jest put a few kindlin's in the stove, Mis' Peters, an' set in the kettle an' made me a cup, I could git up, I know. I've got to go an' kerry them quilts hum to Mis' Bliss an' Mis' Bennet."

"I don't believe but what you've got all tired out over the quilts. You've been working too hard."

"No, I ain't, Mis' Peters; it's nothin' but play piecin' quilts. All I mind is not havin' a front winder to set to while I'm doin' on't."

Mrs. Peters was a quiet, sensible woman of few words; she insisted upon carrying Martha into the bedroom and putting her comfortably to bed. It was easily done; she was muscular, and the old woman a very light weight. Then she went into the pantry. She was beginning to suspect the state of affairs, and her suspicions were strengthened when she saw the bare shelves. She started the fire, put on the tea-kettle, and then slipped across the yard to her own house for further reinforcements.

Pretty soon Martha was drinking her cup of tea and eating her toast and a dropped egg. She had taken the food with some reluctance, half starved as she was. Finally she gave in—the sight of it was too much for her. "Well, I will borry it, Mis' Peters," said she; "an' I'll pay you jest as soon as I kin git up."

After she had eaten she felt stronger. Mrs. Peters had hard work to keep her quiet until afternoon; then she would get up and carry the quilts home. The two ladies were profuse in praises. Martha, proud and smiling. Mrs. Bennet noticed the pink roses at once. "How pretty that calico did work in," she remarked.

"Yes," assented Martha, between an inclination to chuckle and to cry.

"Ef I ain't thankful I did them quilts over," thought she, creeping slowly homeward, her hard-earned two dollars knotted into a corner of her handkerchief for security.

About sunset Mrs. Peters came in again. "Marthy," she said, after a while, "Sam says he's out of work just now, and he'll cut through a front window for you. He's got some old sash and glass that's been laying round in the barn ever since I can remember. It'll be a real charity for you to take it off his hands, and he'll like to do it. Sam's as uneasy as a fish out of water when he hasn't got any work."

Martha eyed her suspiciously. "Thanky; but I don't want nothin' done that I can't pay for," said she, with a stiff toss of her head.

"It would be pay enough, just letting Sam do it, Marthy; but, if you really feel set about it, I've got some sheets that need turning. You can do them some time this summer, and that will pay us for all it's worth."

The black eyes looked at her sharply. "Air you sure?"

"Yes; it's fully as much as it's worth," said Mrs. Peters. "I'm most afraid it's more. There's four sheets, and putting in a window is nothing more than putting in a patch—the old stuff ain't worth anything."

When Martha fully realized that she was going to have a front window, and that her pride might suffer it to be given to her and yet receive no insult, she was as delighted as a child.

"Lor sakes!" said she, "jest to think that I shall have a front winder to set to! I wish mother could ha' lived to see it. Mebbe you kinder wonder at it, Mis' Peters—you've allers had front winders; but you haven't any idea what a great thing it seems to me. It kinder makes me feel younger. Thar's the Mosely children; they're 'bout all I've ever seen pass *this* winder, Mis' Peters. Jest see that green spot out thar; it's been greener than the rest of the yard all the spring, an' now thar's lots of dandelions blowed out on it, an' some clover. I b'lieve the sun shines more on it, somehow. Law me, to think I'm going to hev a front winder!"

"Sarah was in this afternoon," said Mrs. Peters, further (Sarah was her married daughter), "and she says she wants some braided rugs right away. She'll send the rags over by Willie to-morrow."

"You don't say so! Well I'll be glad to do it; an' thar's one thing 'bout it, Mis' Peters—mebbe you'll think it queer for me to say so, but I'm kinder thankful it's rugs she wants. I'm kinder sick of bed-quilts somehow."

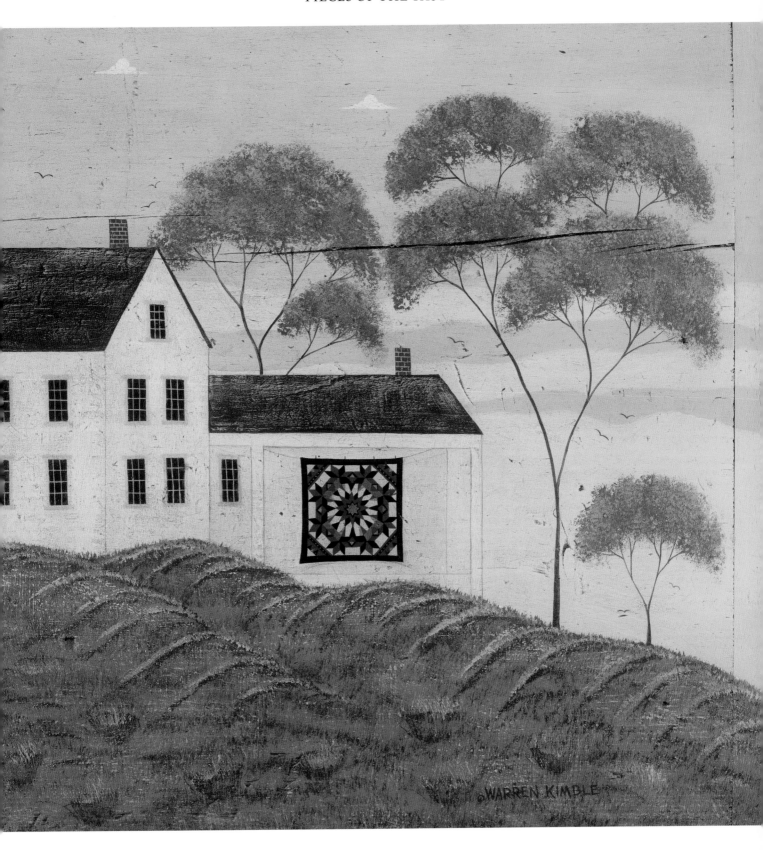

"HOUSE WITH QUILT"
Artist Warren Kimble is best known for his paintings of rural Vermont scenes and their whimsical yet sophisticated style of American folk art. His depiction of a home displaying a quintessential handcrafted quilt evokes the warmth and artistry of our ancestors. (Artwork © Warren Kimble)

Mandy's Quilting-Party

By Anonymous

QUILTINGS WERE ONCE huge social events that the entire community looked forward to with great anticipation.

In this story, first published in 1899, a young girl named Mandy is so taken with the idea of having a quilting party of her very own that she invites the whole village to one at her house—without informing her mother or other members of the family first. With no food prepared, needles gathered, or quilt top on the frame, they scramble to throw together a respectable affair. The impromptu quilting bee turns out to be one they will not soon forget.

Long ago, "so long ago 'tis like a dream," there lived somewhere away up among the green hills of Vermont a little girl whose name was Amanda Brown. She was, at the time of which I am going to tell you, about eleven years old, old enough to have considerable sense; she had that, but she had considerable mischief in her composition to counterbalance it, and was always getting herself into trouble. She was remarkably pretty, with a bright, beautiful complexion, warm, fun-loving brown eyes, and soft, close-curling hair. She had, no doubt, been told often that people thought her pretty, and like many other little girls who have been called pretty, put on airs accordingly. Little Mandy Brown was a favorite everywhere; all her little pranks and capers were overlooked or laughed at just because they were kind-hearted, sweet-tempered Mandy Brown's capers and pranks.

She had several sisters and three brothers. In those days little boys and girls often had very many brothers and sisters; quite enough to have had a nice little party all by themselves every day in the year. Little Mandy, dear demure piece of mischief, was often the occasion of much mortification of pride to the older girls, who looked upon her as very much beneath them in worldly wisdom, because of her age; and I am very sorry indeed to have to confess that sometimes our pretty, brown-eyed little Mandy was made to feel by her own sisters that she was a little girl, while they were big ones; that she was to be "kept in place," wherever that was, and not expect to keep pace with them at all. She rebelled in her own little heart tremendously at all this; nobody knew the storms of indignation that passed through her brain at being put off, nay, almost pushed

off, because she was a little girl. Nobody ever dreamed of the ambition slumbering in her soul; if they had, the knowledge might have saved them some trouble.

Her mamma alone understood her little girl's peculiarities; and although she always gave the older ones all their due advantages, she never overlooked the younger ones, nor was she ever asleep to the ambitions of Amanda. When the older ones were invited away, mamma often took Mandy with her to compensate for the coveted invitation; and upon one occasion took her to a quilting-party.

In those days, making a quilt was quite a grand affair; ladies puzzled their heads for weeks over the beautiful patterns they were to make out of thousands of little pieces of calico which they had been collecting for months; and after all the pieces were put together into one beautiful whole, then came the grand work of spreading it out, placing the cotton, and quilting it.

We have grand receptions now,—balls and parties wherein to meet our friends; just as elegant and fashionable was it then to meet one's friends at the "quilting," lend a helping hand to the pretty new quilt and assist at the social entertainment which followed.

So little Amanda went one day with her mother to a quilting-party. She listened to the gossip of the day, watched all the "lines" and "figures" drawn by the old, experienced quilters, and made up her mind, as she sat in a quiet corner by herself, about the beauties of quilting. Being always a little girl, or being always considered as such, was something she was not going to be contented with, not she! She'd let people know she was not always going to be set up in one corner of the house and talked about by the old ladies! But supper came, and supper pleases little children; it was only second in importance to the quilt; it was the "*grande finale*" to the evening's entertainment.

Amanda was very quiet on her way home; so quiet that her mother became anxious, thinking that she might not have enjoyed herself, and being rather suspicious of her quiet moods always.

Amanda vouchsafed no particular remarks about the quilting-party, except to make just one very simple remark:

"Mamma, why don't you have a quilting as well as Mrs. French? I'm sure our house is as large as hers, and we can go right about patching up pieces, and Joanna can put the cotton in."

"Well, dear, when we are all ready and the pieces sewed, we'll talk about it."

"*I* like to talk about it *now*," said our little girl; but withal she thought a great deal more than she said.

Amanda, with three sisters and one brother, went to a school which was a long way from home, quite two miles. They started in the morning, bright and early, with two baskets containing dinner. I think no pleasure of their after life could equal their enjoyment of those beautiful summer mornings. Often they overtook other scholars, on their way too, with books and dinner.

"What has got into Mandy's head lately, I wonder?" says Joanna, the oldest.

"O, some of her capers, I'll warrant," says kind-hearted Mercy.

"Better let her alone till her own time for disclosures or we may all get mixed up," says John, breaking off some huckleberry bushes for the girls. Mandy ran along eating her berries as she picked them, her bonnet hanging about her neck, her flushed face betraying her to be in a dangerously thoughtful mood.

"Mrs. Bohannon says Mandy is the prettiest child in the neighborhood, but 'so queer' she can't understand her."

"Just like Mrs. Bohannon! She can't praise any one without a 'but' or 'if' to take away all the good she pretends to say," says John, bringing up such a large bundle of berry-bushes that they all concluded to stop a few moments and pick them into their baskets to be relieved of the bushes.

John always took Mandy's part, always covered up her "scrapes" and lightened her troubles,—always her champion, and she always his favorite.

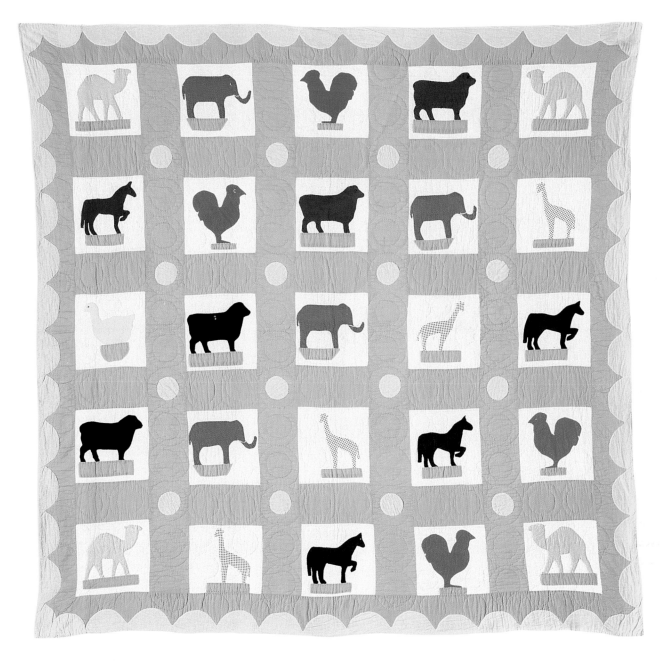

ANIMAL ALBUM
The silhouettes of animals that appear on this 1920s quilt make it perfect for a child's bed. (Stella Rubin Antiques)

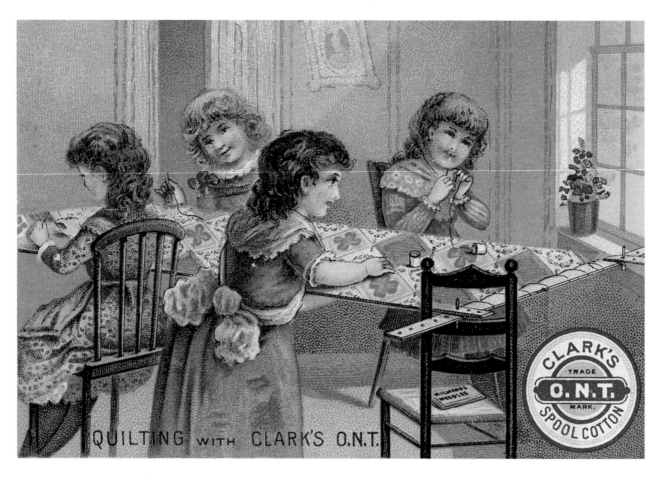

QUILTING WITH CLARK'S
Four girls enjoy their first quilting bee on this vintage trade card issued to advertise Clark's spool cotton.

"I suppose," says he earnestly, "that what she calls 'queer' is Mandy's being so much smarter than Keziah and the rest of the Bohannons."

"Yes," says Mercy, "Miss Morse says she is the smartest scholar in school."

"Well, you know," says Joanna, taking a careful look around to see that her little busy sister is not within hearing, "you know Mandy does do so many things to mortify us in company! She thinks she is as old as the rest of us and can do just what we do. Why, when George Blakely called by for me to go to singing-school the other day, I came into the parlor and there she sat with my new silk dress on, so long she couldn't take one step in it without holding it up, and fanning herself with my new goose-feather fan."

John nearly laughed all the berries off the bushes, and Mercy quite tipped over the dinner-basket.

"That isn't half so bad as she served me," says

Mercy sobering at the recollection. "She thought mother ought to have bought her the new shawl instead of me, and Sunday morning when I was getting ready for church my shawl was missing, and so was Mandy, and I went to church in my old one, with fear and trembling, because I knew she was responsible for it, and when I got there, she was sitting up as straight as a statue and as innocent, with my shawl on, and reading the hymn-book."

"What did mother do?"

"Why, nothing, of course, 'cause 'twas Mandy; if I had done it, or Mary or Martha or Abby, I guess *something* would have been done."

Mercy tried very hard to look merciful over her little sister's offences, but it is not half so easy to be merciful over our own trials as over other's.

All the berries were picked and made quite a dessert for their dinner, so they trotted on again towards

school, but sister Amanda was nowhere to be seen; she had been making good speed while the others were wasting time talking about her. When they arrived at school the scholars were all in place, in order, and the school was commencing morning prayers. Their first thought was for their little sister, but she was in her seat, rosy and innocent as usual. To-day was the last day of school for a week; Miss Ruth Morse had engaged to teach in another town, and the new teacher would not commence immediately.

John did not notice particularly, being with the boys, but the two older girls wondered during recess at the extreme friendliness of the scholars; and Mercy said, "Something must be in the wind; the girls are too good, by half, to-day." Joanna thought some of them must want their sums done for them, as she had noticed the same thing, and thought them, as Mercy expressed it, "entirely too good."

Fate—or was it their little sister?—decreed the loss of their baskets when they were ready for home. They searched long for them, but without success, till the teacher was ready to lock up and the shadows grew long behind the tall trees. As little sister never troubled her head about such things they were much surprised upon reaching home to find the missing baskets by the door-step. They had come home by themselves, all the other scholars, including Mandy, having left them to their search.

"Did you bring home the baskets, Amanda?" asked John. He always called her "Amanda" when quite serious.

"Yes," said she, trying hard to look dignified and to keep from saying more. With all her pranks, Mandy was too brave to tell a falsehood, and as little could she act one. It was afterwards supposed that she carried home the baskets purposely to delay the older sisters and John behind the others.

"Well," says Joanna rather impatiently," the next time you wish to be so obliging, just let us know beforehand. Why couldn't you have told us and saved us all that trouble? You know we always bring them ourselves; what on earth put it into your head all at once to do it?" And Joanna walked up to her as if she were going to take off her head.

"Don't be so cross, Joey, dear. I can't answer all your questions at once."

CATHEDRAL WINDOWS
Because the pieces in this quilt are outlined in black, it gives the illusion of stained glass. The cotton quilt pictured here was made circa 1920. (Stella Rubin Antiques)

"Mother, I do believe Mandy's up to some mischief. She has been in a brown study for a week." Mother took a sharp, long look at her "queer" little daughter, and then said gently, "Well, well, Joanna, do let the child alone; she'll come out all right."

"Yes, I've no doubt *she'll* come out right enough; if the rest of us do we'll be lucky—just remember what I tell you!"

"Mandy's all right if you let her alone," says her champion John. "Come Mandy and let's have a chase with old Pompey."

And away John and Mandy galloped with their old friend the house-dog.

One week from that day Joanna and John were sitting on the big, flat stone in front of the house, the morning's "chores" all done, talking over school affairs. School was to commence the next day, with the

new teacher. Joanna and Mercy were busy about some sewing, but John sat idly enough, playing with old Pompey at his feet, lazy as his master.

Presently John exclaimed, "Look, Joanna, look down the road! I do believe the whole school's turned out, and all the neighborhood! I wonder what's up now?"

But there was no time to talk; slowly along the road, some distance from the house, moved a variegated mass of humanity; neither Joanna nor John could distinguish at first who or what it was. John shaded his eyes with his hand, and Joanna dropped "needle, thread, and thimble too," and raised herself to the top step to get a better look. Presently she cried out:

"John, it *is* the whole school!"

Mercy ran to call mother who was folding away some clothes into drawers, with little "curly head" as busy as a bee helping her. John continued to gaze in utter astonishment and Joanna was dumb. Surprise parties had never been heard of then, and the country was so thinly settled that a crowd of people anywhere was surprise enough.

"Why, what under the canopy is the matter?" said mother, into whose mind flashed visions of accidents, funerals, or some other dreadful thing. "John go down to the gate and see what has happened."

But even as she spoke, a crowd of girls came up from the road to the gate, followed by nearly as many boys. John walked down to meet the foremost, and although he was too well-bred to betray his utter astonishment his good breeding did not find him any words at all to utter. Holding out his hand, he contented himself with saying, "Good morning, Betsey. Good morning, Keziah!"

"Good morning, John. Why do you keep staring at us so?"

"Well, I was a little taken aback to see you all here," stammered John, not knowing just what to say.

"Why," they said, surprised, " why, we've come to the quilting!"

"*The quilting!*" says Joanna, aghast.

"Yes," says Betsey French, their nearest neighbor. "We've come to the quilting, of course."

Fortunately, she was too much occupied with a brier which had caught on her dress to notice the consternation depicted in the faces of her entertainers, and she walked along leisurely, followed by the whole school of about sixty scholars, large and small.

The attention of the home quartette was now called in another direction. Mandy came along, smiling and radiant.

"It's *my* quilting-party, mamma," she chirruped. "I 'most forgot it. Haven't we something to quilt? Let's put in some aprons, mamma, if we haven't got anything else, and quilt *them*."

"Quilting-party! Aprons! Child, what *do* you mean? *Quilting-party!*"

Poor mamma got no further, for the same moment she took it all in at a glance, and like a dear, good mother made up her mind to meet the emergency; and, without one useless word to the author of this "scrape," she went about her preparations.

But behold the little mistress of this affair!

"Good afternoon, girls. You are all well, I hope; and ready for the quilting, I see. Keziah, how do you do? Take off your things here, if you please. Lorena, I am so glad, *glad* you have come. Let me help you with your bonnets."

Once in the big parlor, overflowing at doors and windows, great was the chatter, great was the fun among the guests, and great was the delight of at least *one* member of the family.

Away in the kitchen pantry, with closed doors, were mother, John and Joanna, putting their heads together to carry all this through.

"John, for pity's sake do go out and try to help Mandy keep their attention till mother and I think what's to be done. Do keep them entertained someway—set them all by the ears—I don't much care what."

John gone, Joanna burst into tears.

"Now, mother, I believe that girl will kill me! We shall never hear the last of this to our dying day." For Joanna's and Mercy's mates had been scrupulously invited by little Mandy.

"Well, well, we'll do something, only we can't

IN REMEMBRANCE OF NANNY
Nancy Rink, of Bakersfield, California, made this quilt as a tribute to her great-grandmother, who inspired her to become a quiltmaker. Rink entered her hand-appliquéd quilt in the 2002 contest "Quilts: Reflections of Heritage," sponsored by Quilter's Newsletter Magazine. *The quilt measures 71 by 76 inches. (Photo by Melissa Karlin Mahoney, courtesy of* Quilter's Newsletter Magazine*)*

stand here and cry about it. Call Mercy, and we'll have a quilting yet."

"But, mother! oh, dear! what *shall* we do? Where are needles and thread for forty girls, even if we find something to quilt ? I'll never, *never* forgive this caper of hers!"

In about an hour, when the busy company was beginning to wonder where the quilt was, mother, with pleasant face, somewhat flushed, came in and smilingly invited the older girls "to the quilt" in the spare room up-stairs.

"My dears, we want you little ones to go out and enjoy yourselves in play while we 'old folks' go to work," she added.

A quilting indeed, but without the pretty patchwork, had been improvised by putting together two sheets; their stock of raw cotton had been exhausted long ago, but mother was still equal to the situation. They had nice white wool ready for the winter's spinning packed away in barrels. They had spread this as well as time and wool would permit, and with John's help the sheets had been tacked to the quilting-frames—always kept by housekeepers—and here was the result—a pure white quilt for little Mandy's own bed. Thread, coarse, fine, middle-sized, and all sizes, was wound off into little balls and given round to the zealous young quilters; and needles, coarse, fine, middle-sized, and all sizes, were also given round.

They were not so fortunate with the thimbles; but the merry little quilters wound papers or "rags" round the merry little fingers, and all went gaily as "the marriage bell."

And so the quilting commenced! No one worked so industriously as Amanda. How her needle flew! It was only equaled by her tongue. Not one whit did she falter in her duty. She regarded the family flutter outside as if it in no way concerned her.

Dear, loving mother! How she "put her hand to the plough!" A basket of big red apples pacified the younger ones for a commencement of the afternoon's fun. A neighbor had been sent for, and between them

how the doughnuts multiplied! how the pies covered the tables! and how the cookies and dumplings and little round white biscuits popped into view every few minutes!

At six the quilt was done; and a warm, soft beauty it was. They had it bound with strips of red flannel for want of a better binding; but they all declared it set off the white beautifully, and all were delighted, even Joanna. They had quilted it in roses, diamonds, leaves, and all the other fantastic shapes considered necessary for fashionable quilting in those days.

Mandy had not once been down-stairs to inquire about "refreshments," but, calm as ever, she led the way when mother asked them all down into the big, hospitable-looking kitchen, which was nice and clean enough for anybody's sitting-room, where was spread a most bountiful repast.

The sun was setting in fair rosy clouds when the quilters bade Mandy and her sisters good evening and started for home. John had taken good care of the boys among the nests, squirrel houses, brooks, hiding-places about the barn, and all over the farm, and they all set off in great glee. Amanda, to be sure, felt a little disappointed that mother did not allow them to stay later in the evening as they did at the older "quilting bees"; but, this being the only drawback, on the whole she congratulated herself on the success of her party. Indeed, none of the guests knew for a long time that the party had been an impromptu affair.

When mother and John and Joanna settled themselves with tired fingers, hands and backs, to talk over the affair after the others were in bed, in spite of all the worry and vexation, they agreed that it had been a happy afternoon for all, and they were delighted with their unexpected quilt, which they decided should not be used but kept for Mandy when she should be a grown woman.

And so it was; and to this day three old ladies get together sometimes, and, talking over old times, grow young again over little "Mandy's quilting-party."

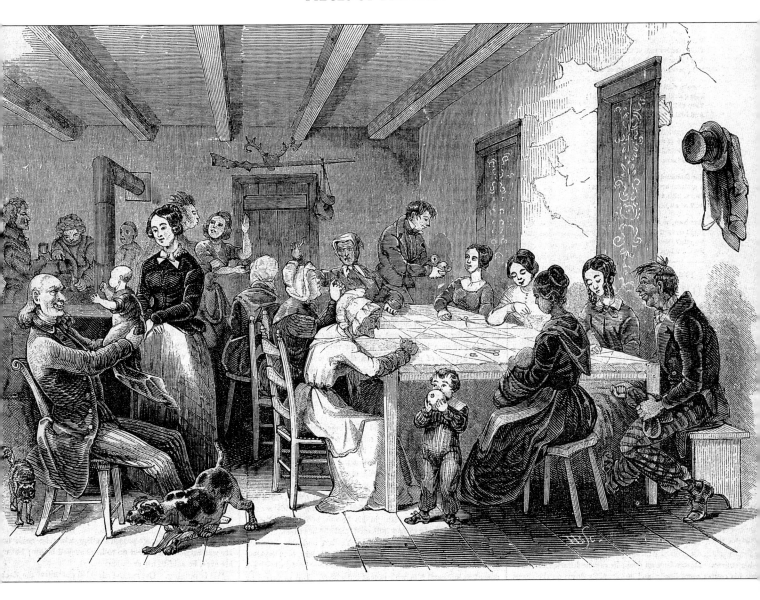

IN THE COMPANY OF QUILTERS
*This engraving, titled "A Quilting Party in Western Virginia," first appeared in Gleason's Pictorial Drawing-Room Companion.
Its description says, "The expressive countenances of the group are full of meaning, and the various relationships each sustains to the
others will readily suggest themselves to the observer."*

Fannie and the Busy Bees

By Carolyn O'Bagy Davis

PART OF THE fun of being a quilter in the early twentieth century was belonging to a club with other women of the community. This essay unveils the inner workings of the Busy Bee Club, a Midwestern group that quilted together for almost seventy years. The women saw numerous changes occur over the decades and helped each other through many hard times, including the Great Depression and World War II.

Carolyn O'Bagy Davis is a quilt historian and author who lives in Tucson, Arizona. Her complete research on the Busy Bees was first published in the American Quilt Study Group's *Uncoverings*.

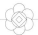

The Busy Bee Club, formed in Mitchell, Nebraska, in 1920, met twice a month for nearly seventy years. Sharing information, friendship, and moral improvement were the goals of the members, but quilting was their primary social and charitable pastime, as it was for hundreds of similar rural women's clubs that sprang up in the early twentieth century. Even their name was not unique; "busy bee" clubs likely existed in every state in the country. However, such a complete record of a club's history, seven decades' worth, is rare.

The journals stated the business of the club: quilts stitched, illnesses of members, marriages, births of their babies, deaths, local events such as devastating prairie and home fires, and national affairs, especially World War II and the Depression. They also reveal endearing humor, universal jealousies (there was great competition with neighboring clubs), charity efforts, and deep affection among the club members that extended through three generations.

Fannie Mae Leonard Springer Schumacher, a lifelong quilter, was instrumental in organizing the club. Born in 1877, she was typical of the homesteading families of the prairies, arriving in Nebraska via covered wagon as a child and living in a dugout. She married William Springer in 1895, and their only child, Retta, was born in 1896. After living in a sod house on their farm for nine years, William built a lovely two-story farmhouse for his family. Like many early farmhouses, the upstairs bedrooms had no heat, and many quilts were required to keep out the piercing Nebraska winds. With the expanded quarters, Fannie finally had room for quilting. During the long, cold winters, when less out-of-doors work had to be done, she always had a quilt on the frame.

Fannie did fine hand piecing and quilting, but for heavy use in a wagon or bedroll, she pieced and tied crazy quilts of denim and heavy woolens cut from worn clothing. Sheep were raised on the Springer farm,

so Fannie used wool as batting in heavy-duty quilts. Since wool quilts would shrink when wet, they had to be taken apart, the wool batting removed, and the top and bottom gently washed. The lining was then restretched on the quilting frame, the wool batting was retarded and laid down, the top added, and the whole quilt was retied and rebound. The process involved tedious work, but fabric and quilts were in such limited supply that nothing could be wasted.

William's business success and philanthropy, and Fannie's service as midwife for family and neighbors, made their home a center for the community. In summertime, the quilting frames were moved to the big front porch where quiltings became occasions to gather and pass a few hours visiting and stitching.

William died in 1917 and two years later, Fannie married William Schumacher, a widowed neighbor and friend. She had more time for quilting, and produced a great number of them. Some still survive, but many more were worn out through the years.

In 1920, as an outgrowth of her wide circle of friends, Fannie gathered the women in her parlor, and held the first meeting of the Busy Bee Club. At that time, rural women's days were filled with long hours of work, caring for large families, and doing heavy housework and farming chores. Church on Sundays and an occasional trip to town for supplies and groceries were the extent of their social life. A chance to gather once or twice a month to visit provided a much-needed social outlet.

Women's clubs were extremely popular in that area; at one time there were thirty-nine women's clubs in Scottsbluff County. The Busy Bees often invited members of the nearby Sunflowers or the Sunshine Club to attend meetings, just to be friendly. Women named their clubs for their mission, the region where they lived, or purely by whimsy. In the Midwest, Sunflower was a popular designation. In Beatrice, Nebraska, HMS stood for "Help My Sister," and SOS, a group from the Scottsbluff Methodist Church, was an acronym for "Sisters of the Skillet." The members of the TOB Club would never tell what their club initials represented. When asked, they would only reply, "That's our business!"

State quilt documentation projects have records of quilting groups that spanned decades and genera-

tions. The Ring Quilters of Oakland, Nebraska, have been in existence for more than fifty years. One club, the Wea Willing Workers, of Wea, Indiana, may hold the record for longevity. Formed in 1887, the club used to transport quilting frames to meetings in a horse and buggy. Some current members are granddaughters of the original founders.

The women who met that day at Fannie's house decided that they would be the Busy Bees and meet on the first and third Wednesdays of the month at a different member's house each time. The hostess was required to serve a lunch of at least "two eats, drink and pickles." Dues were one dollar a year. Club colors were green and gold, and the official flower was the goldenrod. To maintain the friendly rural atmosphere, a club bylaw stated that "Any member who comes dressed in anything but their house dress will be fined." If a member violated a bylaw or failed to answer roll call, a fine was collected and the money stored in a Calumet Baking Powder tin.

Roll calls were an important, creative aspect of the gatherings. Each meeting had a theme for roll call, such as My Favorite Book, My Most Embarrassing Moment, or The Where and Why in Kitchen Arrangement. In March, the request might be to tell an Irish joke, and in July, members could respond with a patriotic quotation. In August 1928, a recipe was to be shared at roll call, but club secretary Irene Lewis noted wryly in the minutes, "as no one cooks in this club we got only two responses, other than present." In November 1928, the topic was What We Were Thankful For, and in March 1929, it was Hints for Spring Housecleaning. Mrs. Lewis recorded, "Nearly everyone responded with helpful hints. One or two don't clean house." An April 1929 topic was Garden Making Hints, but Mrs. Lewis wrote in jest that "very few responded. Perhaps as this is a farm women's club they don't make gardens." More likely, they all had gardens and assumed no one needed hints.

The members decided that they would "work for some member each club day," meaning that they would piece or quilt for the hostess, designated individuals of the club, or the community. Because of the formal rules for club proceedings, motions were recorded in the minutes specifying those quilt recipients, such as Lucille Spear, who had been "burned out" in 1927.

COMBINATION QUILT
This pieced quilt combines the patterns Tumbling Blocks and Grandmother's Flower Garden to produce a fascinating design. It was made circa 1930 and measures 100 by 80 inches. (Stella Rubin Antiques, photograph by Harriet Wise)

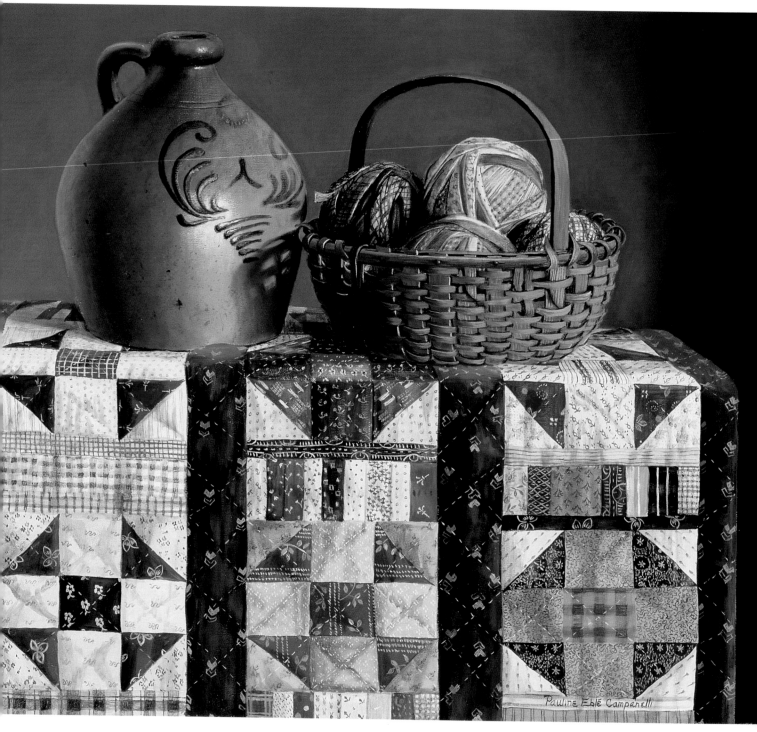

"SHOO FLY"
A jug and basket of rag balls rest on a Shoo Fly quilt in this oil painting by Pauline Eblé Campanelli. The humble collection of objects is a study in the simple life. (Artwork © Pauline Eblé Campanelli, published by New York Graphic Society)

Numerous meeting minutes reflect that an "all day meeting was had. And was spent in quilting," or as Hazel Casson wrote in 1930, "a fine lot of quilting was did." Because quilting was a given, most of the events recorded in the minutes related to other activities: officer nominations, subjects of roll calls and demonstrations, and work for special events such as the summer picnics or the annual banquet for the husbands.

For Fannie, the club was a family affair. Lucy and Dora Springer, her former sisters-in-law, and Fannie's daughter Retta were Busy Bees. Retta's four daughters even entertained the group: Eleanor dressed as Sunbonnet Sue and Arlene dressed as Overall Jim. They sang and danced to the popular quilting song "Sunbonnet Sue and Overall Jim." A decade later the two younger sisters, Clela and Donna, were recruited to repeat the performance for the club.

Membership varied between twenty and forty women. In winter, fewer members attended because the rural dirt roads became snowy or muddy and travel impossible. Many times the work of harvesting, putting up food, and caring for a large family prohibited a wife's absence for a whole day, a luxury that could not be squeezed into the work schedule.

Attendance was most often between ten and twenty women, but children often outnumbered adults. These were the days of large families and no day care, so mothers brought youngsters with them. Attendance could be ten members and twenty children or fourteen members and nineteen children. Indeed, one wonders how much visiting and how much quilting could have been done with so many children about! The meetings must have been loud and bustling.

The tent-like area under the quilting frame was a favorite spot for children. One or two older children were recruited to babysit. Babies were tucked away in cardboard boxes or empty drawers to nap. If the weather was fair, they would all be sent outside to play. Club day must have been a treat for them as well as their mothers.

Friendship quilts, then as always, were a popular and visible reminder of the bonds of community, as the Busy Bee Club documented in the simple quilts they stitched for each other. Fannie's friendship quilt contained thirty-five solid peach blocks and thirty-five blocks embroidered with images of butterflies, flowers, and baskets. Names or initials of the Busy Bee quilters are in twenty-three of the blocks, and a center block features the year 1929. The other Busy Bee friendship quilts had similar designs, but with background colors of blue or pink, according to the preference of the recipient. At least one friendship quilt was given to a nonmember. Mary Mae Holmes, the county agent for the Mitchell area, often gave formal lessons at club meetings, and was popular with the Busy Bee ladies. In November 1932, Fannie proposed that each club member piece a block and contribute thirty-five cents to make a quilt for Miss Holmes, which the Busy Bees presented to her at the March 1 meeting.

The record books offer a delightful glimpse at the humor and strength the ladies mustered to greet each day. When the Depression was upon the country, the club had a Hard Times Party. Members then had the entire year to pay their dues. Bylaws stated that when a member's dues became delinquent for one year, "she shall be dropped." There is, however, no record in the minutes of a member ever being ousted for nonpayment of dues.

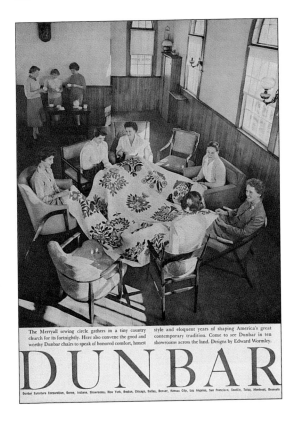

CIRCLE OF FRIENDS
The Dunbar Furniture Corporation emphasizes that quality chairs are the most important part of a quilting group in this 1959 ad. The ladies working on the Album quilt might disagree.

TEAMWORK
Friends gather around the quilting frame on a warm afternoon to help complete a new quilt, in this 1940 photo taken in Utah. Quilting was often more pleasant when accompanied by a cool breeze. (Library of Congress)

The club tried to give five dollars to charity every December, but in 1936, they did not have even that modest amount in their bank. With tough times continuing, the dues were dropped to fifty cents a year in 1938.

As with many clubs, filling officers' positions sometimes became a problem. On one occasion, members resorted to somewhat underhanded methods to fill their officers' slate. When Mrs. Williams resigned as secretary in 1931, "Mrs. Scott, Mrs. Judd, Mrs. Hill and Mrs. Pickerel, all were nominated for sec. & all declined. As Mrs. Hattie Scott was absent we proceeded to elect her as sec."

Through the '30s, the club grew in size. The Busy Bees had to purchase folding chairs to take to meetings at members' homes. In 1936, the club voted to join the Federated Women's Clubs. As a result, their meetings became more formal, with planned lessons and more programs but less quilting. As the decade

drew to a close, omens of war appeared in the news. The roll call topic at one Busy Bee meeting was What I Can Do to Prevent War.

Minutes of the meetings in the '40s display a change in tone because of the emotional and financial stresses of wartime. The club quilted less to focus on sewing for the Red Cross to aid the war effort. Members learned to cook without meat or sugar because those items were rationed. However, they did register the club for the sugar allowance: five pounds per month to be used for food for club dinners and gatherings.

Fannie developed heart problems late in life, but neighbors dropped in to pass the time quilting with her until the end. She died in the fall of 1946. The following year, the Busy Bee Club purchased the book Best Loved Poems of the American People and donated it to the Mitchell Public Library, where it was dedicated to the memory of Fannie Schumacher.

As the original members grew older and passed

SUNBONNET SUE
This Walk-Around variation of the famous Sunbonnet Sue pattern was made in California in the 1930s. Sunbonnet Sue first appeared as an appliqué pattern in 1910. (Stella Rubin Antiques)

away, their daughters and other young women came into the organization. But changing times and different demands on women snipped away at the core of the club. As more young women went to work, membership in the Busy Bee Club fell. Sadly bowing to the inevitable, the club formally disbanded at their gathering held on October 10, 1988, at the West Nebraska Nursing Home in Mitchell. Ten members, ages seventy to ninety-one years, attended.

The club records provide a rare view of these prairie quilters, their yearning for education and personal growth, caring for their neighbors and community, and the weekly business of their club. They reveal the response of humble, ordinary people to national events, and the heroic efforts and patriotism of everyday

Americans in rural communities across the land.

In 1968, Busy Bee Ida Casson summed up the ladies' feelings for their club and for the dear friends they gathered with for seven decades:

The winters are cold
The summers real hot
But to club we go
Our troubles forgot
Our friends are true as you can see
I'm so thankful
I am a Busy Bee.

"EVENING GLOW"
Although quilts and quilters may change over the years, the warmth they provide to hearts and homes doesn't. This painting, from Iowa-born artist Doug Knutson, beautifully illustrates that fact. (Artwork © Doug Knutson/Apple Creek Publishing)

PATCHWORK HOPES

"When this you see, remember me."
—*Traditional verse*

Quilts once played a special role in the world of romance and courtship. Quilting parties provided ample opportunity for young women to meet and mingle with the young men from their communities. Patchwork creations were presented to loved ones as a sign of affection or as a good-bye gift that would be sure to remind the recipient of his sweetheart. They were also often pieced and quilted to prepare for a coming wedding. After the honeymoon was over, however, the spouse of a quilter often wondered if he came in second fiddle to his beloved's scrap bag.

Many relationships sealed with a quilt remain as strong as the stitches that bind it together.

"SPRING"
Left: *The tulips and daffodils are blooming, the robins are singing, and the season seems full of promise in this painting. It is the first in a series of four limited edition prints called "Seasons of the Quilter's Garden" by artist Dennis McGregor of Sisters, Oregon. (Artwork © Dennis McGregor)*

MORNING GLORY
Above: *A new world of quilt patterns await the reader of this booklet produced by the Taylor Bedding Manufacturing Company of Taylor, Texas.*

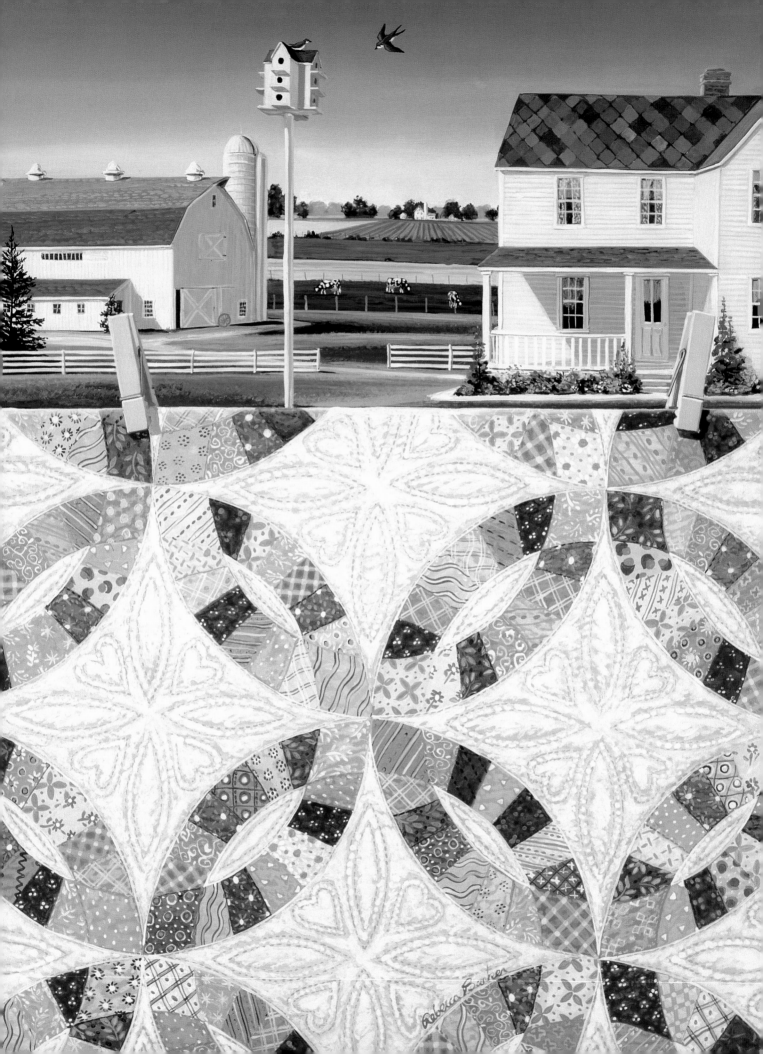

Hannah's Quilting

By Anonymous

THE QUILTING PARTY was often the place where young love would blossom, so who was invited to the event was of utmost importance. The smart hostess was sure to request the presence of the sister or mother of the young man she was smitten with, in the hopes that he would appear for the evening's festivities.

This piece, which first appeared in *Harper's Bazaar* magazine in 1870, tells the story of what can happen if a hand-written invitation is left undelivered. The resultant misunderstandings can add a new twist to the quilting bee and a new obstacle for budding romance.

Hannah thought she knew the state of Aleck Freeman's heart. She had trifled with him a little, and her own mind was not quite made up.

She was sitting now in her chamber, sweet and clean with whitewash and new buff paper, and bowery with green light which fell from the pear-tree boughs through freshly-starched muslin curtains. Hannah was a nice-looking blonde maiden, dressed in a tidy chocolate print, with a blue bow nestling in her thick, wavy hair. She had been writing a note by the stand, and was sealing it with one of the motto seals then in fashion. This one said, "Come;" and it was easy to see that it indorsed a note of invitation.

She ran down stairs into the fresh morning air, where her father, Deacon Ashley, was just ready to head old Charley toward the village. Her mother, a buxom matron, was standing bareheaded beside the democrat wagon, handing up the molasses jug, and charging the Deacon not to forget that pound of Castile soap and the lamp-wicks. Hannah tucked up her trim skirts, and ran out through the dewy grass.

"See here, father," she called, in her pleasant voice, "you must stop at the school-house and give this note to Andy Freeman. It's for Jane, you know, asking her and Miss Lang to come to the quilting."

"Ain't there one for Aleck, too?" inquired the good-natured old Deacon, with a wink.

"I told Jane he could come in the evening, if he chose," returned Hannah, with slightly heightened color. "Doctor Bingham will be here," she added, "and some other young men."

"Aleck Freeman is worth the whole kit," responded the Deacon; "and that young pill-box, according to my way of thinking, runs too much to hair-ile and watch-chains; but Aleck has got good hard sense and first-rate learning. He can appear with any of 'em. If you don't look out, Han, he'll be shining round that pretty girl from Hillsdale."

"It makes no difference to me, who he shines round," returned Hannah, with a slight shade of offense; but, nevertheless, there was a little pang at her heart as she turned back toward the house. Hannah's mind was not quite easy about Jane Freeman's visitor, the pretty girl from Hillsdale, but she thought if she could see Aleck and Mary Lang together, she would know in just what quarter the wind was setting.

The Deacon tucked the note into his breast-pocket, took the molasses jug between his feet, and gave old Charley a cut with the lines preparatory to making him begin to move, an operation of some length, as Charley believed the Deacon to be under his orders. At last, however, the two were trotting and rattling past the goose-pond, and the big barns, and the tall elms that cast some very cool shadows across the brown dust of the road, until with a kind of mutual understanding and sympathy they came out against a stretch of post and rider fence, inclosing a field of the biggest kind of clover. It looked like good farming to the Deacon's eyes. He could calculate pretty closely the number of tons of sweet, juicy feed there would be to the acre; and yet this morning the fragrance and the rosy bloom and the hum of insects among the thick heads brought him a different kind of pleasure.

With the long sight of age he could see the cows grazing in the back pasture, and he thought of the "cattle on a thousand hills," and whose they are. His gaze wandered back lovingly even to the old stone-walls with mulleins growing beside them, and the shadows of birds flitting over them, and everything seemed good, even the Mayweed and daisies and Canada thistles that farmers hate by instinct. He felt a gush of childlike thankfulness, because "the earth is the Lord's, and the fullness thereof."

Presently the Deacon and Charley came across a group of schoolchildren—brown, freckle-faced little urchins, in calico shirts, tow trowsers, and shilling hats much the worse for wear. Then there was a tall red-headed girl who had outgrown all the tucks in her dress, and had torn her apron in following the boys over the wall after a chipmunk, and one or two little tots, with very flappy sun-bonnets, whose short legs would not allow them to keep up. They all carried dinner-pails and dog's-eared spelling-books, and at the very end of the string there was a low-spirited yellow dog.

DOUBLE HEARTS
The quality of this quilt would set any collector's heart aflutter. It was made circa 1850, features a scalloped edge, and measures 80 by 96 inches. (Collection of Toby and Oscar Fitzgerald, Stella Rubin Antiques, photograph by Harriet Wise)

"Whoa!" cried the Deacon, setting his two boot-soles, which resembled weather-beaten scows, against the dash-board, and pulling in hard—an operation Charley did not at all relish, although he at last yielded, with a shake of his homely head, which intimated it was done by special favor, and could not be repeated.

"Jump in, children!" cried the good-natured old man; "I'll give ye a lift as far as the schoolhouse. Beats all how much little shavers think of ketchin' a ride. There, don't crowd, boys. Let the girls in first, and mind your manners;" and he lifted in a little roly-poly maid, with pincushion hands and a very suggestive stain of wild cherries around her dimpled mouth, and seated her on the buffalo beside him. The others all tumbled in in a trice.

"'Pears to me I wouldn't eat them puckery things," said the Deacon, in his grandfatherly fashion, pointing to some suggestive smears on the little maid's high gingham apron. "They'll give you the colic."

JAPANESE LANTERNS
Twenty-five quilt blocks alight this square, cotton quilt, made in Pennsylvania circa 1920. (Stella Rubin Antiques)

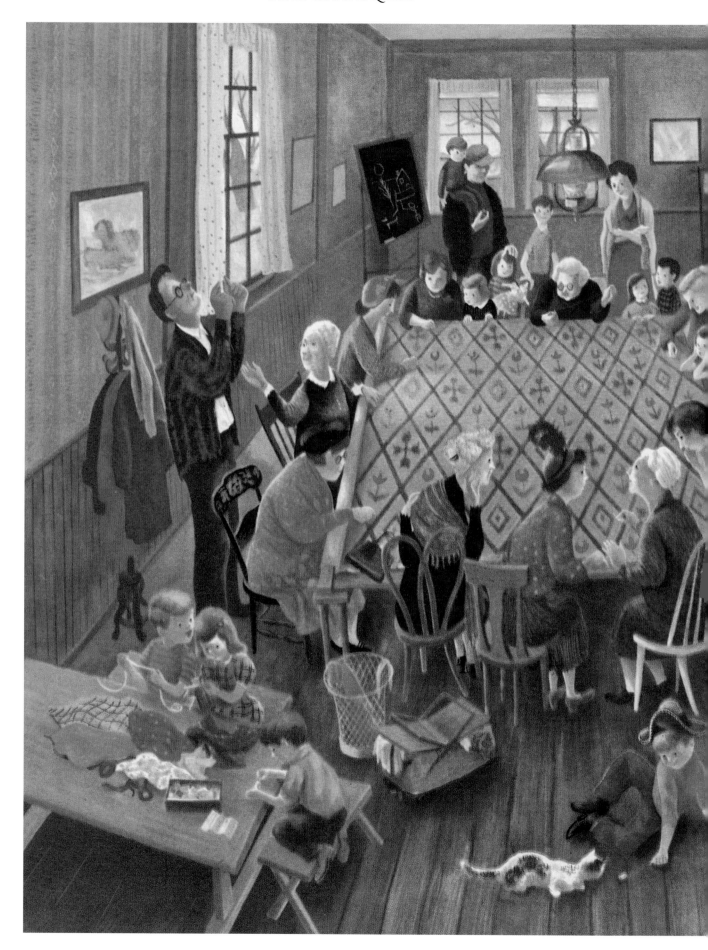

"QUILTING PARTY"
Everyone could partake in the fun of a quilting, as can be seen in this 1940s print by Pauline Jackson. Kids, grown-ups, family, and friends all had a place at the celebration.

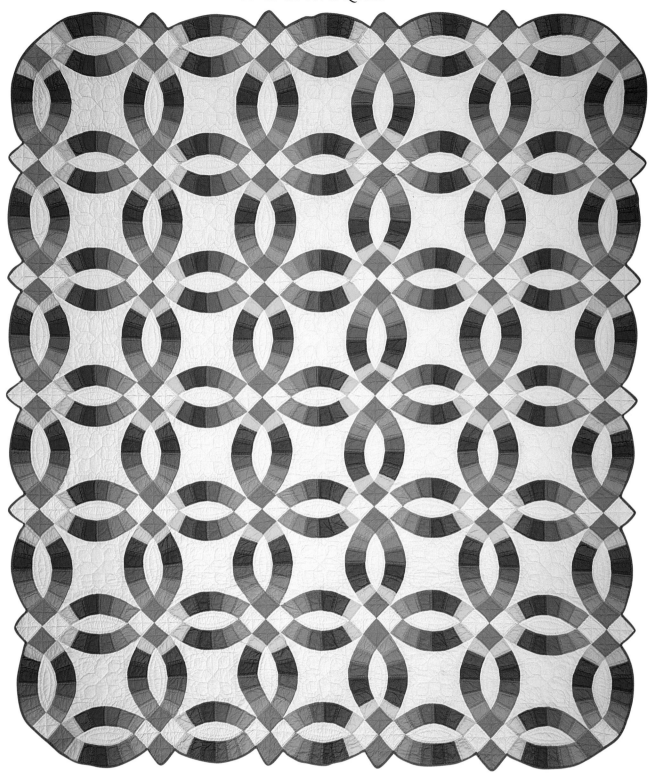

RAINBOW RINGS
In bygone days, every young lady was to have a hope chest full of quilts ready in time for her wedding day. This colorful Double Wedding Ring quilt was stitched circa 1920 in California and measures 84 by 72 inches. (Collection of Deborah C. Hull, Stella Rubin Antiques)

"Yes, Sir," replied the child, folding her funny little hands contentedly in her lap. "Sissy had the measles and I didn't, and my mother said I might have the colic if I wanted to."

The Deacon leaned back and laughed, and Charley shook his ears and turned up at him an eye of mild reproach.

"What a little goose you are!" said a bright-faced boy, who had been very much squeezed in the legs, and had just administered several sharp punches in the side of the squeezer, as he leaned over the back of the seat to pinch the little girl's ear.

"Bless me! there's Andy Freeman, and I had like to have forgot the what-d'ye-call-it—billy-do—my Hannah sent to the girls up at your house."

The Deacon veered half round, and checked Charley, who by this time began to consider the whole thing disgusting, especially as the low-spirited dog had mixed himself up with his feet.

"This must be it," he went on, fumbling in his pocket. "You see I've left my best eyes at home; the old pair I carry in my head don't amount to much."

Andy took the folded paper, and promised to be careful of it; and by that time Charley and his load had arrived at the stone schoolhouse, which looked very much like a juvenile penitentiary. The school mistress was standing in the door ringing the bell; and the children scrambled down the side of the wagon, and scampered off, to save their marks for punctuality.

Jane Freeman had been busy all day with her friend Mary Lang, the pretty girl from Hillsdale. There is nothing, at first, so engrossing to the mind of a country girl as the stylish clothes of her city visitor. Mary had a number of fashionably-made dresses, and, as old Mrs. Freeman remarked, she had got the "very latest quirk" in her pretty hair. She was a good-natured girl, and had let Jane cut the pattern of her visite and her tabbed muslin cape, and had shown her just how to do the captivating twist. Now the two girls were bending out of the sitting-room window, which looked upon the orchard, with its gnarled boughs, and cool green lights, and white clover-heads dropped upon the grass like unstrung pearls. Aleck had come up from the garden, and was leaning on his hoe-handle, talking to them. He was a muscular, well-made young fellow; and the fact that he had once passed three years in a city, and had rubbed off his rustic bashfulness, told upon

him well. Now there was a half-quizzical, half-pleased look peeping out from under his dropped eyelids; and old Mrs. Freeman, sitting on the back porch, with her glasses in the fold of a magazine story, and the toe of one of her husband's socks covering her knobby finger-ends, glanced at the group, and thought to herself that Mary Lang, with all her finery, wouldn't be sorry to catch Aleck. Then at the memory of Hannah Ashley there came a little twinge of anxiety; for Hannah was her prime favorite; and, after the manner of substantial matrons, she desired her boy to marry a practical wife, who knew how to cook his dinner and make him comfortable. The sight of Mary Lang's white nerveless hands, with their pretty rings, caused the old lady to shake her head, and mutter something about "dolls and poppets."

Andy had come home from school, and had let the low-spirited dog out into the back lot to bark at the hens a little while by way of wholesome recreation. He was preparing to go down to his squirreltrap in the woods; and as he sat fussing away and whistling on the porch step, suddenly he pulled a paper out of his jacket pocket, and scampered off with it to the window.

"Here's something Deacon Ashley told me to give you, Sis. He called it a billy."

"You mean a William," put in Mary, chucking him under the chin.

"Why it's nothing but that advertisement of Puffer's Pills the Deacon promised father! I thought Hannah would be sure to invite us to her quilting," said Jane, in a disappointed tone. "Say, Aleck, have you and Han been quarreling?" and she gave him a provoking little thrust, such as sisters are wont to administer.

Aleck turned round, and set his elbows squarely against the windowsill, and began to whistle low to himself.

"Let's take that ride over Saddleback Hill I promised to give you tomorrow afternoon, Mary," said he, veering back again and chewing an end of grass.

Miss Lang expressed herself delighted to take the ride; and every body appeared satisfied but Jane, who now would have no opportunity to display the new twist to the girls before Sunday.

Hannah's quilt had been put on the frames the day before, up in the spare chamber—a large apartment with a carpet in Venetian stripe, a high-post

bedstead draped in the whitest dimity, a heavy mahogany bureau with respectable brass knobs, and an old-fashioned glass adorned with festoons of pink and white paper. There were faded foot-stools, worked by Mrs. Ashley when a girl, in chain-stitch embroidery; and framed samplers and silhouette portraits upon the wall of a cappy old lady and a spare old gentleman and matronly bunches of life-everlasting and crystallized grasses filling the plethoric vases upon the mantle-piece. Every thing was in apple-pie order, from kitchen to parlor. A pleasant, moist odor of Hannah's sponge-cake clung to the walls; and if you don't know what Hannah's sponge-cake was like, it is useless for me to describe it.

Hannah had put on her prettiest lawn dress—a pale green that became her blonde beauty, and touched it up here and there with a bit of pink ribbon. Mrs. Ashley was pinning on her false puffs before the glass, and fastening her collar with a brooch adorned with a daguerreotype likeness of the Deacon, which looked as if it had been taken in a particularly bad fit of dyspepsia. She dearly loved young company; and there was a bright twinkle in her eye, and a pucker about her mouth provocative of jokes.

When the girls had assembled, and the kissing and taking off of things was well through with, the grand business of the afternoon began. Every body praised Hannah's pretty quilt—pink stars dropped on to a white ground. Miss Treadwell was champion quitter. She understood all the mysteries of herrin'-bone and feather patterns; and, with a chalk-line in her hand, as the Deacon's wife expressed it, "ruled the roost." Miss Treadwell was a thin-faced, precise old maid, with a kind of withered bloom on her cheek-bones, and a laudable desire to make the most of her few skimpy locks.

"Beats all how young Salina Treadwell appears," whispered the Deacon's wife to her next neighbor. "She's as old as I be, if she's a day, and here she goes diddling round with the girls."

"Hannah, you ought to give this quilt to the one that gets married first," put in Susan Drake, threading her needle.

"I know who that will be," said Mrs. Ashley, winking hard toward Hetty Sprague, a pretty soft-headed little maiden, with cheeks of the damask-rose and dewy dark eyes.

"Oh, Miss Ashley!" cried Hetty, simpering sweetly, "how can you talk so? You know I never mean to get married all my born days. Men are such deceitful creatures!"

Miss Treadwell heaved a deep sigh, and snapped the chalk-line sentimentally, as if she too could a tale unfold that would tell of the perfidy of the male sex.

"I don't, for my part, see why every thing should be given to the married folks," returned Hannah, tapping lightly on the frame with her thimble, and feeling annoyed because Jane Freeman and her friend had not yet put in an appearance. "When I get to be an old maid I'll stuff every thing soft with feathers and wool, and keep sixteen cats, like Aunt Biceps."

"You an old maid!" cried merry little Nancy Duffy. "That's a likely story. I guess Aleck will have a word or two to say about it."

"It looks as if Aleck had got a new string to his bow," remarked Miss Treadwell, who knew how to give a sharp little thrust of her own. "He appears to be mighty thick with that girl from Hillsdale."

"Why, there goes Aleck now!" cried Hetty Sprague; and the girls ran to the window, upsetting one end of the quilt, just in time to see Aleck's sleek chestnut mare trot past, with Aleck himself so absorbed in the companion by his side that he did not appear to remark the battery of bright eyes under which he was passing.

Hannah colored and bit her lips, but she recovered herself with a light laugh.

"Never mind, girls," said she; "there are as good fish in the sea as ever have been caught. I'll show you Doctor Bingham to-night, and you'll all say he is perfectly splendid."

Then began a little mild gossip over the Doctor, as to who he was, and what had brought him to out-of-the-way Drastic—for the young man was only a visitor in the neighborhood—and in the clatter of tongues, before the second rolling, Hannah had slipped out to get tea. At first she did a very curious thing for a sensible young woman to do. She got behind the buttery door and hid her face in the roller-towel, and something very like a genuine sob shook her bosom, while some bitter tears were absorbed into the crash. The truth is, Hannah was jealous. The sight of Aleck devoting himself to that girl from Hillsdale, whom she had begun to detest, woke her up to the state of her

own feelings, and perhaps nothing but that would ever have done the work.

Nevertheless, there was the sponge-cake to cut, and the best doyleys to be got out, and the ivory-handled knives to be taken down from the top shelf of the closet. She had to calculate how much of the strawberry preserves it would take to go round and not look skimpy, and who should sit by the glass dish, and how many custardcups would be required to fill the middle of the table. All these things Hannah performed with as much accuracy as if her heart had not been smarting with disappointment and vexation.

Mrs. Ashley was never more in her element than when she presided at a feminine tea-party.

"We won't have any of the men folks round to bother, girls," said she, as they settled like a flock of doves about the table, which Hannah had so temptingly spread. "It's busy times on the farm now, and the Deacon likes a bit of something hearty for his tea, so I told him he and the boys might wait. Ahem, Salina, do you take sugar in your tea?" as she poured out a cup of the delicate, green flavored beverage that diffused an appetizing fragrance through the room.

"Oh, Miss Ashley," cried Nancy Duffy, "you'll tell our fortunes, won't you? There isn't a soul here to know about it, and we'll keep as whist as mice."

"Now, girls, don't make me appear simple," said Mrs. Ashley, leaning back and wiping her red and smiling face free from the steam of the tea-pot. "If Miss Whitcomb should get hold of it she'd say it didn't become a deacon's wife."

"Never mind Miss Whitcomb," broke in Susan Drake. "She thinks she's arrived at perfection, and such folks are always disagreeable. Here, do look at Salina Treadwell's cup. If I'm not mistaken there's an offer in it."

"Of course there is," said Mrs. Ashley, taking up the cup with professional interest. "Don't you see that ring almost closed, with a heart inside? And she's going to accept it. It's coming from a lightcomplected man. Looks like Sile Winthrop down at the Corners."

"Oh, Miss Ashley, how you do talk!" cried Salina, mincing her biscuit and blushing up on her cheekbones.

"He ain't a-going to live long, whoever it is," the Deacon's wife went on, twirling the cup with the girls hanging over her shoulder, and her eyes dancing with

LOVE OF QUILTS
Quilt patterns, borders, and quilting designs fill the pages of this vintage booklet.

fun. "Yes, Salina, you will be left a widder."

"What a sad thing it must be to lose a companion," put in sentimental Ann Davis. "I should hate to be left a relic."

"Never you mind, Salina," the Deacon's wife continued, with a wink. "If I'm not mistaken you'll console yourself with number two. Look there, girls, at the true-lovers' knot and the bow and arrers."

Miss Treadwell held up her hands in mock horror, and affirmed that she didn't believe a word of it; but it was noticeable, as Mrs. Ashley said, that she was "chipperer" all the rest of the evening.

"Come, now tell Hannah's," cried Hetty Sprague. So Hannah passed along her cup.

"Why, child, you're going to shed tears; and there's a little cloud of trouble round you; but it will clear away, and you'll get your wish in spite of every thing."

"Don't you see saddle-bags and pill-boxes there?" inquired Nancy Duffy.

"Go along with your stuff and nonsense, girls!"

exclaimed the Deacon's wife, waving away the cup. "If husband should get hold of it, he'd say I was trifling."

That evening, after Doctor Bingham had fooled a good deal with Hannah—had pressed her hand at parting, and whispered he should hope to see her next evening at the singing-class—she remembered her fortune, and did let some bitter tears soak into her pillow. She was not wise enough in worldly ways to suspect that the Doctor, a town-bred man, had set Hetty Sprague's silly little heart a-fluttering while he walked home with her under the warm star-light, although, in very truth, he did not care a fip for either of them. Hannah was content to play him off against Aleck, let the consequences be what they might; and more and more as she thought the matter over, she blamed that designing girl from Hillsdale.

The next night set in with a mild drizzle; and, in spite of Mrs. Ashley's protestations, Hannah was off for the singing-class. This class had been established to improve the church music, which, as the Deacon said, sadly needed "tinkering;" and gradually it became a resort for the young people of the village, while its functions were stretched to include a good deal of mild flirtation. Hannah, on entering, looked anxiously round to discover the Doctor; but, strange to say, he was absent. Aleck, who belonged to the choir, sat in his usual place alone. Neither Jane nor her young lady visitor had accompanied him. These facts Hannah ascertained before she let her eyes drop on her note-book. She watched the door keenly all through the hour of practice; but the Doctor did not make his appearance, and her indignation grew apace. She hoped to slip away a little in advance of the crowd, before the exercises were quite over, and the cordon of young men had formed about the entrance. But just as she was stepping off into the darkness, with the warm summer rain falling steadily, a hand touched her arm.

"Let me walk home with you, Hannah. I have an umbrella, and you are unprovided." It was Aleck's voice; and Hannah was nettled to remark not even a touch of penitence in its tone.

"No, I thank you," she returned, stiffly. "I prefer to go alone."

"But you can not refuse my company for a few steps, at least," said he, pushing up his umbrella and shielding her whether or no; "for I have brought an apology from Bingham. I am going to tell you, as a great secret," Aleck went on confidentially, while Hannah kept still from sheer astonishment, "that the Doctor and that forty-'leventh cousin of ours, from Hillsdale, were engaged once. The Doctor's a capital fellow; but there's a jealous streak in him. He wanted, to keep a loose foot, and wasn't willing Mary should do the same. She's an uncommonly pretty, lively girl"—a sharp twinge in Hannah's left side—"and, of course, she wasn't going to be cooped up, and the result was, they quarreled. But they did really care for each other, and now, the thing is made up, and I guess they have found out what a sneaking, unrighteous thing jealousy is."

"There might be cause for it," returned Hannah, faintly, as she felt her spirit oozing away.

"Come now, Hannah, you mean to hit me, and I might hit back again, but I won't; for I haven't loved any body but you—just as much as you would let me—ever since I was a boy. I am one of the constant kind. Don't you know I am, Hannah?"—very softly spoken for such a big fellow. "My heart has learned one trick of loving, and it can't unlearn it."

"Why, Sir, didn't you and Jane come to my quilting party?"—spoken in a shaky voice, and showing the white feather badly—"and why did you go gallivanting off with that girl?"

"You did not ask us, in the first place, and that girl was a visitor, and I liked her."

"Don't be saucy. I sent a note to Jane, and told father to give it to Andy."

"Ha, ha!" laughed Aleck, "it is all explained now. The old gentleman sent us an advertisement of Puffer's Pills by mistake, and you will find the note quietly reposing in his pocket."

I am afraid Aleck was saucy, for when Hannah got into the house there was something very sweet and delicious tingling upon her lips. She crept into the sitting-room, where she could hear the good old Deacon calmly snoring, and slipped the little note out of the breastpocket of his coat.

Long afterward, when she had been Aleck's wife many a year, and the colors of the pretty star-quilt had faded upon her bed, Hannah would take the little billet, grown yellow now, from an inner drawer, where she kept it long with a silky tress cut from the head of the baby she had lost, and kiss it tenderly, as if new faith and trust could emanate from its folds.

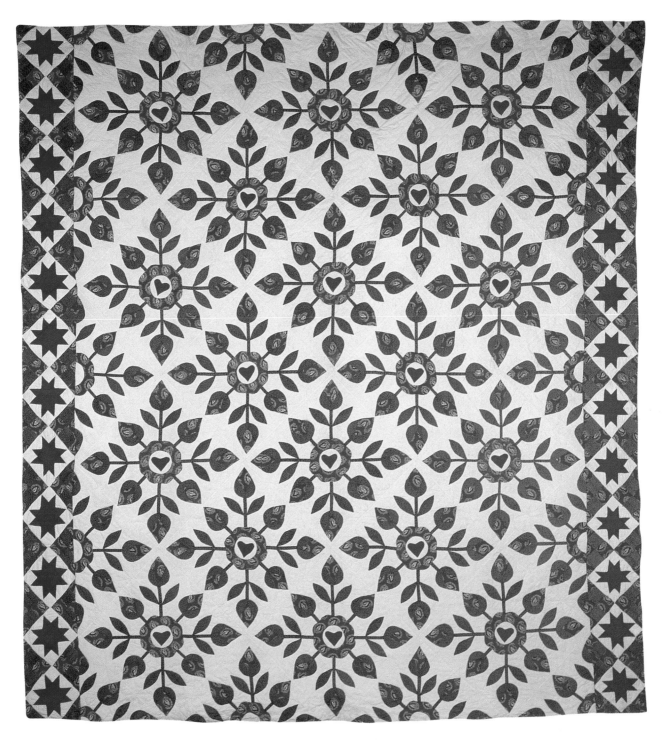

HEARTS AND FLOWERS
This cotton quilt was made in Maryland circa 1840 and measures 92 by 84 inches. Its heart motif suggests romance was on the mind of its maker. (Stella Rubin Antiques)

Pauline Eblé Campanelli

Alice's Tulips

By Sandra Dallas

THE CIVIL WAR brought hard times for all, and quilters were no exception. Many of the women who gathered to quilt together were the mothers, sisters, and wives of the men fighting on the battlefields.

In *Alice's Tulips*, author Sandra Dallas tells the story of newly married Alice Keeler Bullock, whose husband Charlie has enlisted in the army. The fiery young woman writes letters to her sister describing the Friendship quilt she presented to Charlie, her trials with her mother-in-law, and the plans of the Slatyfork Soldiers Relief Society to send much-needed quilts to their brave soldiers.

Sandra Dallas of Denver, Colorado, is the best-selling author of such novels as *The Persian Pickle Club* and *The Chili Queen*.

Pieced Friendship

A Friendship quilt was presented to a beloved friend or family member on an important occasion—a marriage, an anniversary, a move west, an army enlistment, for instance. The quilt became a remembrance of loved ones left behind. Names and sometimes a sketch or sentiment were embroidered or signed in permanent ink on patchwork blocks. The blocks were assembled into the Friendship quilt, also known as a Signature, Presentation, or Album quilt. Among the most popular quilt patterns were Churn Dash (Love Knot), Double Monkey Wrench, Hole-in-the-Barn-Door, Shoo-Fly, and, after the Civil War, Sherman's March.

December 3, 1862

Dearest Sister Lizzie,

Are you surprised to hear that Charlie has gone for a soldier? You knew he would do it, I told you so, but he left sooner than we ever expected. Now I am shut up with his mother on Bramble Farm, and she is no better for conversation than prune whip. If I didn't have you to write to, I think I should die. I have no close friend at Slatyfork, and you know I can't write my true thoughts to Mama or to most friends back home in Fort Madison—not after the way they passed it around why I married in haste and young, being yet sixteen, although Charlie was twenty-one. By now they know they were wrong, but I still do not think kindly of them. Me and Charlie never did anything wrong until we got married, although, Lordy, I was tempted. The day I walked into that dry-goods store in Fort

BETTER QUILTS
Ten cents bought you a copy of Better Homes and Gardens *in May 1925. For that price you could also read about the latest household and sewing tips.*

Madison and saw him the first time, I knew he was my life's companion, and he felt likewise. I don't know why Mama and Papa were so set against it. After all, they approved of you marrying James when you were still fifteen, and moving off to Galena. I guess they believed James had a future but that Charlie would always be a clerk. Or maybe, me and you being the oldest and the only girls, Mama wanted me to stay at home to care for the six little boys. Well, I don't care about any of them as much as I do you, Lizzie. Me and you were always as close as two apples on a stem, and I know I can write you frank, without you giving me what for.

My Charlie is a gay little soldier, and a tiger to fight the Johnny Rebs. Why, he is as full of fight as any swill tub, though he himself took the pledge so is dry as the ash heap. (We'll see about that after he is in the army awhile, however, for Charlie likes his good times.) They had better watch out, those Secesh. Charlie won't have a fear for his safety. He worries that the war will be over before he can get himself some scalps. Oh, I wish I could be a soldier, too, and shoot the Southern fire-eaters and be the one to hang old Jeff Davis higher than Haman. But no, I must be left behind with Charlie's mother on a farm. I wish Charlie had not gone, but to tell him to stay in Slatyfork and not enlist, well, I might as easy try to cut the morning mist with scissors.

The folks here gave our boys a first-rate send-off. This is the biggest regiment raised in the vicinity, and the town did the boys proud. Charlie and the other recruits marched off grand. People drove in from farms and ran from the shops and stood in the road bare-headed, shouting hurrahs as the soldier boys marched smartly along. The church bells rang, and a brass band led the parade, blasting out the "Battle Cry of Freedom." Little children threw flowers, ladies waved their handkerchiefs, and gents who'd climbed on top of the bandstand in the square cried out, "Union forever!"

Then marched the Wolverine Rangers—for that is what they have called themselves—eighty-six fine soldiers who shook the earth with their thundering footsteps. Oh, it was a fine time, with only a few scowls on the faces of traitorous copperheads. Here along the Missouri border, I am sorry to say, copperheads are as thick as princes in Germany. One of them called out, "Ho for old Jeff Davis," and a group of boys thumped him. Myself, I don't care so much about freeing the slaves, nor does Charlie, but we both say the Union must be preserved.

It's my guess that Uncle Abe has used up all the single boys, and now he's asking the family men like Charlie (more of that presently) to sign up. Most are joining now to get their hundred-dollar bonuses, instead of waiting to be called up by the government, in which case, they would not get a plug nickel. Some call it "greenback patriotism," but I say it's little enough to pay a wife for being left behind to work Bramble Farm, and a hardscrabble farm at that. This was the last place made when the world was created, and the material ran out.

Charlie says he will give all but ten dollars of his bonus to Mother Bullock for the farm, which doesn't set well with me. "Charlie, which one is your wife?" I asks. "Well," says he, "I don't want you to worry about any creditors, so I'll give it to the old lady." He'll keep five dollars for himself and will make me a presentment of the other five. Since it's as good as in my pocket, I spent a dollar of it at the mercantile for a hat with red, white, and blue streamers, which I wore to the parade. Mother Bullock did not approve of the purchase and scolded, saying that if Charlie doesn't come back, I will have to wear black bonnets for the rest of my life, and who would give me back my dollar?

"I would wear black for only a year at most, for there are others to take Charlie's place," I reply, with a wink at Charlie. He laughed, but Mother Bullock scowled. She spent a nickel on a flag to wave at the parade, which is a bigger waste of money, for I can wear the bonnet ever so often (if Charlie doesn't get killed, that is, and I believe the bullet has not been molded that can harm him), but she won't wave that flag again until the war ends.

Sister Lizzie, what do you think, I was asked to make the battle flag for the Wolverine Rangers! Charlie said when the subject of it came to be discussed, he rose right up and volunteered my name. Then Harve Stout—he was the lightning rod agent before he joined up—said his new wife, Jennie Kate, sews better. (The talk is Charlie was sweet on Jennie Kate before he went to Fort Madison, but it was the other way around. She was sweet on him, but he didn't care for her any more than a yellow dog. My presence in Slatyfork as Mrs. Charles Bullock, a bride of one year, does not sit finely with her.) Charlie spoke up for me, and even though I have been here only two months, I was requested to make the flag. It is handsome indeed, with the head of a wolverine, cut from red madder. I applied the head onto canvas, using good stout thread; the flag may get shot up by the Rebs, but that wolverine will never ravel. Charlie carried the colors in the parade, and as he passed by, he dipped the flag to me, although Mother Bullock thought he saluted her. Well, let her, the old horned owl.

The night before Charlie left, I gave him the Friendship quilt I had worked on in secret, and told him it was my love letter to him. Your block with your name and sentiment arrived just as I was assembling the pieces. I was in a busy time, as I was making drawers and blouses for Charlie, too, but I wanted the quilt to be perfect, so that meant making the blocks myself. You saw them. They were the Churn Dash pattern, in blue and brown and cheddar yellow. Don't you think that's a pretty combination? After I made the blocks, I passed them around among Charlie's friends to be signed. Some drew pictures and wrote verses. One neighbor printed an X, and wasn't she the embarrassed one at doing it? Mother Bullock spoilt the fun by writing "Mrs. E. Huff" over the sign, so no one would know. I set up the quilt frame at Aunt Darnell's house to keep it secret from Charlie, and ladies from the town came to stitch for an hour or two. Most did a good job, but I had to rip out the work of one because her stitches were long as inchworms, with knots the size of flies. Lizzie, you know I am not vain except for my sewing, and I think I can't be beat at quilting. My stitches were the finest, even though, being in a hurry to finish, I took but eight stitches to the inch instead of twelve, as I usually try to do. When no one was about, I tucked powerful herbs and charms into the batting to keep Charlie safe. My husband pronounced the quilt a peach, fit for the bed of a king, and he is never going to lay it on the ground but what it has a gum blanket beneath. He says he will sleep every night with my name over his heart. Did you ever hear such a pretty speech? My patch is in the center, like a bull's-eye. Yours is beside it. Mother Bullock's is on the side. Jennie Kate Stout wrote:

When This You See
Remember Me

Well, he won't see it often, because it is at the bottom of the quilt, and when he does see it, he will think what a sloppy wife she would have made him, because the ink was smeared. She asked for a second square to sign her name, but I said I hadn't any extra.

I used leftover scraps to make Charlie a cunning housewife that is brown with blue pockets, bound in red twill, and it rolls up nice and fastens with hooks and red strings. Inside, the housewife is fitted up with needles and pins and thread so Charlie can mend his

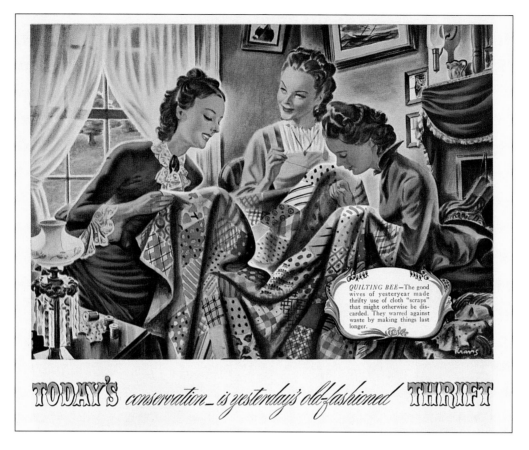

QUILTING BEE—The good wives of yesteryear made thrifty use of cloth "scraps" that might otherwise be discarded. They warred against waste by making things last longer.

TODAY'S *conservation is yesterday's old-fashioned* THRIFT

WASTE NOT, WANT NOT
Wartime required that all citizens work to conserve their resources. This World War II–era ad from Martex recalls that "Today's conservation is yesterday's old-fashioned thrift," and cites that quilters "warred against waste by making things last longer."

uniform if he gets shot. It's told that many soldiers go ragged because they won't sew for nothing, but Charlie sews as good as a woman. Remember when he boarded at the McCauley farm so that he could be close to me? The McCauley girls jollied him into learning to work a needle. Mattie McCauley says if a woman can plow, a man ought to know how to thread a needle. But how many do? I ask you.

That last night, after she gave Charlie a fork and spoon to take with him, Mother Bullock walked out to visit her sister, Aunt Darnell, giving me and Charlie time alone, as she should, since we haven't been married so long, and I expect he'll be away for some months. Then she sent word by a man who was passing by that she was took tired and couldn't walk home, so was spending the night there. That was a good thing, because it gave me and Charlie the night alone without the worry of rattling the corn shucks in the tick when we got to romping. (Now, Lizzie, I said I would be frank, so you musn't take offense, and besides, you

have wrote me about you and James and that business under the parlor table. I wanted to try it with Charlie, but I've told you how I thrash about so, and I was afraid I would bang my head on the underside of the table and break it—my head, that is.) That's when I told Charlie he was one of the family men who'd enlisted. Now you musn't say a word about it, because I don't want Mother Bullock to know awhile yet, for she is always one for acting proper and would make me stay away from the town. Charlie says it will be a boy, and he wants to name him for his brother Joseph. That's to please Mother Bullock, because Jo was her favorite, and she misses him. Well, I'm sorry he got drowned, too, for if he was on this earth yet, me and Charlie never would have left Fort Madison to help her with the farm. But I don't think we have to name my baby for him.

I told Charlie I fancy something patriotic for the name. "How does Abraham Lincoln Bullock suit you?" I asks.

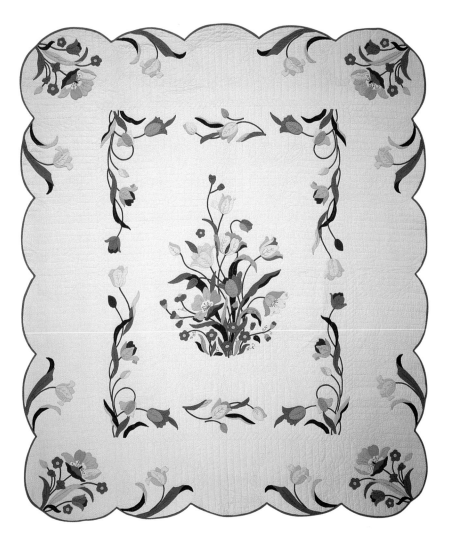

BOUQUET OF FLOWERS
Tulips spill across this quilt, which was made in Pennsylvania circa 1930 and measures 75 by 82 inches. (Stella Rubin Antiques, photograph by Harriet Wise)

"Not unless he's born with a beard and top hat," replies Charlie. I think maybe I will be like the Missouri Compromise and try to come up with something to please everybody. How do you think Mother Bullock would like the name Liberty Jo? Maybe, like the Compromise, when the day is over, it won't suit anyone.

When we took Charlie into town in the morning to climb aboard the wagons that took the boys away, he gave me a good squeeze and says, "Now, Doll Baby, you got to promise not to step whilst I'm away." I reply real saucy, "When dead ducks fly! But I guess I can give my word not to step with a Reb." Then I told him to promise he would come back with both his legs. You know how I love to dance, and I won't be tied to a cripple with a stump. "Oh cow!" says I, "I'd rather deliver you up to the jaws of death than to see you hobble back on a pegleg." Charlie laughed and promised his strong Yankee legs would keep him safe.

Mother Bullock said she'd welcome back her son in any condition, which put me out of sorts, because it was only a joke I'd made. She is as sour as bad cider when she wants to be, that one, and she is only the mother, not the wife. But I feel sorry for her, because if Charlie falls, she will never more have a son, and I could have plenty more husbands, I suppose, although I don't want any but the one I have. Well, Charlie thought it was funny, and he was glad I sent him off with a laugh and not tears and lamentations, like some I could name—Jennie Kate Stout, for one. He said I have the right kind of pluck and will do for a soldier's wife. I replied he is brave and true and will do for a soldier.

This from the proud wife of a Yankee volunteer, your sister,
Alice Keeler Bullock

January 17, 1863

Lizzie dearest,

The hired man is as lazy as Pussy Willow, that fat old cat of Mama's, and Mother Bullock has been laid up with poor health, so it is up to me to do all the work. I have started milking the cows, and you know how much I hate milking. The cows know it, too, and they are a mean bunch, especially Lottie, who is the worst cow I ever saw. Yesterday, she kicked me with her sharp hoof and knocked me off the stool. It is blizzardy outside, and the cold sets hard on Mother Bullock, who keeps the fires high because she has the chill. It is so hot inside the house, it most roasts eggs. I can't get comfortable leastways. I wish Charlie would come home. I never missed anybody so much in my life.

Mother Bullock is improving, and yesterday we went into town for the first meeting of the Slatyfork Soldiers Relief Society, which event was held at the

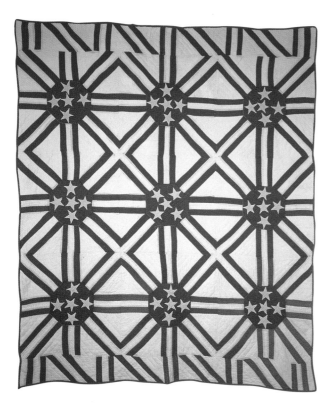

RED, WHITE, AND BLUE
This patriotic quilt from the World War I era is made up of bold stars and stripes. It measures 70 by 61 inches. (Stella Rubin Antiques, photograph by Harriet Wise)

home of Sara Van Duyne, who is rich as cream. Slatyfork is not much of a town, and every other person you pass is a hog. It has many log houses and a few of plain red brick, but this was very large and such a pretty place (although Mrs. Van Duyne herself looks like a fleshy plucked goose, with faded hair and cap, and uses lamp black on her eyebrows). She has mirrors in gilt frames and mahogany furniture with the latest horsehair covering, hard and slippery and as black and as smooth as an icy pond at midnight. There are orangy red velvet curtains at the windows and tidies on all the furniture, and she served us cake on dainty blue-and-white feather-edge plates. We looked like a Methodist camp meeting. A few ladies wore their best. One had on the new military jacket, with epaulets, brass buttons, and gold braid; I am going to make one for myself the first chance I get. But most were dressed plain, some in butternut. There were only a few hoops, and those small ones, and fewer corsets. No traitors welcome. The wife of one attended, and we scoured the little copperhead as bad as you would scour a copper pot-all but Mother Bullock, who is a spoilsport, you bet. All were very nice to me, or perhaps more curious than nice, and each asked for news of Charlie.

"Oh," cries Jennie Kate Stout. "Charlie's the worst there is for letters. He promised to write me every week when he went to Fort Madison, and he never did once, and us being all but—" And she stopped of a sudden, hiding her face, which had turned the color of the draperies, which tickled me.

Mother Bullock says to her quick, "Why, he never wrote to me neither, the wretched boy."

Afterward, Jennie Kate came to sit beside me on the horsehair love seat, her slipping and me sliding on the hard fabric, and she says, "Alice, if they got to go to war, I'm glad Harve and Charlie have each other. One'll keep the other out of trouble."

"Or in it," I reply.

"Harve's wrote me five time," Jennie Kate says, a little too proud for my taste. "How many time has Charlie written you?" She was knitting socks and poking me with her needle, and I misdoubt it was an accident.

"I guess one of 'em's got to spend his time learning soldiering, and Charlie's it," I tell her right back, getting up so fast that when she leaned toward me for another poke, she almost slid off the horsehair.

We elected Mrs. Van Duyne president of the society, which was fine by me, for I hope we can meet at her house each time and eat her cake-spice, with cloves and nutmeats. She wasn't surprised in the least at being asked and already had a list of duties wrote out. Mother Bullock agreed to take charge of bandages, and Jennie Kate volunteered to make the havelocks, since she's already run up a dozen or two. Do you know them? They look like sunbonnets, and the men wear them to protect their faces and necks from the sun. I heard soldiers at Fort Madison say they're good for nothing but to wipe their guns, but telling Jennie Kate something is like spitting in the rainstorm. I guess she's no different from me in that regard.

Other ladies will be in charge of knitting socks and sending food bundles to the Wolverine Rangers. Mrs. Van Duyne appointed Phoebe Middleton, a Quaker, to see to the knitting of mittens, which caused one lady to remark she hopes Mrs. Middleton will not follow the example of other Friends and knit mittens without trigger fingers. We all had a laugh, and Mrs. Middleton seemed to enjoy the joke, too.

Then, Lizzie, what do you think? Mrs. Van Duyne asked me to be head of the quilt making. "I have it on the best authority that you are most accomplished with your needle," says she. "And we all take pride in the flag you made for the Wolverines." The ladies set down their knitting, for nobody goes anywhere without her knitting, these days, and there was a clapping of hands, and I blushed bad. I bowed my head a minute, to keep them in suspense about my answer, but Mother Bullock says, "She'll do it." Serves me right for trying to

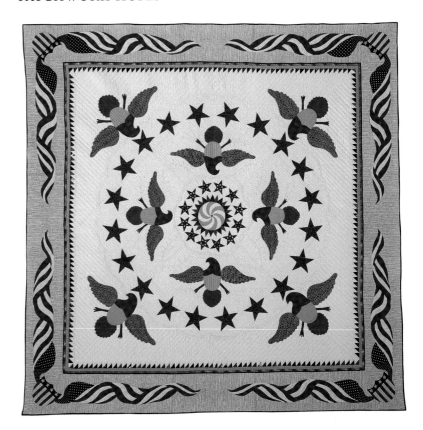

FREEDOM
Gerry Sweem of Reseda, California, was in the process of making this quilt when the events of September 11, 2001, occurred. The quilt was appliquéd and quilted entirely by hand, features trapunto, and measures 94 by 94 inches. (Photo by Melissa Karlin Mahoney, courtesy of Quilter's Newsletter Magazine*)*

act important. The committees are going to meet as often as necessary to get the work done, and the whole group will gather once a month. Dues, five cents. Mother Bullock said they should be voluntary and left in a bowl at the door, since money's hard to come by. Jennie Kate asked to be a member of the quilters. Well, that is all right, for she can sew a good seam. I wonder if she will take orders from me. I wouldn't take orders from her, but then, I don't take orders from anybody. A body who tried to boss me would wear herself into a grave. . . .

Give my respects to all inquiring friends. Do any inquire?
Alice Bullock

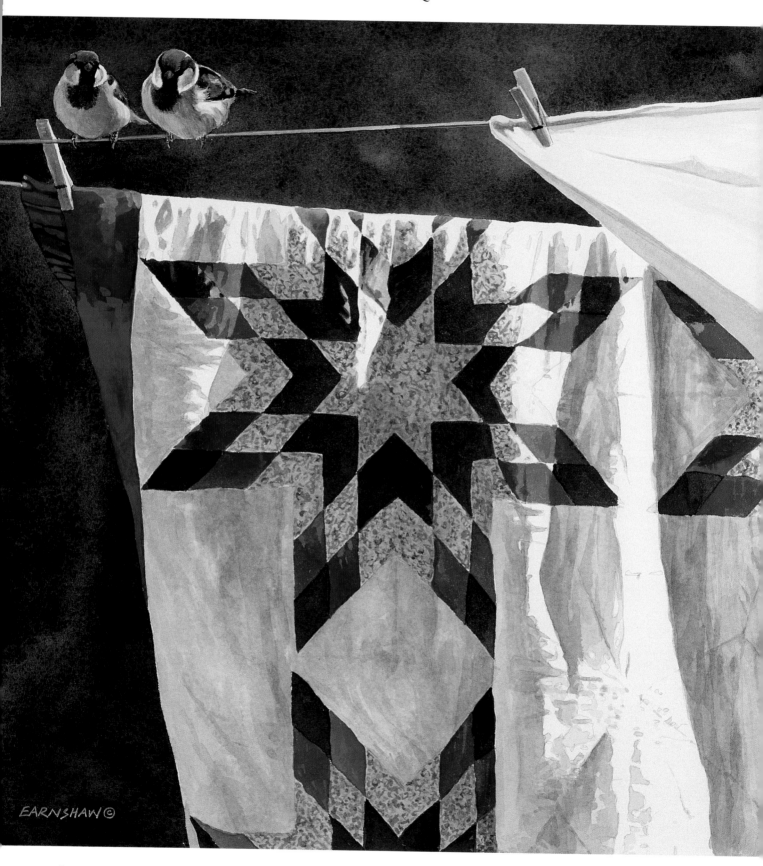

"STITCH IN TIME"
Two chickadees perch on a clothesline, while linens and a Star quilt dry in the sunlight. (Artwork © Adele Earnshaw)

February 1, 1863

Dear Sister,

I seat myself to pen you a few lines and ask you for your help. Me and you raised all of Mama's babies, so I guess there's nothing you can tell me on that score. But I don't know leastways about giving birth. Those women shooed us out of the house when Mama's time came, and we never paid attention, except for that once when we hid under the bedroom window and heard her holler so. We thought it served her right for

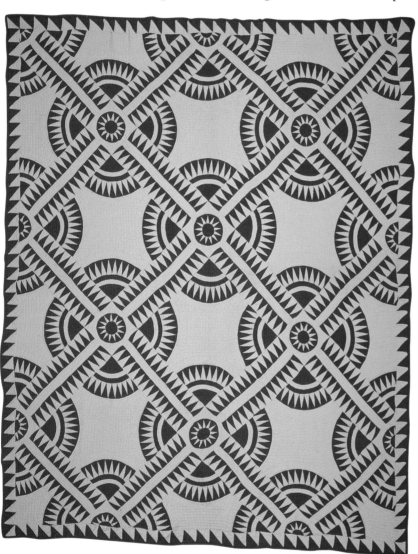

NEW YORK BEAUTY
This dramatic red and white quilt was made circa 1870 in a classic New York Beauty pattern. (Stella Rubin Antiques)

bringing another baby into the world for us to tend. All I know about having babies is it causes men to get drunk. So please to write and give me the details. I never saw the sense of being dumb about a thing. Don't spare my sensibilities, because I'll know soon enough. I can't hardly ask the details of Mother Bullock, who doesn't suspicion my state, since I do more than my share of the work and try to be cheerful about it. . . .

I presided at the first meeting of the Soldiers Relief quilt group last Wednesday. Mother Bullock let me use her pretty tobacco-leaf plates, which I never saw before. They're for good, she says, and I guess I wasn't good enough. I made a nice gooseberry cobbler, with fresh cream over the top. Jennie Kate Stout asked for seconds. She is a big girl. Besides her, my committee has on it old Mrs. Kittie Wales and Nealie Smead. Mrs. Kittie's last husband got killed off at the second Battle of Bull Run. He is the third husband to die on her, but Mrs. Kittie is not one to carry on. It was all the scandal in Slatyfork when she read his name off among the dead listed at the telegraph office and said matter-of-factly, "The first one drowned, and the second one hanged hisself from a hickory branch. At least this one I lost honorable. Still, don't I have the damniest luck with husbands? Don't I?" Whether she did not care much for Mr. Wales or just feels lucky she survived another husband, I don't know, but she is cheerful as a hog under a persimmon tree. Nealie is the copperhead. I didn't want to let her in, but Mother Bullock says it's a good joke on her people that she's working for the North. They say Nealie's got family fighting for the North and fighting for the South, and some that don't fight at all. That includes her husband. He fights only with his neighbors.

94

At the meeting, Jennie Kate, who is duller than the widow woman's ax, said we should make our quilts in Churn Dash, the pattern I used for Charlie's going-off quilt. I think she wants to try to best me. Each of us would sign a square, so the boys would know who to thank, she said. But even the copperhead knew that was a fool idea, for what if the quilt goes to a soldier who can't read? Besides, why make a fancy quilt top, when in the same amount of time, we could turn out ten plain ones? Nealie proposed tacked one-patches. But Mrs. Kittie said even a dumb soldier knew that was a cheap way to quilt and suggested nine-patch. So it was up to me to come up with the compromise again. And just like that, it came to me, and I says, "Let's make four-patch blocks, then cut an equal number of one-patch blocks, the same size as the four-patch. We'll alternate them in long stripes. Then we'll put bands of fabric between them." Jennie Kate suggested we call them Slatyfork Stripe quilts, but the rest of us did not care for the name, so we shall think on it. Then Nealie suggested we write "Soldiers Relief, Slatyfork, Iowa," with the name of the person who finished off the quilt. That way, if someone wants to thank us, he'll know where to write.

We made out the templates right there, to make sure they are all the same size, and cut out squares, for we'd each brought scraps, and began our stitching. By the time the others left, I myself had finished sewing five four-squares. At this rate, we'll make a quilt for every soldier in the Union army by Christmas. Lizzie, I know I'm bragging, but only to you, and that's what sisters are for, aren't they?

It was the best time ever since Charlie left. I got to say, I like that Nealie better than Jennie Kate, who is too righteous for me. She said we ought to start a Bible Society to pray for the end of the war. "You can pray till the crack of dawn, but that don't do what stitching will," says Nealie.

Jennie Kate tells her right back, "Well, if sewing would win the war, it would have done so long since."

"Maybe the Rebel girls stitch faster than us," I says. Since Jennie Kate had finished only half as many squares as the rest of us, that shut her mouth. . . .

Remember me kindly to all and
pray for a little happiness for your sister,
Alice

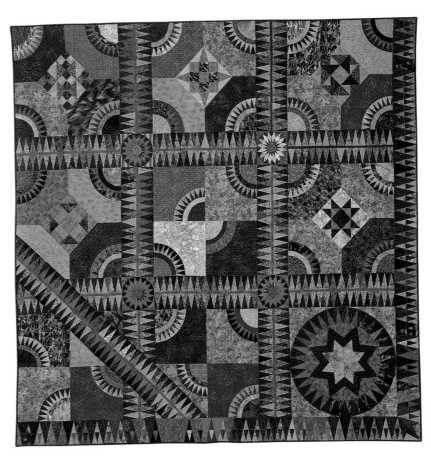

ONCE A NEW YORK BEAUTY
Cindy Starkey Robinson of Northfield, Minnesota, was ready to start a New York Beauty variation quilt in August 2001, but when the country was effected by September 11, she changed her color scheme to include grays, browns, black, and red. The completed quilt measures 88 by 88 inches. (Photo by Melissa Karlin Mahoney, courtesy of Quilter's Newsletter Magazine)

The Low Cost of Quilting

By A. B. Silver

THE SPOUSE OF a new quilter sees first-hand how the love—or lust—of quilting can quickly blossom.

A. B. Silver began writing about the antics of his wife, Joan, when she retired and discovered the art of quilting. As her fabric stash grew, so did A. B.'s collection of stories. He started posting his humorous, conversational pieces on the Internet, using the pen name "Popser," and was met with an enthusiastic response from quilters and quilting spouses alike. Today, he has published two collections of his essays, *A Year in the Life: 52 Weeks of Quilting,* and *A Year in the Life: 12 Weeks of Sewing.*

SUNDAY BEST
Everyone wanted to put on their most refined get-up and pose with the family quilt. Here a man stands against a Drunkard's Path quilt.

How do you afford it?" our friends always ask.
"But doesn't all that fabric cost a fortune?"
"But don't all those quilting supplies cause bankruptcy?"

I always answer that we can't afford it, that fabric costs a fortune, and buying quilting supplies causes bankruptcy. Darling Wife, the quilter, however, has a different answer for each question. All have to do with the fact that she has developed a quilter's brain, which is probably at an angle or pointed or squared off or stripped. No doubt her brain cells form a kaleidoscope or her brain is now pieced together following some pattern from a manual for beginner quilters.

"How much did that fabric cost?" I asked in her second month of quilting. She had just come back from some trip to some quilt shop where quilters talked to one another in secret code and encouraged each other as if they were all members of a 12-step quilting support group. All twelve steps, no doubt, had to do with spending more money at each step of the addiction that quilting brought to the innocent.

"Not much," she said.

"Not much how much?" I asked. Before she took up quilting, she would tell me what she spent. Now, no doubt after she had taken some quilters' vow of secrecy, she might evade, sidestep, mislead, or circumvent, but she would never lie.

"I got a great bargain," she said, sidestepping, misleading, evading, and circumventing.

"How much did the bargain cost?" I asked. The trick was to be persistent. Our retirement depended on it. We didn't have social security yet, and wiping windshields at stop signs didn't exactly appeal to me as a future job.

"Less than I thought," she said.

"How much less?" My tone of voice was designed to show my impatience with her answers.

"Do you want to know exactly?" she recognized the tone.

"How much did the fabric cost?" I asked.

"Twelve ice cream cones," she said.

That was eleven months ago and the beginning of her version of quilting accounting. Quilter accounting, according to my DW's new way of thinking, was designed to show that through careful budgeting, all her quilting was essentially cost free. In fact, she was going to prove over the next quilt-filled shopping months, it would save money.

"Ice cream cones?" I asked her that day. "Twelve ice cream cones?"

"I'm not going to eat twelve ice cream cones," she said.

"And?" I asked her that day.

"Substitution," she said. "The money I save from not eating the ice cream cones will pay for the fabric." She was delighted with her version of new math, quilter's math.

"You're not going to eat twelve ice cream cones?" I asked, but I didn't expect any further explanation. She fooled me.

"Remember when you bought the computer four years ago?" she said.

"Yes," I said cautiously.

"And remember what you told people when they asked how you could afford such a nice computer?"

"Go on," I said.

"You told everybody that you didn't buy the more expensive car you wanted but settled for a less expensive one and used the difference to buy the computer."

"I said that?" I did say that. It made sense to me at the time.

"I'm not going to eat twelve ice cream cones, so I can buy the fabric with the money I don't spend."

"That makes sense," I said.

"And I have four dollars a day to spend because I don't smoke two packs of cigarettes."

"You haven't smoked in forty years."

"So, I bought the sewing machine with that money."

"I thought we bought the sewing machine with the money from the trip we didn't take to Fuji."

"We used that money for the trip to Paducah to see the quilt museum."

"I thought we paid for that trip by not eating caviar for breakfast each day."

"You don't like caviar," she said.

"I like turkey," I said.

"Yes, and I was able to buy all that batting by not buying a hundred cans of cranberry sauce."

"And we didn't have yams this year," I said.

"You don't eat yams. I bought bias tape with that money."

"And what else that I don't eat didn't you buy?"

"You're allergic to shrimp, so that paid for the quilt templates."

"How much shrimp didn't I eat?"

"About ten cans. I could have not bought fresh shrimp and saved even more money."

"I don't eat squid. I suppose you didn't buy any?"

"I didn't think of that. I do need some more black thread for the next quilt. I think not buying squid would take care of that."

"I seem to be making all the sacrifices."

"I gave up having my nails done."

"For what? You've never paid to have your nails done in your life."

"And I don't plan to in the future. I used that money to buy the three rotary cutters and the three Olfa mats."

And so it went and so it goes. Whenever I show her evidence of our going broke, she begins to sacrifice new things. This morning she was looking through the catalogs to find some new fabric for sashing the quilt she's working on. Halfway through the second catalog, she looked up at me as I crossed the room. "What?" I asked.

"Let's not climb Mount Everest for New Year's Eve," she said.

"I don't plan to go anywhere," I said.

"Good, then I can get a new quilt book, too."

"As long as it doesn't cost us anything," I said. And with her doing the accounting, we will probably

"FISH QUILTSCAPE"
A school of fish swim around two contemplative anglers in this dreamy scene by Rebecca Barker. Perhaps they're thinking of their future brides—or maybe they just have their minds set on reeling in a prize-winning trout. (Artwork © Rebecca Barker, from Rebecca Barker's book Quiltscapes, *published by the American Quilter's Society, 2003)*

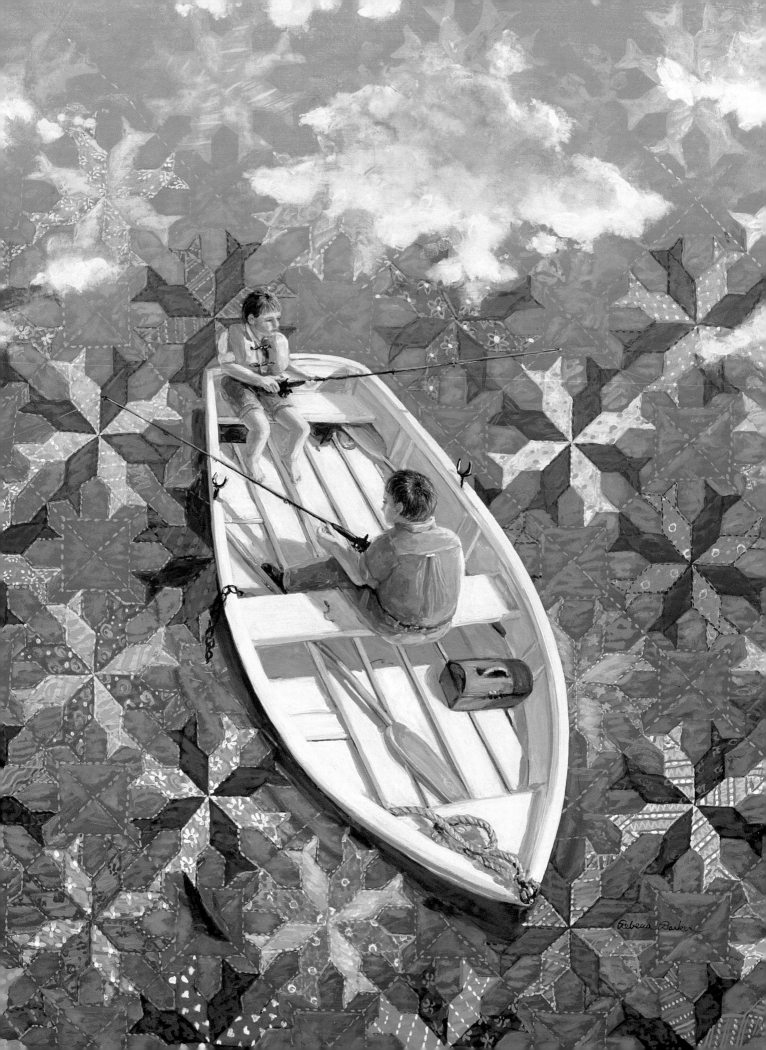

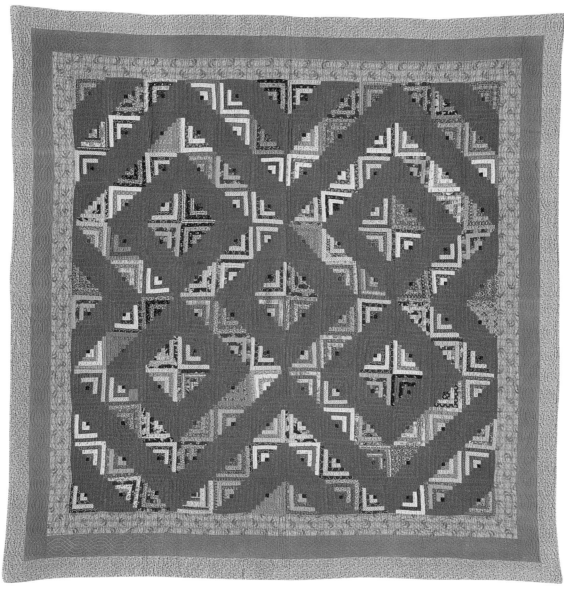

LIGHT AND DARK
Above: *The strippy construction of the Log Cabin quilt enables quilters to use smaller pieces of fabric from their scrap bags. This Log Cabin variation was pieced circa 1880 in Pennsylvania. (Stella Rubin Antiques)*

WEDDED BLISS
Right: *What better wedding gift than a brand new treadle sewing machine? The husband pictured on this vintage trading card has just scored big points with his new bride.*

EVERY QUILT TELLS A STORY
An amorous couple, birds, flowers, and flags all appear on this magnificent quilt from Virginia, appliquéd circa 1880 and quilted circa 1950. To the right of the house, a person climbs a ladder to pick cherries from the tree's boughs. (Collection of Toby and Oscar Fitzgerald, Stella Rubin Antiques, photograph by Harriet Wise)

THREADS OF CHANGE

"Quilts satisfy the basic human need for warmth. They also fulfill the desires for self-expression and for creating things of beauty."
—Robert Shaw, Quilts: A Living Tradition, 1995

The quilting world has seen many changes over the centuries, from the introduction of the sewing machine to the invention of the rotary cutter. The biggest change, however, is that quilts are no longer only made to keep our bodies warm. We also make them to warm our souls, hang on our walls, and carry our legacies.

As the years passed, quilting techniques evolved, attitudes shifted, and the appreciation for quilts grew to new heights. Today, quilters feel free to express themselves through their patchwork creations, and their finished masterpieces are considered works of art. This chapter highlights the reverence we feel for quilts and the respect we have for their makers.

CHEVRONS LOG CABIN
Left: *This variation of the beloved Log Cabin pattern was made of wool in Virginia circa 1890. It measures 80 by 75 inches. (Stella Rubin Antiques, photograph by Harriet Wise)*

OLD FAVORITES AND NEW
Above: *Aunt Martha's Studios of North Kansas City, Missouri, was a popular pattern resource for quilters. This vintage pattern booklet was just one of their publications.*

The Quilters Hall of Fame

By Karen Biedler Alexander

THE IMPORTANCE OF quilters' work was not always recognized before the inception of the Quilters Hall of Fame. The mission of the QHF is to celebrate quilting as an art form by honoring the lives and accomplishments of the people who have made outstanding contributions to the world of quilting. They can be contacted at P.O. Box 681, Marion, Indiana, 46952.

Here, Karen Biedler Alexander takes us on a journey through the development of the organization. Her passion for quilt history developed when she began quilting and joined the American Quilt Study Group in 1981. Today, she is a Quilters Hall of Fame board member who lectures and writes on the history of quilting.

In 1975, as the United States prepared for its bicentennial, Hazel McDowell Carter was busy making a quilt to commemorate our nation's two-hundredth birthday, just as American needleworkers have celebrated historic and political events since the founding of the country. Four generations in her family contributed blocks for that quilt, carrying on a long tradition among quilters of working together to reach a common goal.

Hazel McDowell was born in Salem, Iowa, and learned how to quilt early in her childhood from her mother, Grace McVey McDowell, and her maternal grandmother, Elsie McVey. Hazel still has one of those first hand-pieced blocks in her possession. In 1958, she moved to Washington D.C. to work in the office of her Iowa Congressman, and she continued to quilt. In 1964, she married Joseph G. Carter and was the busy mother of two small children by 1971.

Hazel McDowell Carter brought more than her administrative skills with her from Iowa. She brought her love of quilting. Her first serious study of quilting history began with the discovery of an article in a 1970 issue of *Needlewoman and Needlecraft* magazine about a 1708 English-made patchwork quilt with accompanying bed hangings and curtains. Over the next few years, Patsy and Myron Orlofsky's book, *Quilts in America,*[1] and articles in *Quilter's Newsletter Magazine, Nimble Needle Treasures,* and *Quilters' Journal* would form the backbone of her knowledge of quilting history. In 1973, Hazel Carter and Jinny Beyer met at a local gathering of quilters, and together began studying old fabrics in order to learn how to date their growing collections of antique quilts.

Just months before meeting Jinny, in December 1972, Carter had founded Quilters Unlimited of Northern Virginia in order to create a quilting community for those individuals desiring to quilt together, as

well as to offer classes for those who wanted to increase their skills. QU would one day grow into an eleven-chapter, 1,400-member, nonprofit organization that would not only offer classes, but would spread good will throughout the greater community by making and donating thousands of quilts to hospitalized children, foster care children, seniors in long-term care facilities, and victims of natural disasters. This was grassroots America in action. Quilters coming together to make things happen.

As the then-small group continued to discuss the approaching bicentennial, an idea began to form in Hazel's mind. Her vision was of a giant quilting bee where hundreds of quilters could come together in one place to learn, share, and shop. That dream came to fruition in 1978, when she founded yet another organization: the Continental Quilting Congress, an educational nonprofit entity based in Vienna, Virginia. It was one of the earliest quilt conferences in the nation, where quilters got together to learn the art and craft of quilting from Beginner to Advanced, to participate in a Show and Tell, and to shop at a Quilters Merchant Mall set up just for quiltmakers and their specialized needs. Such conferences would quickly prove to be one of the great revolutionary movements of twentieth-century quilting history.

The first Continental Quilting Congress convention in July 1978 brought more than five hundred "delegates" to the Sheraton Hotel in Arlington, Virginia, with additional shoppers raising the final attendance total to more than one thousand quilt enthusiasts gathered under that first hotel roof. Husbands and families of quilters across the country were in shock. What had suddenly come over their wives and mothers? Why were they headed for Arlington, Virginia? Why in the world would a wife/mother/sister/sweetheart pay money to stay in a hotel (sometimes five to a room) just to quilt? Couldn't she do that at home? Women had been quilting for generations without going to all that expense and trouble!

Hazel tells stories of quilters who had never spent a night away from their families in their lives, suddenly hitting the road with a quilt friend and discovering new dimensions to freedom and self-expression. Perhaps it is hard for us to contemplate today just how revolutionary this idea was for quilters at the time, but most quilting had traditionally been done at home

WHITE DOGWOOD DETAIL
In 1911, Marie Webster started a mail-order business to fulfill the demand for her popular patterns. This White Dogwood design was copyrighted that same year. (Courtesy of Rosalind Webster Perry)

or in church groups, with relatives or friends teaching the "how-tos"—not a stranger in a hotel! Freedom was in the air for women in the 1970s. Freedom was in the air for quilting in 1978. Ten Continental Quilting Congresses were held over a thirteen-year period, as well as five overseas tours to meet with quilters around the world and learn of quilting in other cultures: Australia, Japan, China, New Zealand, Great Britain, Scotland, and Ireland.

In 1979, a milestone occurred at the Continental Quilting Congress. As Hazel digested all the comments and feedback she had received from that first CQC meeting in 1978, she realized another need existed in the quilt world that was not being met: the need to bring to the attention of her delegates the work of previous generations of quilters and to recognize and

"COUNTRY KITCHEN"
Quilts were once confined to domestic spheres, but today groups like the Quilters Hall of Fame recognize them as important parts of our history. (Artwork © Doug Knutson/Apple Creek Publishing)

POPPY QUILT
Marie Webster was an extremely influential quilt designer in the early twentieth century. Her design for this Poppy quilt was copyrighted in 1909. (Courtesy of Rosalind Webster Perry)

praise the individuals of the present day who were bringing the story of quilting to the fore. Many delegates appeared to be ignorant about the history of their quilting heritage, the art form and craft they obviously loved with some passion. How could this be remedied?

After careful exploration and discussion with her fellow quilters, Hazel's insightful solution was the creation of the Quilters Hall of Fame. The souvenir book for that first induction ceremony in 1979 stated, "The Quilters Hall of Fame has been established to recognize the people behind the quilting renaissance, to pay tribute to their accomplishments, and thereby establish documentation of an important part of quilting history." A selection committee was formed from a cross-section of the quilting community to study nominations for future Honorees. That first committee consisted of: Mary Graunbaum (TX), Rachel Maines (PA), Bets Ramsey (TN), Joyce Gross (CA) and Isobel Ann Smith (Canada).

Immediately after the announcement of the first Honorees in 1979, the nominations began to pour in.

In the early years, each new Honoree was recognized at a special luncheon at CQC and a souvenir booklet prepared that gave a brief history of the contributions of that year's Honoree(s). Sometimes the award came posthumously: Dr. William Rush Dunton, Jr., Ruth Ebright Finley, Lenice Ingram Bacon, Anne Orr, Florence Peto, Bertha Stenge, Carrie A. Hall, Rose G. Kretsinger. At other times Honorees were present for the ceremony: Marguerite Ickis, Gail van der Hoof, Jonathan Holstein, Grace Synder (unable to travel due to poor health), Jean Ray Laury, Bonnie Leman (unable to travel at last minute due to emergency), Cuesta Benberry, Mary Barton, Jinny Beyer, Patsy Orlofsky, Jeffrey Gutcheon, Carter Houck, Donna Wilder. And so the tradition would continue.

With each new Honoree, the CQC delegates' understanding of their quilt heritage expanded, and word of the Quilters Hall of Fame began to migrate beyond the bounds of CQC into the larger quilt world. Indeed, many changes occurred in the quilting community almost simultaneously with that first 1978 CQC gathering: Bonnie Leman (1982 Honoree), founder

Marie Webster, Pioneer of Twentieth-Century Quilting History

Born in Wabash, Indiana, Marie Daugherty Webster (1859–1956) had many advantages in life, but her dream of a college education was thwarted because her family felt she was too frail for the rigors of such studies due to a "mysterious 'eye disease,' which later was diagnosed as severe hay fever. Ironically, apart from her allergies, Marie proved to be anything but frail," writes granddaughter Rosalind in her updated version of Marie's 1915 book, *Quilts: Their Story and How to Make Them*, "and she lived to be 97!"

With college out of the question, Marie accepted the challenge of educating herself through her voracious love of books and later, after she married George Webster, a young businessman in nearby Marion, furthered her education through travels to Europe. Like most women of her era and station, she had a strong grounding in the needlearts, but her own unique artistic bent would bring her fame in an era when few women knew such individual national acclaim.

It wasn't until she turned fifty that Marie began making quilts using her own designs, which drew strong inspiration from her beloved flower gardens and the Arts and Crafts movement of the early 1900s. Her friends exclaimed over her stunning interpretation of the traditional Rose of Sharon pattern, strongly urging her to submit it to the editors of *Ladies' Home Journal*, then the most widely circulated women's magazine in the nation. Marie eventually acceded to her friends urging, and the rest, so to speak, is history.

In 1910, *Ladies' Home Journal* had added color to their fashion and needlework pages, the first magazine in the industry to do so, and in January 1911, they published four of Marie's quilts in full color: Pink Rose, Snowflake, Iris, and Wind-Blown Tulip. The impact of those published quilt photos created a sensation in the quilting world of the time, and another new era in Marie's life began: Marie the businesswoman.

In addition to creating her own pattern business, Marie was approached by Doubleday in 1912 to write a book on the history of quilting, one that would appeal to "a general audience as well as needlewomen and collectors of antiques," writes granddaughter Rosalind. *Quilts: Their Story And How to Make Them*, the first book ever written solely dedicated to the history of quilts, was published in 1915 and is a must-read for any quilt lover.

Marie Webster, 1905. (Courtesy of Rosalind Webster Perry)

*Quotes concerning Marie Webster's life are from the new edition of *Quilts: Their Story And How to Make Them* by Marie D. Webster, with a biography of the author by Rosalind Webster Perry. Santa Barbara, CA: Practical Patchwork, 1990.

and editor of *Quilter's Newsletter Magazine* in 1969, helped compile and write the standard rules on judging quilt shows in 1976; Joyce Gross (1996 Honoree) of Mill Valley, California, began publishing *Quilters Journal* in 1977; Quilt National in Athens, Ohio, was founded in 1979 by Nancy Crow and friends (1997 Honoree); International Quilt Market was founded in 1979 by Karey Bresenhan (1995 Honoree) of Houston, Texas; Barbara Brackman (2001 Honoree) self-published the first version of her quilt pattern dictionary, also in 1979, which would prove to be the guiding star of many of the State Documentation Projects to follow; in 1980, the American Quilt Study Group (AQSG) was formed by Sally Garroute (1994 Honoree) in Mill Valley, California, to promote and publish serious research in quilt history; and North Carolina Public Television produced its first-ever televised "how-to" series in 1980 featuring quilt teacher Georgia Bonesteel (2003 Honoree). This gives you just a little taste of the incredibly fertile, productive period in quilt history immediately before and following the bicentennial in 1976.

Dreams often converge in serendipitous ways that can change the landscape of one's own vision. In July 1991, two dreams merged at the West Coast Quilters Conference in Sacramento, California: Hazel Carter's vision for the Quilters Hall of Fame and Rosalind Webster Perry's vision concerning the legacy of her grandmother, early twentieth-century author and quilt entrepreneur Marie Webster. When Hazel and Rosalind met, the former was inducting the 1991 Honoree, Marie Webster, into the Quilters Hall of Fame, and the latter was present to receive that honor in her grandmother's name. Their paths most likely would not have crossed in life otherwise.

A most unexpected event took place at that ceremony. Within thirty minutes of their meeting, Rosalind—who had only months earlier rescued her grandmother's Marion, Indiana, home from demolition—asked Hazel if she would like to use the house as the permanent home of the Quilters Hall of Fame. With Hazel's fearless "yes," a whole new chapter in quilt history began.

How does one create a museum out of a condemned building? With lots of elbow grease! Grassroots America swung into action once again. Hazel first took her dream to the delegates of the Continental Quilting Congress while Rosalind approached the citizens

QUILTING QUARTET
In their January 1, 1911, issue, Ladies' Home Journal *featured four of Marie Webster's original designs. They include the Pink Rose, Snowflake, Iris, and Wind-Blown Tulip quilts. (Courtesy of Rosalind Webster Perry)*

of Marion via an article in the local paper. A core group emerged out of those first efforts that has been the backbone of the restoration of the Marie Webster House all these many years. Eventually the Marion group would officially organize as the Friends of the Quilters Hall of Fame and welcome members from all over the world.

The Quilters Hall of Fame became an independent nonprofit organization in 1992 with a Board separate from its original parent, the Continental Quilters Congress. The significance of the Marie Webster House was officially recognized in 1993, when it was placed on the National Register of Historic Places and the Indiana Register of Historic Sites and Structures. It has also been designated a Landmark of Women's History and declared a National Historic Landmark by the National Park Service—the only one which honors a quiltmaker! In 1992 Amy Emms, M.B.E. (Member of the British Empire, designating an award

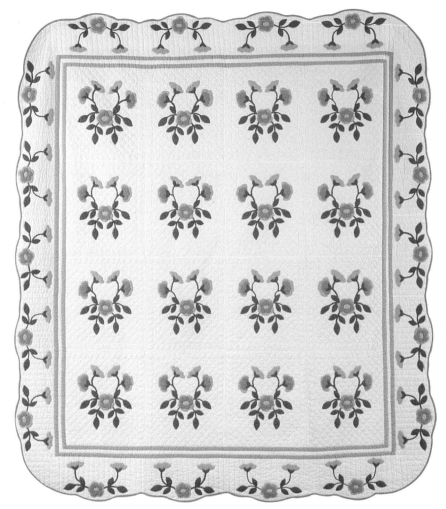

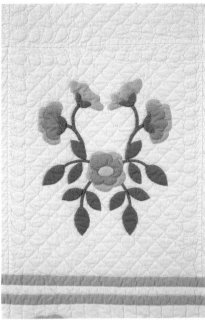

WAYSIDE ROSES QUILT AND DETAIL
This example of Marie Webster's Wayside Roses design was made by the Baltimore Appliqué Society for the Quilters Hall of Fame in 2000. Webster copyrighted the pattern in 1926. (Courtesy of Rosalind Webster Perry)

given by the Queen for "her service to quilting") was the first Honoree to be inducted into the Quilters Hall of Fame from its new location in Marion, Indiana.

The Friends of the Quilters Hall of Fame (FQHF) have raised and donated over $30,000 through their own local Marion efforts of organizing opportunity quilts, bake sales, merchandise sales, and the fees from the annual Celebration seminar. In addition, more dollars have been garnered from quilters around the world. QHF has also been awarded donations from national quilt-related organizations, as well as the Build Indiana Fund, the Indiana Department of Commerce, and Grant County businesses and community groups. But it's the countless volunteer hours of core Marion people like Phebe Smith, Debi and Scott Shepler, Madonna and Richard Fowler, Jean and Rex Chambers, Sue and Bill Munn, Sharon Felty, Cindy Beck, Mary and Norman Cheek, Julie Spangler, Elinor Briggs, Marguerite Cox, Jean Strawser, Carolyn Goebel, and

many more like them that is the real success story. Raising money was an uphill battle every step of the way, as it often is for such dreams, but they kept their shoulders to the wheel and didn't give up. This is grassroots America at its best.

The fulfillment of each step of this vision is reminiscent of the teamwork exhibited by Hazel Carter and her family when they made their bicentennial quilt those many years ago. Following generations of tradition, these modern-day quilters and their friends came together to plan and organize, piece their patch, and add their stitches to help create a glorious finished product: the Quilters Hall of Fame Museum.

[1] Orlofsky, Patsy and Myron. *Quilts in America*. New York: McGraw-Hill, 1974.
Other Sources: Archives of the Continental Quilting Congress and phone interviews with Hazel Carter and Rosalind Webster Perry in February 2003.

Quilters Hall of Fame Honorees

Lenice Ingram Bacon (1895–1978), 1979
> Quilter, collector, lecturer, author of *American Patchwork Quilts*

Mary Barton, 1984
> Collector, donor of quilts, fabrics, and periodicals, playwright, award-winning quilter

Cuesta Benberry, 1983
> Historian, author of *Always There: The African-American Presence in American Quilts*

Shiela Betterton, 1999
> Author, researcher, curator of textiles at the American Museum in Britain

Jinny Beyer, 1984
> Quilter, pattern and fabric designer, teacher, author of *Medallion Quilts*

Georgia Bonesteel, 2003
> Entrepreneur, teacher, host of *Lap Quilting with Georgia Bonesteel*, quiltmaker, author

Barbara Brackman, 2001
> Researcher, teacher, quiltmaker, author of *Clues in the Calico*

Karey Bresenhan, 1995
> Founder of Quilts, Inc. and the International Quilt Festival & Market, author, collector

Averil Colby (1900–1983), 1980
> English quilter, lecturer, author of *Patchwork*, *Patchwork Quilts*, and *Quilting*

Nancy Crow, 1997
> Contemporary quilt artist, quilt surface designer, author, instrumental in founding Quilt National

William R. Dunton, Jr. (1868–1966), 1979
> Collector, researched and popularized Baltimore Album quilts, author of *Old Quilts*

Amy Emms, M.B.E. (1904–1998), 1992
> English quilter, teacher, author, revived Durham quilting in England

Ruth Ebright Finley (1884–1955), 1979
> Collector, author of *Old Patchwork Quilts and the Women Who Made Them*

Sally Garoutte (1925–1989), 1994
> Historian, founder of the American Quilt Study Group, textile editor of *Quilters' Journal*

Joyce Gross, 1996
> Quilt historian, archivist, collector, founder and publisher of *Quilters' Journal*

Jeffrey Gutcheon, 1990
> Designer, originator of American Classic Line, author of *Diamond Patchwork*

Carrie A. Hall (1866–1955), 1985
> Collector, quilter, co-author of *The Romance of the Patchwork Quilt*

Jonathan Holstein, 1979
> Collector, author, co-organizer of the 1971 Whitney Museum Exhibit *Abstract Design in American Quilts*

Carter Houck, 1990
> Pattern maker, designer, editor of *Ladies Circle Patchwork Quilts*, author

Marguerite Ickis (1897–1980), 1979
> Quilter, author of *The Standard Book of Quiltmaking and Collecting*

Michael James, 1993
> Internationally known contemporary quilt artist, author of *The Quiltmaker's Handbook*

Rose G. Kretsinger (1886–1963), 1985
> Quilt designer, appliqué artist, co-author of *The Romance of the Patchwork Quilt*

Jean Ray Laury, 1982
> Pioneer contemporary quilt and textile designer, teacher, author of *Applique Stitchery*

Bonnie Leman, 1982
> Founder and editor of *Quilter's Newsletter Magazine*, author, collector

Ruby Short McKim (1891–1976), 2002
> Pattern designer, entrepreneur, author of *101 Patchwork Patterns*

Patsy Orlofsky, 1987
> Conservator, director, Textile Conservation Workshop, co-author of *Quilts in America*

Anne Orr (1875–1946), 1980
> Pattern designer, magazine editor, founder of Anne Orr Studio

Florence Peto (1884–1970), 1980
> Quilter, collector, author of *Historic Quilts*, museum benefactor

Yvonne Porcella, 1998

Quilt and fabric artist, teacher, author, founder of the Studio Art Quilt Associates

Grace Snyder (1882–1982), 1980

Award-winning quilter, co-author of *No Time on My Hands*

Bertha Stenge (1891–1957), 1980

Known as the "Chicago Quilting Queen," award-winning quilter

Gail van der Hoof, 1979

Collector, preservationist, Whitney exhibit organizer with Jonathan Holstein

Marie D. Webster (1859–1956), 1991

Appliqué quilt designer, author, founder of Practical Patchwork Company

Donna Wilder, 1990

Juror in major quilt shows, merchandiser and promoter of quilting, author

Source: Archives of the Quilters Hall of Fame

Above, top: *Rose Kretsinger, 1985 Honoree. (Courtesy of Karen Biedler Alexander)*

Above, bottom: *Ruth Finley, 1979 Honoree. (Courtesy of Karen Biedler Alexander)*

Carrie Hall, 1985 Honoree. (Courtesy of Karen Biedler Alexander)

Quilting Outlaw

By Lisa Boyer

WHO SAYS YOU have to follow the rules when it comes to quilting? Lisa Boyer dares you to be a quilting outlaw, turn a deaf ear to the "Quilt Police," and follow your heart and imagination instead.

Lisa's humorous essays appear in *Quilting Today* magazine and have been collected in the book *That Dorky Homemade Look: Quilting Lessons from a Parallel Universe*. She lives on the Hawaiian island of Kauai where she is a quilter, pattern designer, sewing-machine mechanic, quilt teacher, writer, and mother. Her quilts have appeared in *Quilting Today*, *Miniature Quilts*, and *Kauai* magazines.

Let me start out by saying that I am basically a good, law-abiding citizen. I firmly believe in a set of written laws that allows us to live together peacefully in society. I pay my taxes, drive the speed limit, and do not take more than my share of the little round soup crackers from the restaurant basket. I don't even take the hotel shampoo home with me.

But I have a dark confession to make: when it comes to quilting, I am an uncivilized barbarian, an unrepentant renegade. I follow no rules. I am a quilting outlaw. Color wheel? Ha! I laugh at the laws of physics. Perfectly pointy points? Who needs 'em? Tiny little micro-stitches? Don't even think about it. (Note: To be really effective, these last few sentences need to be said aloud in your best Clint Eastwood impersonation.)

It isn't that I can't follow these rules. I just don't understand why they exist in the first place. Who made such rules, anyway? Why do we consider some characteristics of a quilt admirable and others detestable? (I'm sure someone has probably written a book on this somewhere, but I'm too lazy to read it, and facts would only confuse my opinion anyway.) I'm sure these rules came about when quilting was considered "only" a craft and not an art form. But now that we have come to appreciate quilts as art, let's pay them the ultimate homage and drop the rules. Imagine telling Van Gogh that his Sunflowers were not pointy enough! No wonder artists go mad. Liberate quilts from the tyranny of standards! Let them be free from artificial constraints!

But wait. Before you grab your picket sign and write your congressperson, I'm talking about this revolution on a personal level, in your own sewing room. Do you follow the rules because you like the

results, or do you follow the rules because you are afraid of the Quilt Police? Oh, you know who I mean. They're everywhere, in your guilds and mini-groups. They're the silent types with the pursed lips and the disdainful looks. As a matter of fact, at this very moment, they are convened in a secret session to discuss that wonky seam in your last quilt.

Do you quilt to please them? Are you afraid to bring an imperfect work to show because someone may whisper about your set-in corners? Don't be afraid! The Quilt Police are imaginary! The overwhelming majority of your fellow quilters are loving and accepting and feel very honored that you bring your work to share. They cherish your imagination, not your six-way seams.

Consider the following situations. What if I told you that I would give you a quilt that is technically perfect in every way? It has 3,000 pointy points, is quilted 24 stitches to the inch, and has an incredible 4,000 tiny stuffed berries on the surface. It hangs straight and true and it has won several awards, and I am going to give it to you to hang in your living room. Sound good? It's yours.

Too bad it won those awards in 1970 and is constructed from burnt orange, avocado green, and earth-brown, polyester double-knit fabric. (It was made from the discarded leisure suits of aluminum siding salesmen.) Will you still hang it in a place of honor in your living room?

On the other hand, imagine being a slave in the days before the Civil War. You have only homespun scraps, rusty scissors, thread salvaged from your master's old clothing, and no straight-edge to boot. You make a quilt that, 100 years later, becomes a national treasure and hangs in a museum, worshiped by millions. Now, who followed the rules and who didn't? Did the rules matter?

Rules are temporal and fleeting; time itself forgives violations of the Quilt Penal Codes. Amnesty is eventually bestowed on even the lowliest. Brace yourself: future quilt museums could be full of yarn-tied polyester comforters because, we all know, they will never biodegrade.

So, where did I put the point of this narrative anyway? Oh, here it is: enjoy the process. Don't worry about judgments, and realize that the rules are something you can embrace or reject at will, whatever suits you. Quilting styles, fabric colors, opinions, and rules change with time. The only truly lasting thing in a quilt is the love you sew into it.

As for me, I love to torment the Quilt Police every chance I get. I guess there's no hope for incorrigibles like me. I'll probably end up in Quilt Jail someday, being forced to stuff tiny little harvest-gold polyester berries for the rest of my life. Come to think of it, I may just turn myself in—I hear that I'm wanted by the Cooking Police. Talk about cruel and unusual punishment . . .

HAPPINESS IS QUILTING
Above all, quilts should bring people joy. The tulip quilt featured on the cover of this 1960s pattern booklet seems to have pleased its maker.

STITCHES FOR THE SOUL
Artist Dennis McGregor created this carefree image for the 2003 Sisters Outdoor Quilt Show, in Sisters, Oregon. The event is the largest outdoor quilt show in the world. (Artwork © Dennis McGregor)

"AUTUMN JOY"
Facing page: *Quilting is a pastime for all seasons. Here, artist Diane Phalen has painted the golden colors of fall.* (*Artwork © Diane Phalen*)

A QUILTER'S INGENUITY
Above: *Look closely to see the circles and stars formed by the ties of this African-American quilt. Made from cotton circa 1920, it measures 73 by 68 inches. (Stella Rubin Antiques, photograph by Harriet Wise)*

RENEGADE QUILTER
This quilt's original design resembles a Snail's Trail pattern. The black, yellow, and red quilt was made in Arkansas circa 1940 and measures 72 by 84 inches. (Stella Rubin Antiques)

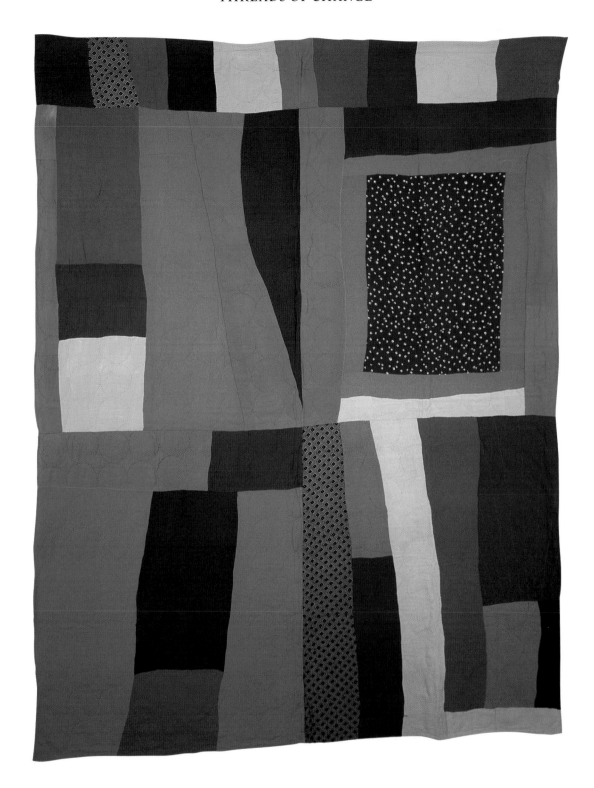

QUILTS WITHOUT BOUNDARIES
Large blocks of color and quilting done in small circles make this African-American quilt an original. It was made in Maryland circa 1930 and measures 91 by 72 inches. (Stella Rubin Antiques, photograph by Harriet Wise)

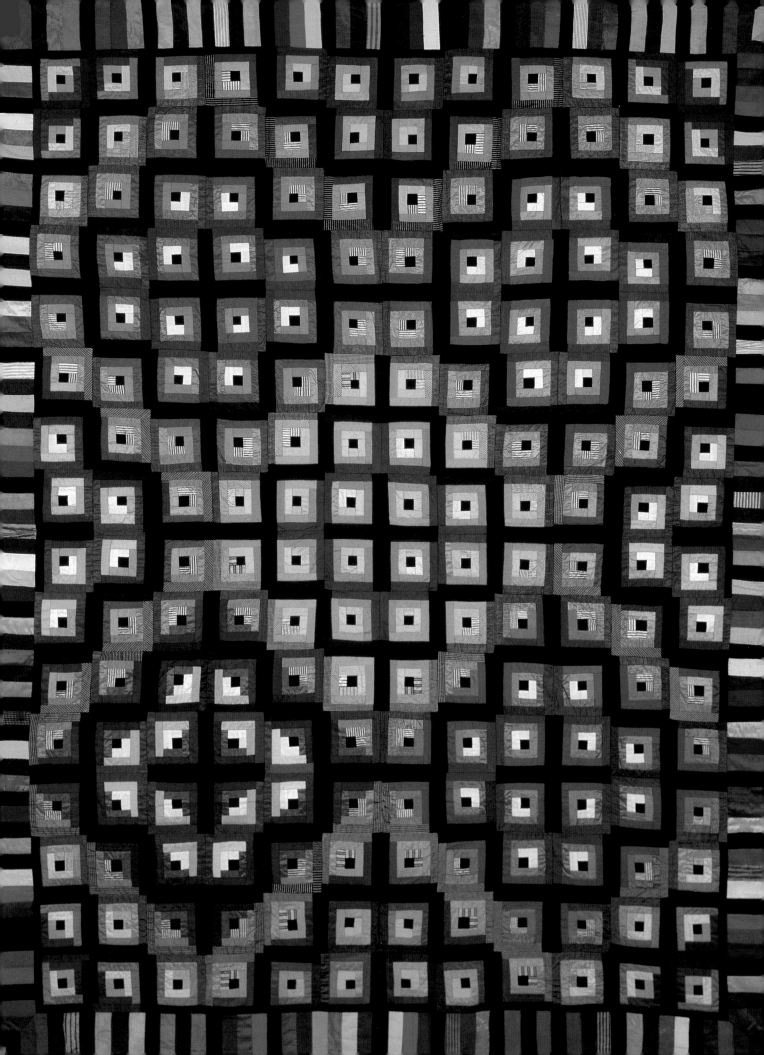

Quilts as Women's Art

By Shelly Zegart

QUILTS WERE ONCE considered everyday, utilitarian objects made to ward off frostbite on winter nights. When and how did these handmade objects become celebrated works of art?

Shelly Zegart of Louisville, Kentucky, explores the long journey that transported quilts from bedrooms and cedar chests to the walls of prestigious museums. Shelly is a recognized expert on American quilts. She has curated many exhibits in the United States and abroad and lectures on all aspects of quilt history and aesthetics. She was a founder of the Kentucky Quilt Project, serves as president of the board of the Alliance for American Quilts, is a member of the Appraisers Association of America, and is the author of *American Quilt Collections: Antique Quilt Masterpieces.*

MODERN ART
Although this silk Light and Dark variation of the Log Cabin pattern looks as though it could have been made in the twenty-first century, it was actually made in Maine circa 1870. The quilt measures 72 by 56 inches. (Stella Rubin Antiques, photograph by Harriet Wise)

In 1907, Eliza Calvert Hall published a best-selling collection of short stories titled *Aunt Jane of Kentucky.* The central character of these stories, Jane Parrish, became one of the nation's most unlikely national folk heroines: an elderly, female, nineteenth-century quilter. What an extraordinary person for Americans to pay homage to—this old quilter whose meditations on life center around women's domestic activities. Certainly, Aunt Jane was neither a suffragette nor a Seven Sisters graduate from the Northeast. She was a folksy, calico-dressed, bespectacled Kentucky woman percolating with stories about quilts. She mused,

> "I've always had the name of being a good housekeeper, but when I'm dead and gone there ain't anybody going to think of the floors I've swept and the tables I've scrubbed, and the old clothes I've patched, and the stockings I've darned. But when one of my grandchildren or great-grandchildren sees one of these quilts, they'll think 'bout Aunt Jane and I'll know I ain't forgotten".[1]

Her clever storytelling, often inspired by and woven around one of her quilts, abounds with universal themes such as death, love, and family, and provides insight into how women claimed immortality when they were disallowed from rights such as drawing up their own will. The women reading this novel identified with the Aunt Jane of Kentucky in themselves—the creative souls bound to undervalued domestic roles within their own families, silently stitching themselves into their quilts.

THE HUMAN QUILT
Think of this as a quilter's version of performance art. On July 7, 2000, 891 people came together to hold fabric over their heads, creating the "Human Quilt" in celebration of the Sisters Outdoor Quilt Show's twenty-fifth anniversary. (Photograph © Dennis McGregor)

The overwhelming success of *Aunt Jane of Kentucky* suggests that the seeds of seeing quilts as more than utilitarian objects, perhaps even as art, were planted very early in America. But when did the magical schism occur, when quilts became valued as art, and why did it happen?

It is unlikely that any woman of nineteenth-century America, such as Aunt Jane, would have described a quilt she created as a work of art or as a masterpiece. Though many quilts were coveted by their makers, social conventions of modesty forbade public praise for material objects and inhibited expressions of pride. Sadly reflected in the paucity of written information—such as diaries, where women might have voiced some feeling about their quilts—comments by quiltmakers focus more on descriptions of their work.[2]

Social reform throughout the last half of the nineteenth century provided women with ample opportunities to quilt together and collectively recognize and admire each other's work. While their artistry played second fiddle to their altruism, quilts were associated

with the full range of women's social reform activities, including abolition, Civil War relief, fund raising, missionary work, and temperance. Beginning in the 1830s, this further increased public visibility of quilts—though not as objects of art, but as community focal points for salient political and social issues. Quilts of this type are some of the earliest examples of American public art. The groundwork was laid during this period for today's commemorative and socially fueled quilts, such as the AIDS quilt and the quilts made to honor those who perished and to comfort those who survived the horrific events of September 11, 2001, in New York, Washington D.C., and western Pennsylvania.

Dramatic and far-reaching changes in technology influenced quiltmaking in the second half of the nineteenth century. The availability of the sewing machine combined with an expanded range of fabric choices launched an era of creativity and invention in the last quarter of the nineteenth century so remarkable that many see the period as the Golden Age of American

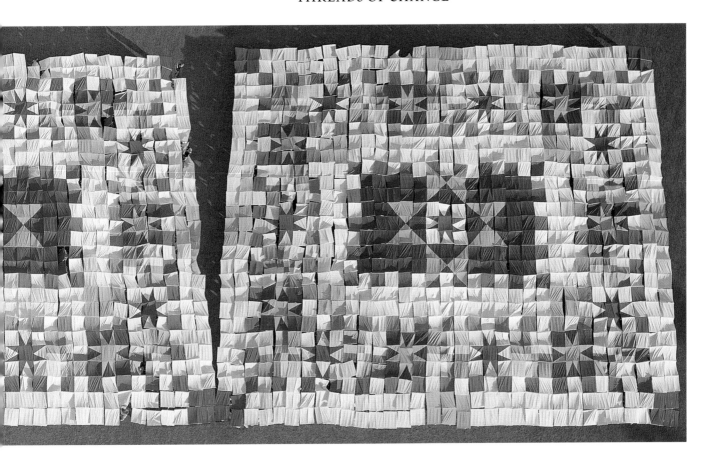

quiltmaking. As America became a world power, so too American quiltmaking became one of this country's greatest artistic achievements.

During and after the Civil War, fabric was particularly scarce and difficult to acquire in the conquered South, and means were exceedingly limited. Habits acquired during periods of scarcity and economic depression are longstanding. Even today some quiltmakers, who can afford to buy new material, prefer to mix and jumble their fabrics in a way that harkens back 150 years. Improvisation has always had a useful place in the making of quilts—to expand a border, finish a pattern, or make creative use of remnants of worn out leg backs and dresses. We now see these improvisatory quilts from a different perspective. They remind us of Picasso, Braque, Matisse, and Mondrian. As our value system has changed for evaluating "art," appreciation for these types of quilts has blossomed.

The Centennial Exposition in Philadelphia in 1876 attracted nearly ten million visitors. Hundreds of quilts were exhibited, and women realized that quilts were a connecting thread among them. Never before had so many women gathered together to admire one another's work on such a grand scale. It was also at this exposition that Japanese culture was first intro-

duced to the American public, and we quickly became fascinated with Asian art and culture. Crazy quilts reflect that fascination. The Crazy became the first type of quilt made solely for decoration—in effect the first "art quilt."

By the beginning of the twentieth century, quilts were considered old-fashioned and were associated with an earlier, more rural America. Most of the women who could do so bought their bed coverings in stores. In contrast, rural and poor women throughout the country were by necessity forced to continue to make quilts, improvising with their available fabric and thread. Particularly within culturally isolated groups, such as rural Kentuckians and African-Americans, quilting remained a highly valued activity. Quilts produced by these groups are some of the freshest and most creative examples of that era in terms of color and design.

The Colonial Revival that began in the 1920s championed and popularized the early American look in home decorating. The first broad public stirrings in scholarly and collector interest in American antiques and folk art began. *The Magazine Antiques* published its first issue in 1922, and the Metropolitan Museum of Art in New York opened its American Wing in 1924.

Quilts lagged behind other American textiles in getting attention from collectors and scholars, and no quilts were included in the seminal folk art shows of the 1930s. A few pioneering collectors began to collect outstanding quilts in the '30s, however. By far the most important early quilt collector was Electra Havemeyer Webb who later founded the Shelburne Museum in Vermont.

In the downward turn toward the Depression, the quiltmaker's sewing prowess became legendary. This was a period of intense interest in commercial quilt patterns and kits. Quiltmaking was revived for very practical reasons—it was a way to make money. Cottage industries located mostly in the Midwest proudly advertised their quilts for sale. Homemakers' organizations, agricultural extension agencies, and quilting cooperatives all contributed to the quilting frenzy. While most Americans quilted to save money during the Great Depression, some quiltmakers prospered as commercialism and mass marketing broadened public interest in their quilts. As their pockets filled with money, other quiltmakers, even those not involved with cottage industries, held themselves to a higher standard of craftsmanship and artistry. The Chicago World's Fair, in 1933, was the site of the largest quilt show ever held. In the midst of the Great Depression, more than 25,000 people submitted quilts to local and regional contests around the country.

The seeds of the Art Quilt movement had begun in the nineteenth century with William Morris and the development of the Arts and Crafts movement. Americans were inspired to investigate their own forgotten handcraft traditions just in time to save many from extinction. Weaving was the only textile discipline taught in most art schools because it had commercial applications. Fiber arts were elevated largely because of the influences of the German Bauhaus School founded in 1919. As World War II loomed, many of the Bauhaus disciples found refuge in the United States. Fortunately for the South, a number of artists came to North Carolina and founded Black Mountain College, which was operational from 1933 to 1956. Annie Albers, a gifted weaver, came to Black Mountain, North Carolina. Her work was considered an art form. Woven hangings went on the walls long before quilts, and paper collage had been explored forty years earlier by Braque, Picasso, and others.[3] The quilt, which can be viewed as fabric collage, now had the potential for artistic recognition.

ELEGANT LADIES
The May 1914 issue of The Modern Priscilla *features an artful quilt and two refined women on its cover.*

In the 1960s, the counterculture rejected the status quo and, in an effort to search for basic American values and ways to live, looked back to earlier times. Traditional American crafts and folk arts were studied closely—many of them for the first time. The women's movement began calling attention to inequities in opportunities offered to women artists. With the nation's bicentennial on the horizon, the greatest and most sustained revival of all was gathering force. Quilts were about to become one of the key threads that would tie together American women's search for the past and hopes for the future.

In 1965, at the height of the op art craze, the Newark Museum mounted an exhibition called Optical Quilts, and a review called it "op art" from prior centuries. Quilts were now on a vertical plane—looked at as abstract art. In 1969, an exhibit called *Objects USA*, a monumental collection of fine contemporary American crafts, was assembled and traveled by S. C. Johnson and Sons of Racine, Wisconsin. For the first time, artists and the public had the opportunity to see works by well known fiber artists.

For the rest of the country and around the world it was the exhibition, *Abstract Design in American Quilts*, which opened in July 1971 at the Whitney Museum of American Art in New York and was curated

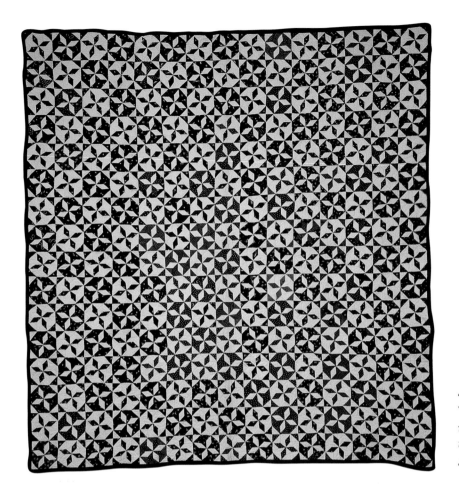

POSITIVE AND NEGATIVE STARS
This quilt is a study in minimalism. It was made circa 1880 and measures 76 by 72 inches. (Stella Rubin Antiques, photograph by Harriet Wise)

by Jonathan Holstein and Gail van der Hoof, that was pivotal. Quilts chosen only for their aesthetics were shown on the walls of a major art museum in New York City for the first time. The exhibition served as an inspiration to many quilt artists and gave respect to the quilt as an art object. The effect was monumental. It was during this time period that quilt exhibitions and dealers developed in earnest. Dozens of great collections, public and private, were also formed and the Art Quilt Movement gathered steam.

The world of today's quiltmaker is infinitely wider than that of her nineteenth-century predecessors, and contemporary quilt artists take full advantage of its richness. Studio quiltmakers draw on a variety of sources in their search for personal expression, but the quilt is their starting point—the basic structure on which they build.

Quilts that qualify as masterpieces of visual art can be found throughout history in every stylistic category and regional tradition. All are part of the rich heritage of American quiltmaking, and all have helped to pave the way for the art quilt. They form a timeless continuum of artistic excellence that challenges

today's quilt artists to rise to the level of their predecessors' ingenuity and expressive capability.

And so we return to the heroine of our story, Aunt Jane of Kentucky, who says it best:

"Patchwork? Ah, no! It was memory, imagination, history, biography, joy, sorrow, philosophy, religion, romance, realism, life, love, and death; and over all, like a halo, the love of the artist for his work, and the soul's longing for earthly immortality."[4]

[1] Hall, Eliza Calvert. *Aunt Jane of Kentucky*. Lexington, Kentucky: The University Press of Kentucky, 1995 print of 1898 and 1908 edition, p. 78.
[2] Oliver, Celia. "Value in the Eye of the Maker: Masterpiece Quilts in Nineteenth Century America" foreword of *American Quilt Collection: Antique Quilt Masterpieces*. Tokyo: Nihon Vogue, 1997, p. 6.
[3] Ramsey, Bets. "Art and Quilts". *Uncoverings*, Vol.14, ed. Laurel Horton. San Francisco, California: American Quilt Study Group, 1993.
[4] Hall, Eliza Calvert. *Aunt Jane of Kentucky*. Kentucky: The University Press of Kentucky, 1995 reprint of 1898 and 1908 edition, p. 82.

The Sewing Machine Revolution

When the sewing machine was made available to the general public in the late 1850s, a new era in quilting began. Innumerable hours were saved by the quick stitchery of the miracle machines, and over the years companies like Singer, White, and New Home promoted them as the key to a quilter's bliss. Even the devil liked to sew when he had a treadle sewing machine to help him!

H. L. FERGUSON,
207 W. 4th St., WILLIAMSPORT, PA.

NEW HOME DREAM

NEW HOME
SEWING MACHINE CO.
ORANGE, MASS.
30 UNION SQUARE, N.Y.

STRAIGHT FURROWS
This luxurious and colorful quilt is constructed from strips of satin. It was made circa 1890 and measures 69 by 78 inches. (Stella Rubin Antiques, photograph by Harriet Wise)

BRIGHT HOPES
Karen Kay Buckley of Carlisle, Pennsylvania, utilized hand appliqué and machine quilting to complete this masterpiece quilt. The pattern was inspired by an antique damask design, and the finished quilt measures 88 by 88 inches. (Photo by Melissa Karlin Mahoney, courtesy of Quilter's Newsletter Magazine)

QUILTS EVERLASTING

"It was not a woman's desire . . . to be forgotten. And in one simple, unpretentious way, she created a medium that would outlive even many of her husband's houses, barns and fences; she signed her name in friendship onto cloth and, in her own way, cried out, Remember me."
Linda Otto Lipset, Remember Me, 1985

Although quilts are made with the simple ingredients of fabric, batting, and thread, there is a sense of permanence that permeates their folds. They hold our memories and experiences, our hopes and dreams, our joys and our sorrows—all of which are preserved in the document of the quilt. And when our quilts are passed on to future generations, or a quiltmaker's skills are taught to an eager beginner, the cycle of the quilt continues.

In the end, our love for quilts and their importance in our lives is everlasting.

"EVENING AT GRANDMA'S"
Left: *With a warm fire in the hearth, and a quilt in the making, Grandma and Grandpa's house is the best place to be on a cold night. (Artwork © Judy Wickersham Shauermann)*

BLUE RIBBON QUILTS
Above: *This vintage pattern booklet advises, "It is for us to try to reproduce some of the beautiful examples of an art form that is peculiarly American. Who knows . . . in years to come, age will soften their hues and they may be treasured as family heirlooms by great grandchildren yet to be born."*

Starting from Square One

By Helen Kelley

HELEN KELLEY IS a quiltmaker, lecturer, writer, and instructor based in Minneapolis, Minnesota. Since she bought her first sewing machine—a Singer Featherweight—in 1946, she has made well over one hundred quilts. Her "Renaissance Quilt" was chosen as one of the 100 Best American Quilts of the Twentieth Century. Helen's "Loose Threads" articles have appeared monthly in *Quilter's Newsletter Magazine* for twenty years, and she is also the author of the book *Every Quilt Tells a Story*.

In this essay, Helen recalls passing on her knowledge of quilts to another generation, as her granddaughter first learns the art and craft of quilting.

"FIRE FLIES"
As evening falls and the sky is flushed with pink, fireflies—mirrored in the quilt's pattern—blink their messages across a darkening field. (Artwork © Rebecca Barker, from Rebecca Barker's book Quiltscapes, *published by the American Quilter's Society, 2003)*

My granddaughter asked, "Will you teach me to quilt?" This young woman has talented hands. Even as a small child, she would stitch intricate counted-thread pictures. She knits glorious sweaters, but never has she quilted.

She loves the story about my daughters and their quilting marathon. When they were young, the week after Christmas was always difficult. The excitement of the gift giving was past, the weather too bitter to play outside, and the four restless girls were caged together. That year, each girl's big present was a box filled with five-inch squares of every fabric in my stash, which was considerable, even then.

I challenged each girl to put her own special squares together and make a quilt top, and then we would have a celebration on New Year's Day where I would help them tie their tops into comforters. It was a quiet week. They sorted their colors, played with them, and finally stitched them. On January 1, all four made themselves comforters. Those "quilts" can still be found on the shelves of their closets today.

For her high school graduation present, Else asked for quilt squares like I had given her mother. I filled a box with hundreds of squares of fabric, and periodically over the years, she has taken those squares out, moved them, arranged them, and put them back in their box without sewing them. So when Else married, I gave her a Featherweight sewing machine, a rotary cutter and mat, and some basic quilting supplies. I assumed that she knew what to do with them. Clever enough to figure out the sewing machine on her own, she tried sewing the squares together. But she needed help.

"Else," I asked, "what did they teach you in school?"

"They don't teach sewing in school anymore," she said, "just fashion design."

That announcement took my breath. Sewing is a basic survival skill! Even if you never intend to make clothing, ifs important to know good fabric to know about fading, shrinking, grain line, and good workmanship. Else needed some practical experience.

Lesson I: We met at a mill-ends score so that she could learn how to tell the textile treasures from the trash. Else didn't know the difference between a sateen and a double-knit, between a fine cotton weave and a slippery cotton/polyester blend. We roamed the aisles, turning over heaps of flat-folds and fingering through the fabrics, feeling loose fibers and pasty fillers, looking at weaves and labels, learning about selvedge markings and brand names, searching for flaws and misprints, and, in general, playing with fabric.

Lesson II: Else arrived early. She had her Featherweight machine and her rotary cutter, and I had spread out a rainbow of fabric on the floor. She chose fabrics to make two Four Patches, one by hand, and one by machine. Her intersections were perfect, but her blocks were made in two shades of lavender. They were gentle and sweet, but she needed to learn how to be adventurous. We needed to experiment with color.

Lesson III: We sorted and splashed about in fabrics, making piles of gentle hues, and exciting, clashing, vibrating shades and tints. We looked at paintings by old masters and photographs of the world around us, seeing how the world is made up of a zillion shades of green. She began to "see" color, and she got excited. I got excited.

Lesson IV: Else tells me that she is serious, now. On this day, she cut triangles to piece of lavender and yellow. Quick to learn, she is a little less timid. Her points came together perfectly, and she discovered some important, practical things such as the scary importance of rotary cutter safety. She learned that patchwork can be an everyday, any day, part of our kitchen-table life.

What a renewal for me! I remember the magic and the excitement of the first time I sewed four squares of fabric together. Having met so many sophisticated, experienced quilters, I had forgotten the sweet moments of the first discoveries, but Else has been reaching me. She has given me a gift. I have seen her excitement grow as she has discovered the amazing possibilities that lie in simple shapes and colors and the miracle that our fingers can produce by putting them together. In watching her, and in seeing her find such joy, I have rediscovered quilting.

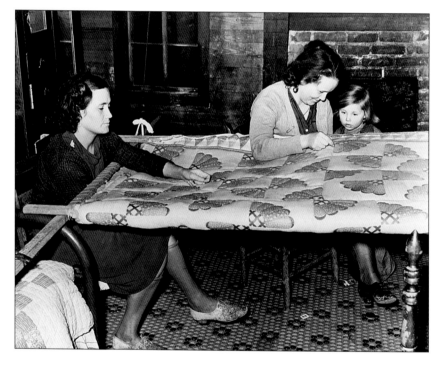

QUILTING LESSON
An aspiring quilter gets her first demonstration at the quilting frame in this vintage photograph from the 1930s. (Library of Congress)

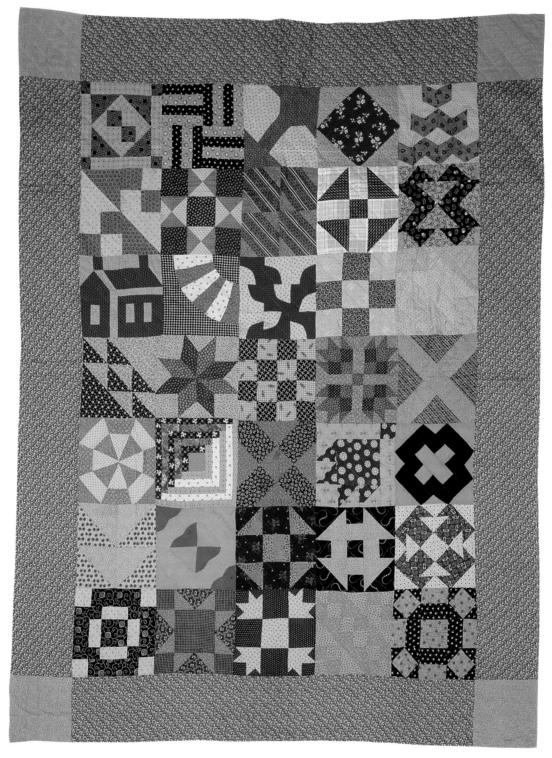

CALICO SAMPLER
A Sampler quilt is often the best way to learn the art of piecing, because it allows the new quilter to learn how to sew many different blocks. This example was made circa 1890 and measures 80 by 60 inches. (Stella Rubin Antiques)

"WHISKERS AND WEDDING RINGS"
The cat on this Double Wedding Ring quilt seems to have a special appreciation for patchwork. (Artwork © Adele Earnshaw)

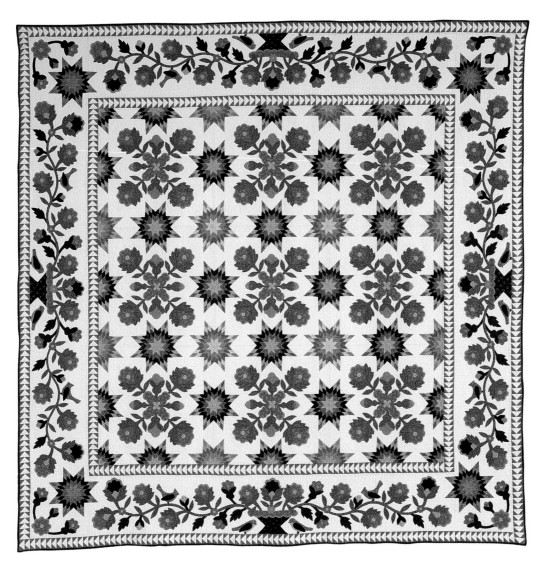

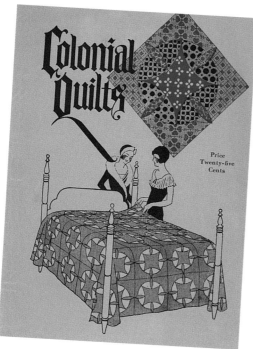

GREAT LAKES STARS AND FLOWERS
Above: *Rita Verroca of Westlake Village, California, used reds, golds, and oranges to suggest an Indian summer by the lakeside. There are over 5,300 pieces in this 96 by 96 inch quilt, which was pieced, appliquéd, and heavily quilted entirely by hand. (Photo by Melissa Karlin Mahoney, courtesy of Quilter's Newsletter Magazine)*

COLONIAL QUILTS
Left: *This pattern booklet from 1933 encourages, "Join the happy throng of women who are finding companionship, peace, contentment, and above all the joy of creating with their own hands a fresh, new quilt of lasting daintiness."*

The Rose and Lily Quilt

By *Elsie Singmaster*

THE DEDICATION AND love that many quilters feel for the patchwork passion makes it impossible to imagine a life without quilting.

In this story, seventy-year-old Grandmother Miller is horrified when her well-meaning but misguided children and grandchildren decide she should live a life of leisure for the rest of her days. This means no baking, sewing, entertaining, or quilting for the perfectly capable woman. In protest, a disgruntled Grandmother Miller marches to the village store and purchases the materials she needs to make a Rose and Lily quilt.

Pennsylvania-born author Elsie Singmaster published hundreds of short stories and thirty-eight books in her forty-year writing career. This piece comes to us from 1913.

QUILTS ARE FOR KIDS
Children often have good intentions, but can easily get into mischief. This little girl is on her best behavior as she poses with the family quilt and the family cat.

Grandmother Miller sat before the fire in her wide kitchen, with her hands clasped in her lap. The kitchen was warm, sunny, and with its plain walls, its rag carpet, and its beautifully carved mahogany dresser, even handsome. A Pennsylvania German kitchen is usually dining-room and sitting-room both. In this house there were many other rooms, but they were closed, and, since it was November, as cold as Greenland. There were other great pieces of furniture, carved like the dresser, and worth a large price from a dealer in antiques, if he had known of them, or if Grandmother Miller could have dreamed for an instant of parting with them.

Grandmother Miller was a picture of beautiful old age. She wore a black dress, and had a little black-and-white checked breakfast shawl folded about her shoulders. Upon the table and upon the chairs lay spread three new dresses, and many colored and white aprons—evidence of the loving care in which she was held. If a stranger had looked in at her through any of the four windows,—two on the side toward the pike and the church, and two on the side toward the village,—he might easily have grown sentimental about gracious and placid old age.

But Grandmother Miller was at least not placid. Her black eyes snapped, her hands clasped each other tightly, and occasionally her foot struck the floor a sharp tap.

"They have made my clothes for me!" said grandmother, angrily. She repeated it as if she were not only angry, but frightened: "They have made my clothes for me!"

She rose and paced the floor.

"I am no child! I am no baby! They want to make out that I am old enough to die! I will not have it! But"—Grandmother Miller sat down once more in her chair before the fire—"I cannot help myself!"

In her misery she began to rock back and forth.

"My own children that I brought up have respect for me," she thought.

"But these others have no respect for me. They are not like their pops and moms. I say yet to-day to my children, 'Do so and so,' and they do it. But these others are different. I was kind to them always. I learned English for them. I let them cut whole pies in the cupboard. When their pops and moms were little, they did not dare to take pie except what was cut. I let them sleep here, three, four at a time. I let them fight with pillows, my good feather pillows. I let them walk over me. This is what I get. Ach, in a year I will be in my grave with trouble!" Grandmother Miller lifted one clenched hand into the air. "If they do not make it different, I will—I will—yes, what will I do? I am old, they walk over me. They have made clothes for me!"

Six months ago Grandmother Miller's subjection had begun. Hester, her namesake and her darling, pretty Hester, with whose bringing up she had concerned herself as much as Hester's father or mother, was the first aggressor. Hester had almost finished her schooling in Millerstown; after another year she and her Cousin Ellen would go away to a normal school. She came into her grandmother's kitchen one bright June morning with a basket in her hand.

"Here are doughnuts, gran'mom, and here are 'schwingfelders' and here is bread."

Grandmother Miller looked with delight upon the viands. She had taught Hester to bake, and she had reason to be proud of her pupil. She patted Hester on the shoulder, praised the bread and cake, and planned to carry some of her own baked things to the Weimers, in whose home were five small children. Hester had on a pink calico dress with a tight waist and a full skirt, such as the girls in Millerstown wore in the seventies, and her curly hair lay damp about her forehead.

Hester had no sooner gone than her Cousin Ellen ran in. She was much darker than Hester, but she and Hester dressed alike, because their grandmother wished them to do so, and presented them constantly with pieces from the same bolt of cloth.

"I have some pie for you, gran'mom," said she, "and some fine cake."

Grandmother patted Ellen on the shoulder as she had patted Hester. Now she could carry all her baking to the Weimers.

To Grandmother Miller's astonishment Hester and Ellen appeared the next week on baking morning, and each carried a basket.

"Here is pie and fine cake, gran'mom," explained Hester.

"And here is bread and doughnuts and schwingfelders," said Ellen.

"We changed round once," they said together.

Their grandmother looked at the two girls proudly. They wore pink sunbonnets this morning, and they were even more engaging than usual.

"They are fine," said she. "But don't bring me any more. I get all the time so many things on hand. I will bake myself to-day. But the things are fine. I have a new dress for each of you. You are good girls."

"But mom baked the bread and the doughnuts and the schwingfelders," explained Ellen.

"And my mom baked the pies and the fine cake," said Hester.

"Then why do you bring them? I thought you wanted me to see how good you could bake."

"Ach, no!" said Hester, laughing. "It is because you are not to bake any more, ever."

"Not to bake any more!"

"You are not to have it so hard," explained Ellen. "We have it all planned."

Grandmother Miller laughed until she could hardly see. When the girls had gone, she chuckled, "The dear children!" She got out her baking-board and heated the old-fashioned oven, and decided that she would bake rhubarb pie and cherry pie. "Then I will send one to each of these girls for a present," she thought.

One morning early in July young John Adam appeared on his way to school. He and Hester were the children of Adam, Grandmother Miller's oldest son. John was short and sturdy and blue-eyed, and he went about work or play with equal vim.

The Rose and Lily Quilt

By *Elsie Singmaster*

THE DEDICATION AND love that many quilters feel for the patchwork passion makes it impossible to imagine a life without quilting.

In this story, seventy-year-old Grandmother Miller is horrified when her well-meaning but misguided children and grandchildren decide she should live a life of leisure for the rest of her days. This means no baking, sewing, entertaining, or quilting for the perfectly capable woman. In protest, a disgruntled Grandmother Miller marches to the village store and purchases the materials she needs to make a Rose and Lily quilt.

Pennsylvania-born author Elsie Singmaster published hundreds of short stories and thirty-eight books in her forty-year writing career. This piece comes to us from 1913.

Grandmother Miller sat before the fire in her wide kitchen, with her hands clasped in her lap. The kitchen was warm, sunny, and with its plain walls, its rag carpet, and its beautifully carved mahogany dresser, even handsome. A Pennsylvania German kitchen is usually dining-room and sitting-room both. In this house there were many other rooms, but they were closed, and, since it was November, as cold as Greenland. There were other great pieces of furniture, carved like the dresser, and worth a large price from a dealer in antiques, if he had known of them, or if Grandmother Miller could have dreamed for an instant of parting with them.

Grandmother Miller was a picture of beautiful old age. She wore a black dress, and had a little black-and-white checked breakfast shawl folded about her shoulders. Upon the table and upon the chairs lay spread three new dresses, and many colored and white aprons—evidence of the loving care in which she was held. If a stranger had looked in at her through any of the four windows,—two on the side toward the pike and the church, and two on the side toward the village,—he might easily have grown sentimental about gracious and placid old age.

But Grandmother Miller was at least not placid. Her black eyes snapped, her hands clasped each other tightly, and occasionally her foot struck the floor a sharp tap.

"They have made my clothes for me!" said grandmother, angrily. She repeated it as if she were not only angry, but frightened: "They have made my clothes for me!"

She rose and paced the floor.

"I am no child! I am no baby! They want to make out that I am old enough to die! I will not have it! But"—Grandmother Miller sat down once more in her chair before the fire—"I cannot help myself!"

In her misery she began to rock back and forth.

"My own children that I brought up have respect for me," she thought.

"But these others have no respect for me. They are not like their pops and moms. I say yet to-day to my children, 'Do so and so,' and they do it. But these others are different. I was kind to them always. I learned English for them. I let them cut whole pies in the cupboard. When their pops and moms were little, they did not dare to take pie except what was cut. I let them sleep here, three, four at a time. I let them fight with pillows, my good feather pillows. I let them walk over me. This is what I get. Ach, in a year I will be in my grave with trouble!" Grandmother Miller lifted one clenched hand into the air. "If they do not make it different, I will—I will—yes, what will I do? I am old, they walk over me. They have made clothes for me!"

Six months ago Grandmother Miller's subjection had begun. Hester, her namesake and her darling, pretty Hester, with whose bringing up she had concerned herself as much as Hester's father or mother, was the first aggressor. Hester had almost finished her schooling in Millerstown; after another year she and her Cousin Ellen would go away to a normal school. She came into her grandmother's kitchen one bright June morning with a basket in her hand.

"Here are doughnuts, gran'mom, and here are 'schwingfelders' and here is bread."

Grandmother Miller looked with delight upon the viands. She had taught Hester to bake, and she had reason to be proud of her pupil. She patted Hester on the shoulder, praised the bread and cake, and planned to carry some of her own baked things to the Weimers, in whose home were five small children. Hester had on a pink calico dress with a tight waist and a full skirt, such as the girls in Millerstown wore in the seventies, and her curly hair lay damp about her forehead.

Hester had no sooner gone than her Cousin Ellen ran in. She was much darker than Hester, but she and Hester dressed alike, because their grandmother wished them to do so, and presented them constantly with pieces from the same bolt of cloth.

"I have some pie for you, gran'mom," said she, "and some fine cake."

Grandmother patted Ellen on the shoulder as she had patted Hester. Now she could carry all her baking to the Weimers.

To Grandmother Miller's astonishment Hester and Ellen appeared the next week on baking morning, and each carried a basket.

"Here is pie and fine cake, gran'mom," explained Hester.

"And here is bread and doughnuts and schwingfelders," said Ellen.

"We changed round once," they said together.

Their grandmother looked at the two girls proudly. They wore pink sunbonnets this morning, and they were even more engaging than usual.

"They are fine," said she. "But don't bring me any more. I get all the time so many things on hand. I will bake myself to-day. But the things are fine. I have a new dress for each of you. You are good girls."

"But mom baked the bread and the doughnuts and the schwingfelders," explained Ellen.

"And my mom baked the pies and the fine cake," said Hester.

"Then why do you bring them? I thought you wanted me to see how good you could bake."

"Ach, no!" said Hester, laughing. "It is because you are not to bake any more, ever."

"Not to bake any more!"

"You are not to have it so hard," explained Ellen. "We have it all planned."

Grandmother Miller laughed until she could hardly see. When the girls had gone, she chuckled, "The dear children!" She got out her baking-board and heated the old-fashioned oven, and decided that she would bake rhubarb pie and cherry pie. "Then I will send one to each of these girls for a present," she thought.

One morning early in July young John Adam appeared on his way to school. He and Hester were the children of Adam, Grandmother Miller's oldest son. John was short and sturdy and blue-eyed, and he went about work or play with equal vim.

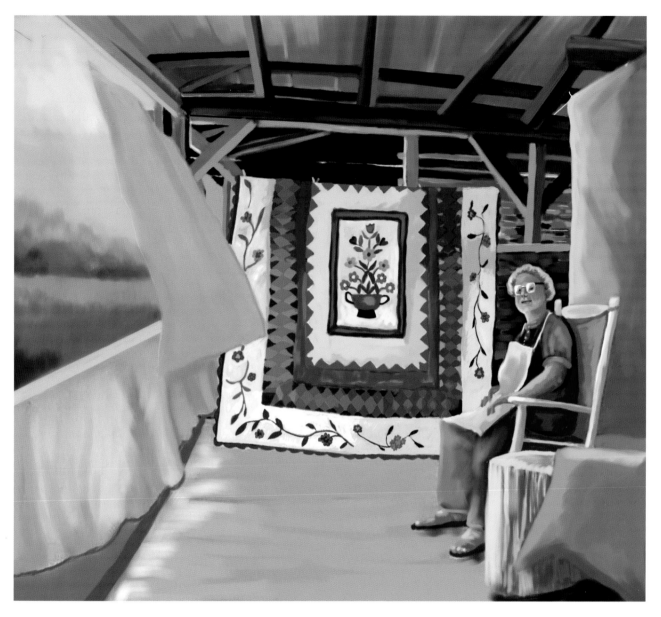

"AN AIRING OUT"
A seasoned quilter sits in a rocking chair on her front porch, admiring the day and her handiwork as one of her prized quilts swings in the breeze. (Artwork © Judith W. Huey)

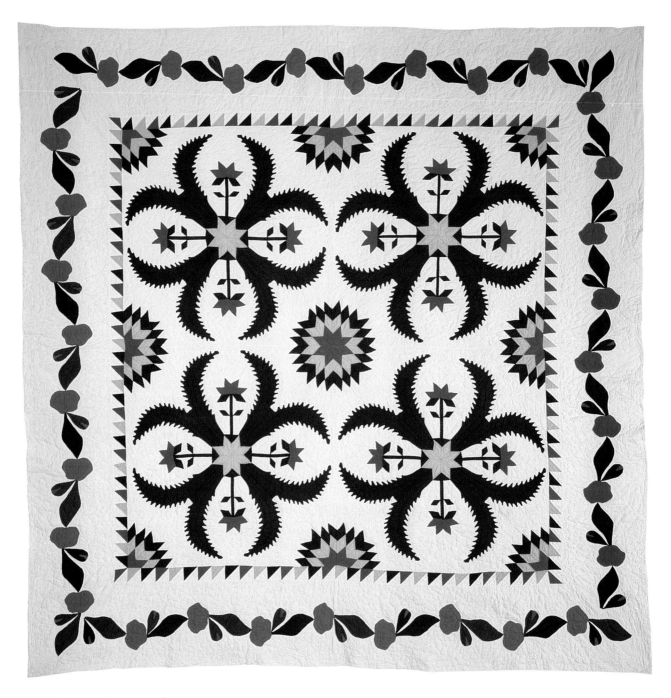

PENNSYLVANIA APPLIQUÉ
This quilt, made circa 1870, features an original design and measures 86 inches square. Both the colors and four-quadrant format are typical of Eastern Pennsylvania appliqué of this period. (Private collection, Stella Rubin Antiques)

He now took the broom from his grandmother's hands. "You are not to sweep the porch any more, gran'mom," he said. "I am the sweeper. And John Edwin is coming to hunt the eggs in the evening always and feed the chickens."

Grandmother Miller did not laugh. She had laughed at Hester and Ellen, but they continued their unwelcome gifts of pie and cake. She stammered out a Pennsylvania German equivalent for "Nonsense!" and made up her mind grimly that she would sweep the porch and the pavement in the morning and gather the eggs in the evening long before John Adam and John Edwin should appear.

In August, grandmother protested angrily to her son Adam.

"What ails these young ones? Why are they all the time after me?"

Adam looked down at his mother uneasily. Although he was forty years old and six feet tall, and she hardly came above his elbow, he was still a little afraid of her.

"Come to us to live, mom. You oughtn't to live here alone any more."

Grandmother laughed. Adam was her child; she had borne him, nursed him, spanked him. She knew how to deal with Adam.

"Pooh!" said she.

As August changed to September, and the days grew shorter, Grandmother Miller began gradually to be aware that she was never alone. Accustomed to visits from her grandchildren, she was slow to notice that before Ellen, who had slept with her, departed, Hester came in to do the breakfast dishes, and that Edwin's children stopped on their way from school at noon, and Henry's children on their way back to school.

When in September grandmother wondered idly whether she should have turkeys or geese for the Christmas feast, Hester told her that she was not to have the Christmas feast.

"We will have it at our house, gran'mom. You are not to have Christmas dinners any more. It is too hard work."

At that, when she had a few moments to herself, grandmother wept. She was hurt and angry, but, worse than that, she began to feel old.

"I didn't know it would ever be like this," she said to herself, bitterly. "I did not think the day would ever come when I would wish to die. But now I wish to die."

Grandmother Miller always did her winter sewing in November. At that time she made herself three warm dresses and many white and colored aprons.

But in September Ellen and Hester, sewing after school hours and in the evenings, made grandmother's aprons and dresses, and a new silk sunbonnet. Ellen and Hester sewed with lightning speed; it was the one art in which they had not obeyed their grandmother's instructions. Grandmother did not like their sewing; their stitches were too long, and an occasional pucker showed where all should have been smooth.

When they presented their grandmother with her wardrobe, she was at once too polite and too confused to express the amazement and disappointment that she felt.

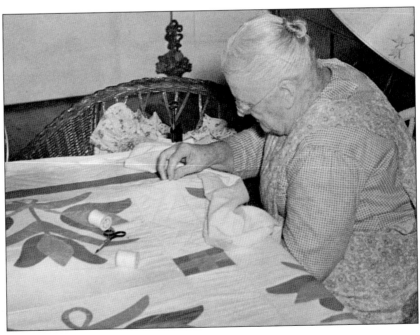

HANDS OF EXPERIENCE
A practiced quilter works at her frame in this vintage photograph.

145

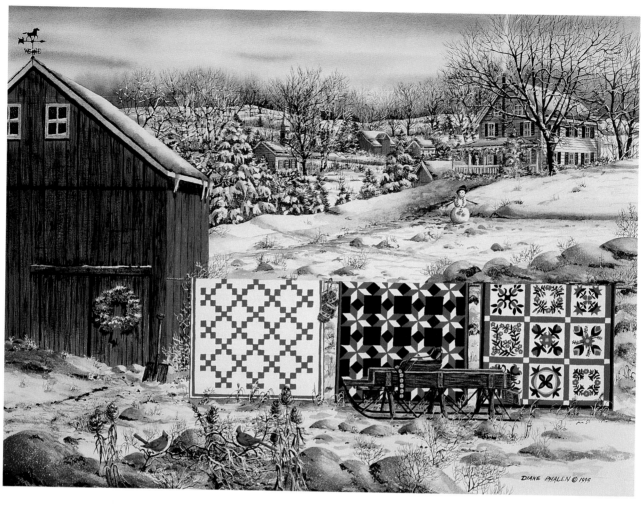

"HOLIDAY AIRING"
Red, green, and white quilts are freshened by the crisp, winter air in this farm-country Christmas scene. (Artwork © Diane Phalen)

She laid down the apron that she had begun, and looked at them stupidly.

"But how will I fill in my time?" she asked, with a mighty effort to keep her voice steady. "What will I do from morning till night?" "You will rest," said Hester, affectionately. "You are to rest, so that you will be with us for many years."

"Your hand trembles, gran'mom," said Ellen. "Let me thread your needle."

Speechless, grandmother let Ellen take the needle from her hand. When the girls had gone, she sat for a long time, and looked at her gifts spread out on the chairs and the table.

"They have made my clothes for me!" she said again.

Then her gaze wandered. She looked down the street toward the village and up the road toward the church. Opposite the church was the cemetery; from where she sat, grandmother could see a tall monument.

Suddenly, as if some firm foundation were slipping from beneath her feet, or as if she were being dragged down by some powerful force, Grandmother Miller clutched the arms of her chair. Then she rose, and without stopping to put on her shawl, ran down the street to the village store.

"I want muslin," she said. "Muslin and cotton batting and tailor's chalk."

Still moving as if she were pursued, Grandmother Miller returned to her kitchen, climbed thence to her garret, brought down her quilting-frame, and set it up in the kitchen.

"I must have work!" she cried. "Cannot sew! Cannot thread a needle! I will show them! I must have work!"

BARNRAISING
This popular variation of the Log Cabin quilt has a Rising Sun motif in its center. It was made in New York State at the turn of the twentieth century and measures 88 by 66 inches. (Stella Rubin Antiques)

Overseaming neatly and beautifully, she sewed the breadths of muslin together, laid the cotton batting between them, and fastened them into the frame. Upon them, by means of an intricate pattern in which tiny rose was set close to tiny rose, and tiny lily close to tiny lily, she printed a design for her quilting. Then, although night had come, and Grandmother Miller was seventy years old and owned no spectacles, she began her work. After her thimble had clicked against her needle for about fifteen minutes, she breathed a loud "Ah!" of complete satisfaction.

"Cannot sew!" said she again. "Cannot thread a needle!" Her eyes sparkled. "Whichever leaves me the most alone, Hester or Ellen, will get this quilt."

"But, grandmother, you cannot see!" protested Ellen, when she came to spend the night.

"Perhaps she could if I threaded a lot of needles."

Hester spoke a little absent-mindedly; perhaps she was already planning the great surprise for grandmother.

In the morning, after Hester and Ellen had gone, grandmother unthreaded their needles.

Every fall grandmother visited the farm that she had inherited from her father. Thither her son Adam took her in the high buggy, and for her arrival her tenants made great preparations. It was not, as a matter of fact, necessary for grandmother to make the eight-mile journey; the Dieners could easily bring in the fat goose and the red ear of corn and the panhas and the sausage that they annually presented to her. It would even be easier for them to bring in the new baby than for grandmother to go to see it.

But to grandmother's amazement, she was allowed to go this year without protest. Adam's wife and Ellen and Hester and a few other women of the family were on hand to wrap her up, and to charge Adam to keep her wrapped up; but beyond that they did not interfere.

Grandmother was unspeakably happy. The thought of her rose-and-lily quilt, growing slowly under her exquisite stitches, gave her great satisfaction; her mind had now something to rest upon when she sat before the fire or lay wakeful at night. Never was quilt so carefully made. With its beautiful close pattern, followed in fine white stitches upon the white background, it would be handsomer than any Marseilles spread. Moreover, grandmother loved to visit, to go armed, as she was now, with gifts—a gold piece for her tenant's Christmas present, a shawl for the mother, a coat and cap for the newest baby, and nuts and candy and oranges for the other children.

Having made her visit, having eaten her dinner with the Dieners, having listened to Mr. Diener's report, and having even

GRACEFUL FLOWERS
This 1920s cotton Center Medallion quilt features pink flowers with stuffed centers. It was made in California and measures 80 inches square. (Stella Rubin Antiques)

inspected the corn-crib and the barn and the spring-house, she let herself be lifted into the buggy, and she and her son started homeward. They stopped at the store for a fresh supply of tailor's chalk to make a new section of the rose-and-lily quilt. Adam did not call for the store-keeper to come out, as Ellen or Hester would have done. He said, "There, mother, hold the lines," and went in himself.

Sitting there in the dark street, grandmother was for an instant disturbed in her contentment. Two women, hooded and shawled against the cold, came down the street, talking busily.

"Ach, she is too old!" said one, and the other answered with a hearty, "You have right!"

"They are talking about some poor soul," said grandmother to herself. "But I am not old."

To grandmother's surprise, Ellen and Hester and the others were not at hand to help her down when she got home. She was delighted. Now she would work a little upon her quilt. Adam held the horse while his mother clambered out; then he handed her the basket, and she trotted happily up the brick walk. The girls, her daughters-in-law and granddaughters, were fine girls; they would have the fire burning brightly and the lamp lighted. After supper—seventy-year-old grandmother meant to have a little of the fresh sausage!—she would stamp the new section of her quilt, and work one rose and one lily. She dreaded the moment when her dear task would be accomplished.

She opened the door of her kitchen. Then she put her basket down and supported herself with her hand against the frame of the door. The fire was burning, the lamp was lighted, on the table was spread the cloth for her supper, and on it were the precious silver spoons and the sugar-bowl and the cream-pitcher that Ellen and Hester insisted she must use—"While you live, gran'mom."

But the quilting-frame was gone, and on grandmother's armchair lay the finished quilt!

Presently, when she could gather strength enough, grandmother walked across the room, picked up the quilt, examined it, and laid it down. Then she climbed into the garret and brought the frame down once more, set it up, and into it sewed the finished quilt. It was not only quilted, it was hemmed. The girls must have worked with incredible speed. Grandmother lighted

two other lamps, flung wide the closed shutters, and began to work at the quilt. But she worked with a long pin, instead of a needle. It was pathetic to see her bending close over her eager strokes.

It does not take long for news to travel in Millerstown. Within five minutes, some one coming down the road saw grandmother's brilliant light, went to find out what in the world she was doing, and then flew, saddened and horrified, to announce that grandmother had gone mad. Hester and Ellen were all ready to start to her house to spend the night; the others ran with them, and all came, panting and breathless, to grandmother's door.

"O gran'mom! gran'mom!" wailed Hester, as she flew. "Oh, dear gran'mom!"

"We should 'a' stayed every minute by her," said Ellen.

Then, with their fathers and mothers and sisters and brothers behind them, to say nothing of other uncounted Millerstonians, they burst into grandmother's kitchen, where grandmother stood by the quilting-frame with the long pin in her hand. The rush of their coming would have been enough to drive a sane person into insanity.

"Oh, what are you doing, dear gran'mom?" said Hester.

Grandmother straightened her shoulders and flung back her head.

"I am ripping," said she, in the steady tones of one who, after unendurable provocation, rejoices to give battle. "I am ripping, and I will keep on ripping till every long, crooked stitch is out of my quilt. I thank myself,"—grandmother's tone was firm, her eye was bright and steady,—"I thank myself for all the trouble, but from now on I will do my own quilting.

"And"—grandmother did not know that at this moment she was adding just twenty happy, independent, useful years to the seventy that she had already enjoyed—"from now on I do my own sewing and sweeping and cooking and baking and egg-hunting and chicken-feeding. And on Christmas, one month from to-day,"—grandmother's voice became excited, jubilant, laughing, and she waved her long implement for ripping in the air,—"on Christmas I will roast here in this oven, for whoever will come, a turkey and a goose!"

The Ashley Star

Marjorie Hill Allee

ELLEN, A THOROUGHLY modern young woman, is put-off by the old-fashioned furnishings and ancient knickknacks and of her stern Aunt Susan's home. When they host a tea party for a visiting friend, Ellen is mortified to discover that Aunt Susan has planned a traditional quilting as the afternoon's entertainment. The guests, however, have a different reaction.

After the party is over, Ellen is finally able to recognize the significance of the family quilt that had been passed down to her, and she understands the connection it gives her to generations past.

Author Marjorie Hill Allee, whose female characters are known for being strong-minded, wrote this story in 1921. Her best known books are *Jane's Island* and *The Great Tradition*.

Ellen rapped cautiously at the door of Aunt Susan's room. If you knocked too softly, Aunt Susan did not hear; but if you knocked much harder, she greeted you with the tart announcement that she was not so deaf as that yet!

A brisk "Come in" sounded over the transom, and with relief Ellen turned the knob; she had particular reasons for hoping to find her great-aunt in an unruffled humor. Aunt Susan sat in a high-backed rocking-chair, sewing patchwork squares. The rocker, which was placed on a braided rug to save the Brussels carpet, was the only chair she ever used; but the big room was crowded with other furniture, and pictures and gift books and little china figures elbowed one another on the mantel, on the walls and on the tables. The whole room offended Ellen's taste. She liked plenty of space, plain colors and simple lines; and ever since she had visited Amy Winston at Christmas time had longed for the Southern mahogany she had seen in Amy's home.

"If this were only colonial!" she thought. "But it isn't; it's just old-fashioned enough to be queer."

Aunt Susan's needle twinkled down to the end of her seam before she raised her head, and Ellen stood waiting like a little girl told to be seen, not heard. However much she might try to assume the dignity of a young lady, the room and Aunt Susan nearly always made her feel uncomfortably young and unimportant. She rebelled against the feeling even more than against the Victorian parlor set; but her rebellion was of no avail.

"Well?" inquired Aunt Susan. "What is it?"

Ellen braced herself and pitched her voice as tactfully as possible. "Mother said I might ask you, Aunt Susan, if you would mind a tea party in your room Thursday afternoon for Mme. Winston and Amy. You know they were so very good to me last Christmas." She paused and watched Aunt Susan's unchanging face. It was a constant wonder to her that Aunt Susan could make her feel so uncomfortable without losing her own composure and without noticing that she was disturbed.

"Who's invited?" Aunt Susan asked at last.

"I haven't spoken to anyone yet. I thought we might ask Cousin Charity and Cousin Mattie; then with Mme. Winston and Amy that would be all."

"Ask Mary Henley, too," directed Aunt Susan. "She was a great friend of Lucy Winston's when they were girls together."

Ellen felt encouraged. "I can make the tea and the cakes and the sandwiches, and I'll dust and bring in flowers Thursday morning."

"Any entertainment?"

"Why, no," answered Ellen, astonished. "They never have anything except music at teas. I don't believe you'd care for that."

"No. I guess we can do better," agreed the old lady dryly. She selected a pink-and-green triangle from the basket beside her and ran down the seam with one swift motion of her needle.

Ellen understood that the interview was over; she left the room much cheered. Aunt Susan had not objected to a single essential point. Ellen searched her memory for details of an at home at which Mme. Winston had poured tea. She assured herself that she could make even Aunt Susan's room attractive. To Ellen's polite invitations all of the guests replied that they would be glad to come. It was indeed an event for them to see Lucy Winston, who rarely came back to her girlhood home. They loved her for the same gracious and friendly qualities that had made them love her fifty years ago; they held in delighted remembrance her beautiful dresses, which were not quite like any of the pictures in the fashion books, and for the stories she told of people and of places she had seen on her travels.

Aunt Susan seemed not to be taking the event seriously. She sewed long hours on the pink-and-green patchwork. She told Ellen that the pattern was called the Ashley star, and Ellen promptly forgot it. On Thursday morning, when she came in with her dust cloth, a great expanse of white squares alternating with blocks of Ashley star lay over Aunt Susan's knees; the quilt top was nearly done.

"Do you want me to help you dress this afternoon, Aunt Susan?" she asked uncertainly. She hoped to get a chance to suggest that Aunt Susan wear her best lace collar.

"Come in about one o'clock," replied Aunt Susan, speaking through a mouthful of pins with the skill of long practice.

After dusting Ellen started to make sandwiches. Luncheon time still found her cutting rounds of bread, and she begged off from eating with the family on the ground that she had tasted too much sandwich filling to be hungry. When the sandwiches were stacked in the refrigerator she returned to the scene of the party, wondering just why Aunt Susan wished to dress so early and cherishing the hope of unobtrusively slipping some unnecessary furniture out of the room, though she did not quite know how she should manage it.

She had difficulty in believing what she saw. With the exception of four ladder-backed chairs that stood out in a fine open space in the centre of the room, Aunt Susan's multitudinous furniture was pushed back hard against the sides of the room, tea table and all. The chairs supported four stout wooden pieces laid in a square, with their ends crossing; Aunt Susan had brought out her quilting frame.

"I'd ask Sarah, but I know she's busy," said Aunt Susan in the most matter-of-fact tone. "You can help me tack this in well enough." Ellen opened her mouth to protest, but no words came; she did not know how to begin. Aunt Susan could not have forgotten the tea party. What earthly reason could she have for deliberately setting up a quilt?

Mechanically, Ellen began smoothing the unbleached muslin laid down for the back of the quilt; she worked patiently, spreading the cotton batting in a thin even layer, and when the gay top was pinned

TUMBLING BLOCKS
Each side of the boxes in this quilt are made of wool and silk strips and are embellished with embroidery. It was made in Kentucky circa 1890 and measures 72 by 74 inches. (Collection of Kathi Regas, Stella Rubin Antiques, photograph by Harriet Wise)

BALTIMORE ALBUM
This 112-inch-square appliquéd quilt is inscribed "E. C. Deckel, April 6, 1848." Album quilts were especially popular in the Baltimore region in the late 1840s. (Stella Rubin Antiques, photograph by Harriet Wise)

down she helped sew it into the quilting frame with stout cord.

"We ought to get it well toward three fourths done this afternoon, if everybody works," said the old lady, surveying it with a professional eye.

Then the horrid truth dawned on Ellen: this was Aunt Susan's idea of entertainment for their guests. She expected Mme. Winston and Amy to quilt!

"Did they quilt at tea parties when you were a girl?" Ellen ventured to say in a trembling voice.

"What?" asked Aunt Susan sharply:

Ellen repeated her question. The tears were very near.

"No, no; they didn't have sense to, any more than they seem to have now. It takes a lot of living to find out you're happier when you're busy." That bit of philosophy was of no comfort to Ellen; she fled to her own room, and there her tears dried in a fever of indignation. She thought about Aunt Susan, about her deafness, her queerness, her disregard of plans. It seemed to her impossible to go on living in the same house with Aunt Susan.

At three o'clock Ellen dressed carefully and then went downstairs. Her party had been completely spoiled, but she should have to go through with it just the same. She did not tell her mother; the party had been given into her hands at her own request, and she was too proud to ask for help, even if she had had any hope that the quilting frame could be bundled out at the last minute.

Village guests are painstakingly punctual. All arrived at the same time, and they were too much absorbed in Mme. Winston to pay attention to Ellen's hot, unhappy face. She and Amy followed her mother and the four old ladies down the dim hall to Aunt Susan's open door. A little cry of surprise and interest rose as they came in full view of Aunt Susan, who was busily making circles on the quilt top with a teacup for a pattern.

"What is it?" asked Amy. Ellen's embarrassed answer stuck in her throat, and she turned her head.

"My dear granddaughter, I'm ashamed of you," said Mme. Winston. "Ellen, she hasn't had your liberal education; she doesn't know a quilting when she sees one."

"Oh—h!" breathed Amy respectfully. She came closer to the frame and touched the quilt with one finger. "Grandmother, do you remember when we were in the mountains two years ago we tried to get back to that settlement where they still made quilts? You said then that quilting was almost a lost art. What is the name of this? Those mountain quilts had the quaintest names. One was Philadelphia pavement, and one was the rose basket."

Aunt Susan beamed on Amy in a manner that astonished Ellen.

"This is the Ashley star," she said proudly. "My mother, Ellen's great-grandmother, named it herself for the little Virginia town she came from, where she learned to piece the pattern. She was about twenty when she married and came West in a covered wagon. I guess she was young enough to get lonesome many a time for that little town. She always pieced the pattern in pink and green just like this, and when I was a little girl I used to think that all the stars over Ashley were pink and green."

"I suspect," said Mme. Winston, "that there would be stories for a great many of these things you have, Susan."

Aunt Susan's eyes swept the chairs that were pushed back into the corners and the knickknacks that were piled on the shelves. "Plenty of stories," she said. "Yes, plenty of stories. Most of this great lot I wouldn't keep at all if they weren't almost as much company to me as the people they belonged to used to be. Mother was so proud when she could buy that little table and set it in her log cabin. 'Twas built by an old cabinetmaker out of a walnut tree on father's farm. This tea set Sister Emmeline bought with her first money from school-teaching to put into the parlor of the new house. I seldom look at it but I think of the time she had with the big boys that winter. She wasn't large enough to whip them, and they knew it; but she wouldn't give up, and she succeeded." Aunt Susan broke off abruptly. "Mary, can you quilt with an open-end thimble? This was Emmeline's too."

Ellen stood back, wondering. She looked at the little tea table with eyes as puzzled as if she had expected to find its story tied to it. Aunt Susan had never told her the tale. The guests rustled happily round the

quilting frame, admiring the quilt, trying on thimbles and exchanging reminiscences of other quilting times. Ellen moved over and threaded needles for them.

"May I try?" asked Amy.

"Do!" said Aunt Susan, and Amy was soon stitching laboriously round a penciled circle. On a sudden decision, Ellen took a needle and went to work. She had not tried to quilt for several years; she had forgotten the effort and the exactness required to sew with tiny even stitches through the two layers of cloth and the filling of cotton. When she straightened up to rest a wry neck she watched with admiration and envy the ease with which Aunt Susan's needle traveled in and out.

The guests soon recovered their expertness at an accomplishment they had learned well years ago. They rolled the quilt from the sides again and again as they traced the intricate pattern toward the middle.

After a while Ellen and Amy were glad to relieve their cramped muscles; but the old ladies were much surprised when the two girls appeared with a kettle of hot water and the tray of cakes and sandwiches.

"I don't know when I've had so good a time!" exclaimed flushed little Cousin Mattie. "Why, I declare, it took me right back again to the days when we were girls together!"

"I feel so, too," announced Cousin Charity. "I declare, I'll take a cup of tea, Ellen. I'd just as soon stay awake tonight to think over this party!"

Mary Henley ate her specially prepared toast and followed it with three cakes and a marmalade sandwich. A group of small girls could hardly have disposed more effectively of the food. Doubting Ellen herself could see that everyone was enjoying the afternoon, and none more than the Winstons.

"I wish we could stay to finish it," said Amy, wistfully regarding the narrow unquilted strip that was left, "I wish we could."

"It won't take long," Aunt Susan assured her. "I aim to have it quilted and bound when you go back home, so you can take it with you. Mother always said a girl ought to have the first quilt she quilted."

"Oh—oh!" exclaimed the enraptured Amy. "Grandmother, did you hear that?"

Guiltily Ellen remembered a quilt upstairs on her closet shelf. Aunt Susan had given it to her two or three years ago because it was the first quilt on which she had ever worked; and she had not valued it at all. They had so many quilts in their family!

After the last reluctant departure Ellen conscientiously swept up the crumbs and washed the plates and the cups. It was twilight when on tired feet she went to the hammock to rest and to arrange her confused impressions of the day.

Presently she knew that her mother had gone into Aunt Susan's room to help her off to bed. Aunt Susan's voice—the high voice of a deaf person—came faintly through the window, "Sit down till I get this finished, Sarah."

Soon it rose again. "Lucy Winston was speaking to me about Ellen. Did she say anything to you? Yes? Well, I thought she would. The trip would be a good thing for Ellen. I want you to let me pay for her clothes. She's done plenty of things for me that I know well she never wanted to do, and she never complained."

Ellen gave a joyful little bounce in the hammock. Aunt Susan must be referring to the Hawaiian trip that the Winstons had spoken of. For six whole months she might exchange the commonplace of her home for the romance of the far-away islands.

Her mother's firm voice brought her down to earth again. "She said that a girl often appreciated her own home more for having seen a thorough contrast. I think it may prove true. Ellen seems perfectly indifferent to the good things we have; she wants whatever other people like, whether it's clothes or family history."

"Oh, well," responded Aunt Susan, "that's natural enough. So did I at her age; but now I cling to family things almost more than I should, whether they're good or not. It's the way of life. Ellen's a good girl, and Lucy Winston will enjoy her."

The lamplight and their voices died away together as they left the room.

Over the tops of the trees a star shone suddenly in the deepening night. "Why, it's the Ashley star," said Ellen happily, "green and pink! And how bright it is! I wonder if it looked like that to great-grandmother!"

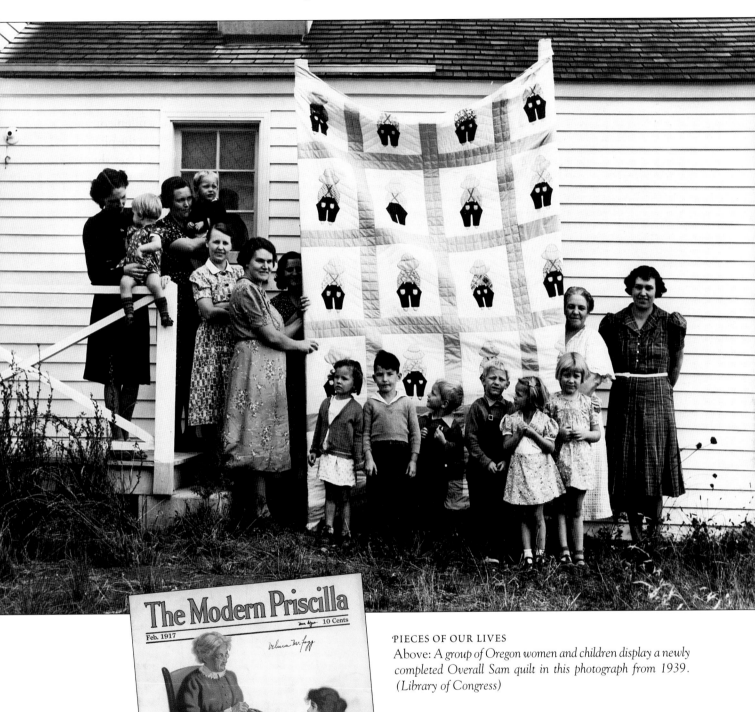

PIECES OF OUR LIVES
Above: *A group of Oregon women and children display a newly completed Overall Sam quilt in this photograph from 1939. (Library of Congress)*

PASSING IT ON
Left: *If quilters continue to pass along their love of quilting to younger generations, the art and craft of the quilt will never die. This vintage Modern Priscilla magazine was printed in February 1917.*

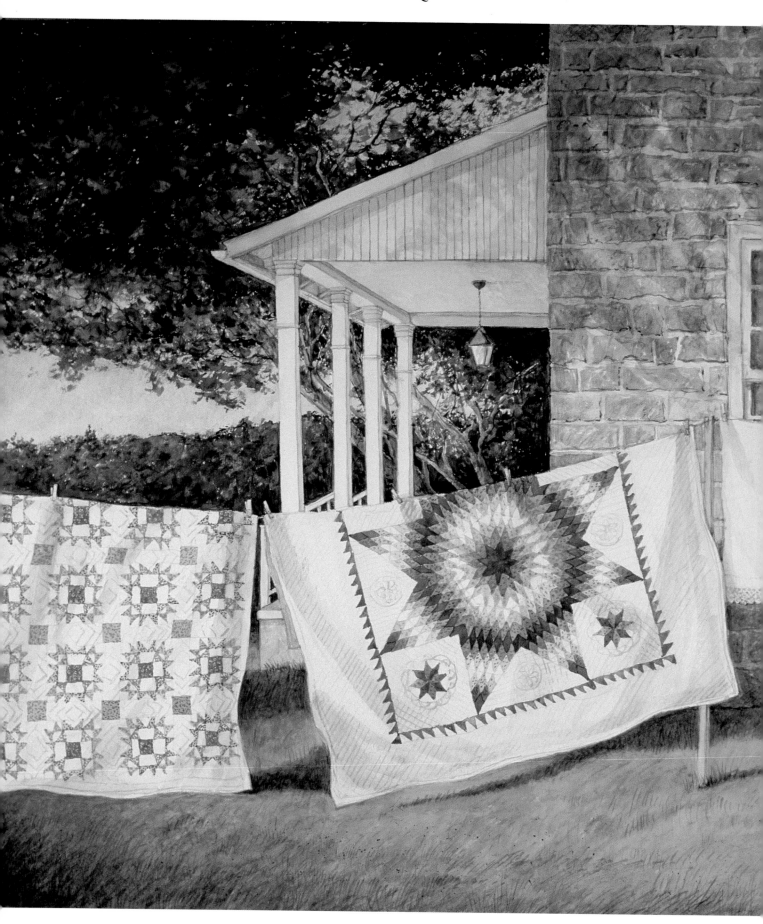

"WASH DAY"
Nothing dries linens like the sun and a sweet-smelling afternoon breeze. Here, two quilts drink in the day's warmth. (Artwork © Dan Campanelli, published by New York Graphic Society)

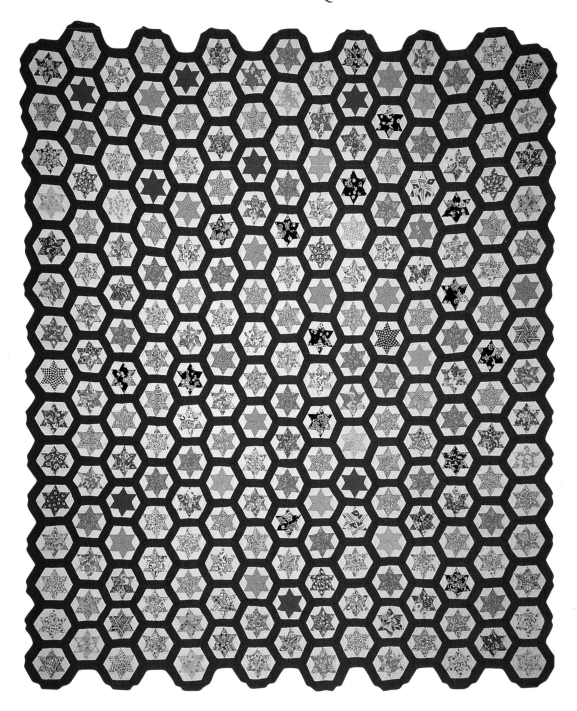

STARS IN HEXAGONS
Multicolored stars light up this quilt like constellations in a night sky. It was pieced circa 1920. (Stella Rubin Antiques, photograph by Harriet Wise)